Goya
and the Impossible Revolution

PANTHEON

Gwyn A. Williams

and the Impossible Revolution

Library of Congress Cataloging in Publication Data

Williams, Gwyn A.
Goya and the Impossible Revolution

Bibliography: pp. 185–86.
Includes index.
1. Goya y Lucientes, Francisco José de, 1746–1828.
I. Title.
NE2062.5.G6W55 1976 760′.092′4 76-5945
ISBN 0-394-49304-4

Printed in Great Britain

FIRST AMERICAN EDITION

1. Frontispiece. Goya, self-portrait, 1815

for Maria Fernandez y Plaza

Contents

Preface

The framework within which I have tried to locate this essay
is outlined in the final chapter: the remainder of the essay
assumes empirical form. I think I have argued for a new
reading of Goya in some particulars.

Four books in particular have moved my mind. I probably
owe most to Edith Helman, whose precise and scholarly
filigree work on the sources and hinterland of Goya's
Caprichos and on his relations with Spain's thin but brave
ranks of the eighteenth-century enlightened is a delight.
Her paramount influence in that section of the essay will be
obvious and I am grateful to Joaquin Romero Maura for
having introduced me to her work. To John Berger's books
I am indebted for continuous challenge and pleasure in a
sense at once more general and more specific. Pierre Gassier
and Juliet Wilson, in their magnificent *catalogue raisonné*, have
at last established Goya in history. Their book is as graceful
and perceptive as it is monumental and I find Pierre Gassier's
interpretation of the Black Paintings convincing. His superb
edition of the drawings appeared too late for my text, but it is
another majestic achievement. Francis D. Klingender's
passionate and generous study of Goya was my initiation
into what has become an obsession; it is a cherished old
comrade of a book. His marxism is not mine, but what
apprentice ever said different to his master?

Goya's work hardly serves as comic relief, but it is very
rich, very rewarding even in its inadequacies, and I have
found it peculiarly relevant. I can recommend it to anyone
over forty. But be careful at forty-six: that's when he had his
breakdown.

Gwyn A. Williams

Goya
and the Impossible Revolution

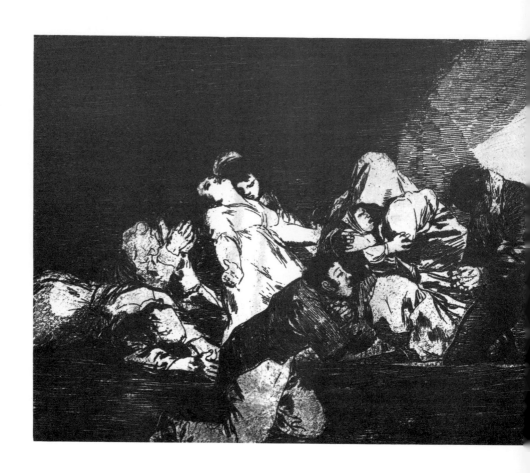

2. One can't look. *Desastres*, 26, *c*.1820

1 *Populacho*

The executioners we do not see. Their rifles thrust in from the right, sharp with bayonets, inhuman and implacable. The eye follows their thrust, from a twilit grey into a blackness. Who are these huddled people? They are ordinary, common; their probably unremarkable lives are ending now in brutal, wanton, faceless killing. They die without heroism or dignity and yet there is something inexpressible about the manner of their dying which makes it an obscenity. One man kneels in prayer, face turned from the rifles. Another, nearer to us, looks at them in futile entreaty. Between the men, light cuts through to a cowled woman huddling protectively over a child, to a face buried in hands, to a woman stretched in despair on black ground; the light spears home on the natural target of the pivoting eye, a woman of the people, distraught, kneeling, arms thrown out, face lifting to the black and unresponsive sky. 'One can't look' says the caption. But one must [2].

It could be anywhere; it could be My Lai. The caption, however, is in Spanish; the engraver is Francisco Goya. So we know that the rifles are French and that this is the War of Spanish Independence of 1808–14: the first guerrilla war, the first 'people's war' of modern history, which was also the first of Spain's modern civil wars. The martyred people are the Spanish *pueblo*.

That central posture – one of the *pueblo* kneeling in despair with arms outstretched – appears again and again and again in Goya's drawings and paintings in these years. Even a Christ on the Mount of Olives looks like one of the martyred *pueblo* [67].

Here is the crucifixion of the ordinary again, now in a painting [3]. This time we see the executioners, but not their faces. On the right, a line of French soldiers thrust forward, their rifles stabbing out of darkness and a black sky broken

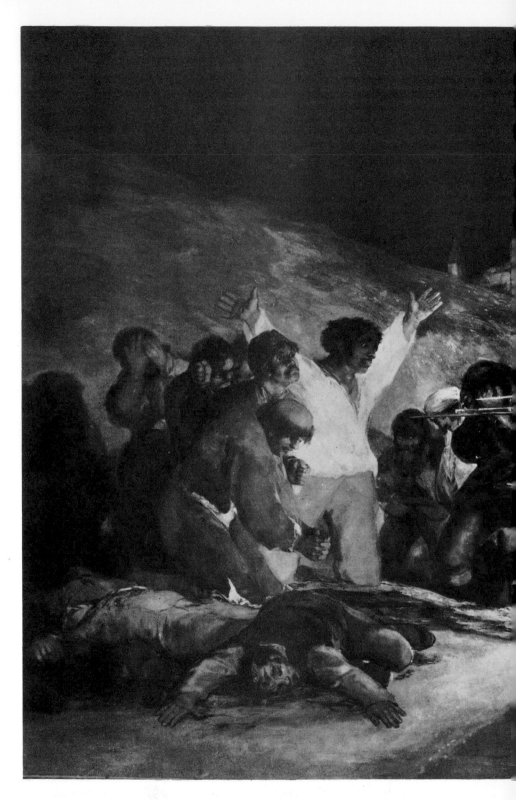

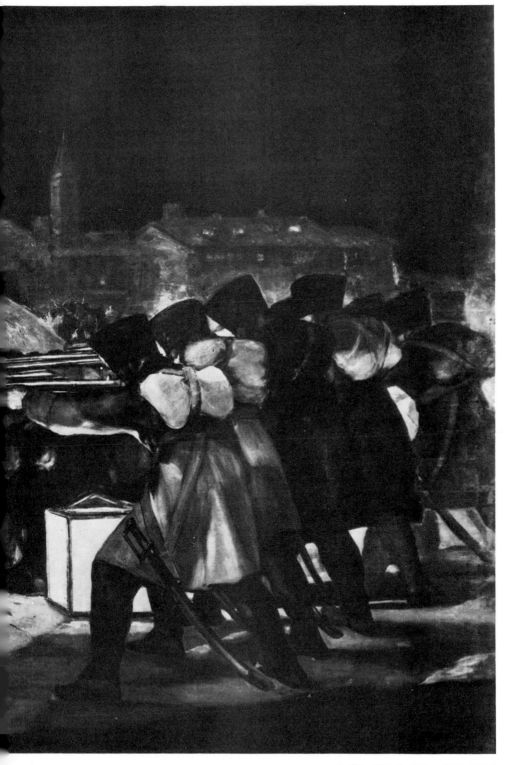

3. The Third of May 1808 (1814)

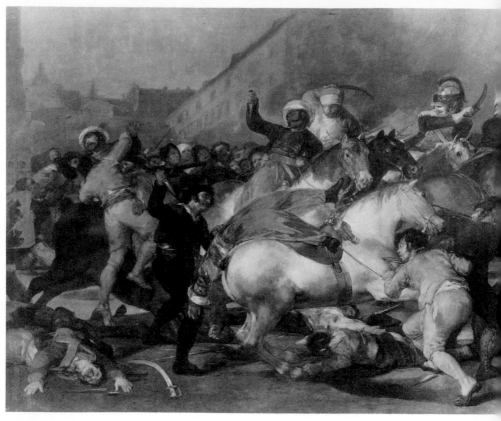

4. The Second of May 1808 (1814)

by grey and ominous buildings. A lantern on the ground throws a blinding light on a humped hill and a column of victims waiting their turn – a strong and stocky figure buries his head in his hands, an unforgettable face holds quivering hands to mouth. A clutch of corpses sprawl. And at the focus of the light, hiding a shadowy woman and child behind, a monk or friar kneels in prayer; one man stares, fist clenched, in a kind of dazed defiance; another face, perhaps a student's, above another fist, turns stoic, unforgiving eyes which are yet glazed in infinite resignation, towards the killers. Pinioned in the blaze of light is the central martyr – a stocky stumpy little Christ-figure from the Madrid plebs, white shirt brilliantly illumined, arms outstretched on an invisible cross, hand carrying the stigmata, swarthy proletarian face, eyes creased in mute pathetic appeal which yet communicates a dumb inevitability. It is the martyrdom of John Doe. For to us, in the twentieth century, this confrontation is brutal but banal; its ritual is the iconography of daily experience, vicarious and

direct. This painting of 1814, the Third of May, seems timeless, transcendent, eternal; it is the 'human predicament'. It is unforgettable.

It is also totally ambivalent. For that haunting face appears again, in the painting's companion piece, the Second of May, which remembers that popular rising in Madrid in 1808 which began the people's war [4]. The face this time is hard and implacable as its carrier wrenches a Mameluke cavalryman from his horse in a city square and thrusts a dagger into him, as his fellows mill around the French, killing, killing, killing. What sort of 'martyrdom' followed then, the next day, on the hill of Príncipe Pío?

This is not reporting. Contemporaries of Goya 'celebrated' these events. González Velázquez, for example, did a 'Third of May', crowded with details, each of them numbered for quick identification. Goya's great paintings were badly received, buried away in the Prado reserves for forty years. His was an idea whose time had not come.

Here are the French again, the humped figures of soldier-murderers, like some kind of collective animal, thrusting their bayonets – and confronting them, two of the *pueblo* jabbing with makeshift spear and dagger. They have faces, they are human, they are the *pueblo* in arms in defence of their homes, their women, their religion, their country. There is something of the heroic about them. But they are totally unidealized. It is plain killing [5].

This is one of the first of the great and terrible series of engravings which Goya made during and after the war of 1808–14 and which have passed into common parlance as *The Disasters of War*.[1] They stand almost without equal as a record of the pitiless inhumanity and more, the purposelessness of war, when all causes and creeds in the end sink into a morass of murder. Their technical skill is superb, the massing of shapes, the textures, the play of light and shade. Even the horrors are coldly beautiful. One strength lies in their apparent evocation of direct experience. All extraneous details are pared away; there are no subplots. Groups of people are pinpointed in light, centre, within the scene. We stand within a few yards of them, as they shovel corpses into a pit, strip the dead, patch up the wounded, carry off the corpses of famine. We stand even closer as men are hanged; we can see their faces screw up, their tongues start from their heads. Men are spitted on tree trunks, dismembered, strangled; women are raped again and again, within touching distance. We look over a soldier's shoulder as he carves a sword into a man's groin.

5

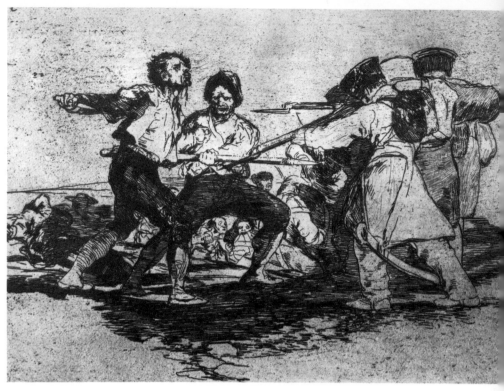

5. With reason or without (rightly or wrongly). *Desastres*, 2, *c.*1820

The paraphernalia of war are expendable. Even the uniforms become indeterminate as people get to grips with the imperative of mutual extermination.

There is very little of the decorative about these; they are quite unlike, say, Jacques Callot's celebrated atrocity studies. No one has gone as far as Goya in the direct representation of the effects of war. As people run and stumble from the flames, they reel and totter towards us; one can feel the flames licking. Through street after street, in the shade of neutral and ominous buildings, the poor die during the famine as the bourgeoisie look on helpless in their big hats, mute observers, as they have been of massacres.

This is *not* 'reportage' in any sense. The whole series is a carefully composed exercise. It is a study of the dialectic of reason and unreason in a real human context, constructed with minute precision from three separate sets of engravings. It begins with an explosion: the popular revolt against the French, driven on by deep and desperate emotion. Men and women are shown launching themselves in blind fury and heroism against the enemy in scenes which build up to a

picture of a heroine of the siege of Saragossa, the Maid manning a gun in the midst of corpses [77]. Then, immediately, we are brought crashing down with a collapsing horse and the caption – 'It always happens', and we set off on a desperate pilgrimage through killings, rapes, famine and atrocity which becomes increasingly purposeless. In the end, we can't tell one side from the other, they grow into frightful beasts and monsters. The ejection of the French is followed by the restoration of the Spanish monarchy which immediately drives Spain back into black and remorseless reaction. It is the ultimate deception. A corpse, half-buried, half-skeleton, scrawls a message from the grave – *Nada*. 'Nothing. That's what it says' [74].

The 'hero' or at least the subject is the *pueblo*. The first impression of anonymity is false. All these people, however crowded. however 'anonymous' their function in the drawing, have faces. They cluster in disaster, individuals from the people. At about the same time, around 1812, Goya was making remarkable paintings of ordinary men and women at work. The water-seller, the knife-grinder, the forge: in heightened muscular realism, the proletarian towers monumental in these, a positive affirmation [50–52]. In the *Disasters*, he is the author of his own destruction.

There is paradox here. The Third of May and the *Disasters* come out of Spain, the 'black' Spain of common usage, the Spain that France and England alike considered blind, bigoted and backward, the Spain of superstition, the irrational and rigid hierarchy, Spain of the Jesuits and the Inquisition. This was the age of the French Revolution, when 'the people' enter history. In 1792 the plebeian *sans-culottes* break into the new French republic and give it their image. Salon songs like the Ça Ira and the Marseillaise are transformed into popular anthems. David makes revolution into a street festival. Gossec's Funeral March for the mutineers of Nancy moves the heart and mind of Beethoven. Democracy, the Sovereignty of the People, Equality enter European history in blood, terror and total war and drench it in their imagery and symbolism. But from that iconography, 'the people' themselves, the Père Duchesne and his brothers, are essentially absent. They become Virtue and Truth; they become symbols. To their enemies they are caricature, the skeletal maniacs of the revolutinary committees. So they were to the English, whose peculiar liberty was a permanent antagonist to the new and abstract freedom of the French. The English had a popular theatre not unlike the Spanish; their 'freeborn

7

Englishman' myth stood at the opposite pole to the racial *casticismo* of the Spanish but the acrid quality of their xenophobic popular identity was analogous in its particularity. They too had a rich popular culture to parallel that of the *majos* of Madrid. The English had opened a world of discourse in the popular prints which many Spaniards found congenial. But with rare exceptions, 'the people' are Gillray's caricatures. In the Age of Revolution, The People make people invisible. They live in their representatives: Marat dies classic in his bath and Napoleon rides romantic in the Alps.

The paradox of Goya's *pueblo* bites deeper. Paradox, contradiction is the heart of his enterprise. To the *Disasters* engravings, the captions are essential. They serve not to clarify but to unhinge. They deepen paradox, sharpen contradiction. The first scene, as Spanish plebs and French peasants in uniform butcher each other, is captioned *Con razon o sin ella* – 'with reason or without', 'rightly or wrongly', 'for something or for nothing' [5]. The play on words is continuous. *Provecho* and its verb *aprovechar* – use or advantage, and make use of – are applied to peasants who build Roman pillars into their cottages; *Se aprovechan* runs one caption; it could mean 'They take advantage' or 'they're of use to each other' or even 'they're learning'. The scene is of people stripping the dead. 'They don't want to', runs a caption to a rape – 'they won't' or even 'they don't love' (*no quieren*); 'nor they', says another, 'nor they either', a third. 'That's tough', says Goya as a man is hideously hanged; 'what's the use of crying', to famine deaths.

The caustic captions send echoes running through the mind, contradictory, ironic, savage; they prepare the way for the *Nada* of the scribbling corpse. They are in fact intensely *dialectical*. The *pueblo* is trapped in its own instincts. The French of the liberating revolution, of that 'Enlightenment' to which many of the best spirits among Spaniards have responded, bring the future to Spain and plunge it into barbarism. The Spaniards, in the cause of their own liberty, murder their best sons. The people rise like lions and die like dogs, sold out finally by the monarchy they have died for. An agonizing dialectic of reason and unreason, both equally human, operating in a world of human deception and self-deception, is the very essence of the *Disasters*.

It is not new in Goya. Take one of the couplings which characterize his work in the *Disasters* and other engravings [6, 7]. The scene is similar: a popular crowd, watched by the bourgeoisie, drag a 'traitor' through the streets, flail at him,

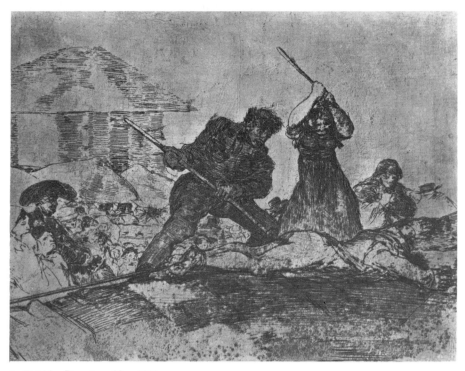

6. Rabble. *Desastres*, 28, *c*.1820

7. He deserved it. *Desastres*, 29, *c*.1820

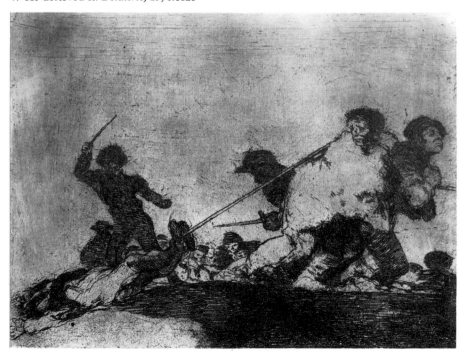

thrust a pike into his loins, beat and torture him to death.
He is probably an *afrancesado,* a Frenchified one, that is some
liberal-minded man, one of the many who rallied to the
French, who copied their 'enlightenment', anxious to serve
the *pueblo* in rational and somewhat antiseptic humanitarianism.
Now he is done horribly to death by the *pueblo* he wished to
emancipate. *Lo merecia* – 'he deserved it' – writes Goya under
one drawing; *Populacho* under the second – 'people' in the

8. Thou who canst not . . . (lift me on thy shoulders). *Caprichos,* 42, 1799

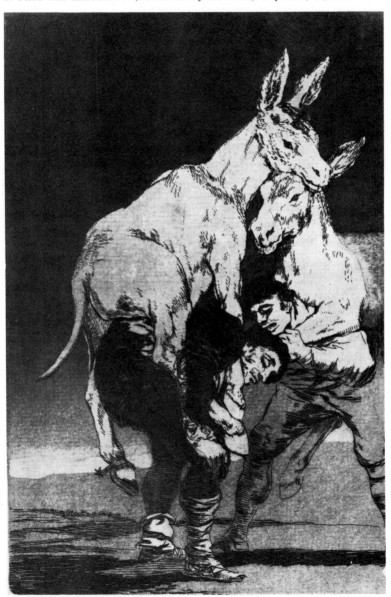

sense of mob or rabble. The people of the *Disasters* is the People as Beast-Hero.

But so they are ten years earlier, long before war broke out, in two engravings he published in 1799 in the teeth of opposition from the Inquisition [8, 9]. One shows two gross mules, *burros,* carried on the shoulders of two suffering peasants. Goya's comment plays with the word *caballero* – rider and gentleman. 'Thou who canst not' . . . runs the

9. See how solemn they are! *Caprichos,* 63, 1799

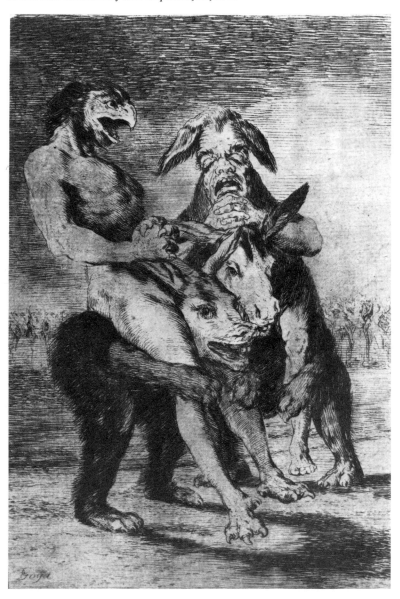

caption, leaving unspoken the final strophe of the proverb, 'lift me on thy shoulders'. But parallel to it is another: two grotesque creatures representing Church and State ride two 'peasants' who have become bestial, gargoyle *burros* themselves. 'See how solemn they are!'. The message, in a different context, is the same as that of the *Populacho* coupling of the *Disasters*.

The *burro-pueblo* appears in the first of Goya's sequences of engravings, the *Caprichos* of 1799. Here, the monsters, vampires and beasts who satirize the reactionary restoration after the war in the *Disasters*, crowd the scene; captions fulfil precisely the same purpose. The context of course is less mortal; it is Spanish society at peace which is being satirized. But the dialectical tension is the same. Moreover, from around 1793, Goya's private paintings suddenly begin to fill with violence, rape, murder. He was painting and drawing 'disasters of war' a dozen years *before* war broke out. It is in the same period that the *pueblo* begin to figure in his work unrefracted through a fashionable mirror.

For this is the final paradox; the man who engraved the *Disasters* was the King's Painter, breath-takingly successful, rich in those brilliant portraits and glowing tapestry cartoons which so comfort the eye. He was sixty-four years of age when he started on the *Disasters*, with three life-times as a painter behind him. But it was not the war which was decisive. He was already King's Painter and fifty-three years of age when he started on the *Caprichos* of 1799. He was King's Painter and forty-six years of age when he suffered a breakdown in 1792. It is from that point that the subjects, the styles, the paradoxes which characterize his major creative achievement of the war and post-war years begin to appear in his work.

His breakdown in 1792 coincided with a particular political crisis in Spain of the *Ancien Régime*, the first of those crises which heralded its destruction. The crisis resulted from the impact of the French Revolution on a Bourbon Spain which for three generations had devoted itself to measured and rational reform in the spirit of the Enlightenment. It was this Bourbon regeneration of the Spain of the seventeenth-century Decadence which created the *ilustrados*, the small but potent minority of enlightened Spaniards, into whose company Goya's climb to success carried him. These were the kind of men whom the *pueblo* were killing in his *Populacho* engraving. The mortal dialectic of reason and unreason in human society which in the *Disasters* achieves transcendence was first

explored by Goya in that crisis of the 1790s. To understand the force and the permanence of Goya's historic achievement, it is necessary to locate him in the contradictions of Bourbon Spain.

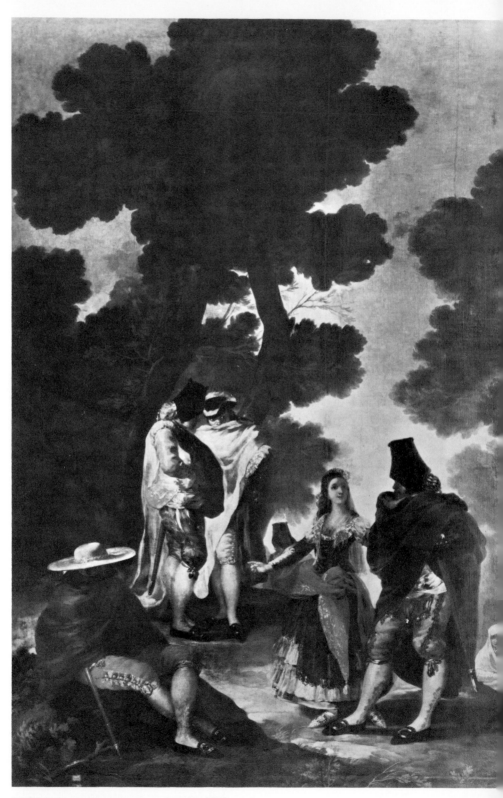

10. *Paseo* in Andalusia (*majos* and *maja*), 1777

2 The Contradictions of Bourbon Spain

On 10 March 1766 the Marquis of Esquilache, who was
minister to that paradigm of an Enlightened Despot, Charles
III, and who had installed novel street lamps in the capital,
re-enacted an ancient and forgotten law, which forbade men
in Madrid to wear the common broad-brimmed slouch hat
and long cape, alleging that the style sheltered the anonymity
of criminals. In response to this assault on the traditions of the
pueblo, Madrid exploded into riot, going into action, very
properly, on Palm Sunday. Uncontrollable crowds yelled
through the streets, attacking the houses of ministers; they
smashed the street lamps. They raged irresistibly around the
royal palace. Over twenty towns and cities in the provinces
imitated them. The king was forced to surrender. The order
was revoked, Esquilache bundled into exile. Rational and
cultivated foreigners turned with a certain gloomy satisfaction
to the appropriate entry in the French *Encyclopedia* (banned
by the Spanish Inquisition in 1759); Black Spain had once
again triumphed over Enlightenment.

It was not so simple. In the first place, Esquilache was a
foreigner, an Italian. He, like his fellow Grimaldi, had been
brought to benighted Spain by Charles III on his transfer
from Naples in 1759, to help in the arduous work of
modernization. The first impact of royal, rational and
bureaucratic reform was rather brutal. Grimaldi engineered
the Family Compact with Bourbon France, which resulted in
the loss of Florida in the Seven Years' War. The renewed
inflow of American silver at the peace intensified an already
severe inflation. New street lamps meant new taxes. Esquilache,
in good reforming fashion, decreed free trade in grain,
according to the best principles of the new economics, in time
for the bad harvests of 1766.[1]

The breakdown in order was the most serious internal
crisis the Spanish Bourbons had to face before the French

Revolution. The Count of Aranda was called in. He was, in truth, much more of an intellectual radical than any Neapolitan secretary, a friend to *philosophes* and an enemy to clerical pretensions. But he was a *grande* of Aragon and an experienced general. Helped by a good harvest, he rode the tide and within a year was able to revoke the concessions of 1766. The outcome was paradox. Who had whipped up the plebs? Clearly the enemies of regalist progress. A royal commission unmasked the 'conspirators' in the Company of Jesus, Spain's original contribution to the Counter-Reformation, already at grips with royal reformers in church and university. In April 1767 the Jesuits were expelled from the Spanish world.

Seventeen years later Aranda, now ambassador to France, played a different role. As the spokesman of an enraged Spain, and in particular of the selectively 'enlightened' Spain which had emerged, at least into print, over the past seventeen years, he delivered a thunderous rebuke to the French government, demanding official apologies for and official action against a Paris publisher, Charles Joseph Panckouke. Panckouke had decided to bring out a less tendentious encyclopedia, the *Encyclopédie méthodique*. The undertaking was blessed by the Spanish government, which warranted a translation. But the first volume in 1783 carried an article on Spain by Nicolas Masson de Morvilliers. To Masson, Spain typified everything the *philosophes* were struggling against: ignorance, sloth, superstition, a bigoted clergy, a futile government, economic incapacity, a cruel and tyrannical Inquisition. 'What do we owe to Spain? What has it done for Europe in the last two centuries, in the last four, or ten?'

The Spanish world of letters was convulsed. Traditionalists, naturally, seized on further proof of the inherently evil nature of modern philosophy and Catholic conservative Spain moved to the attack, not least on the imitative Enlightenment of the Spanish monarchy and its agents. The Inquisition confiscated 1,681 copies of the offending book in Madrid alone and fed them to the worms of its archives. More central was the response of the official Spanish Enlightenment. The minister Floridablanca pushed through a census in 1786 to prove that Spain's population had increased by a million and a half, while the numbers of priests, monks, privileged, the 'useless classes', had declined. Author after author moved to defend the reforming achievements of Charles III. The officially sponsored Juan Pablo Forner, however, normally a defender of cautious improvement, carried his attack to the principles of Enlightenment itself, and was shortly to pen an impassioned

defence of Catholicism. The argument came to focus on the historic character of Spain itself, that *autentico ser*, the authentic essence of Spain, which was to plague so many Spaniards in later years.

For Forner's 'defence' was no defence at all to such as Luis Cañuelo, whose satirical journal, *El Censor*, preached an enlightenment a good deal more radical than that cultivated in court circles. Discourse 113 of the *Censor* mocked the enemies of modern learning. True science, for them, asserted Cañuelo, was that which assured eternal life, those sciences, in short, which promoted subjection, weakness, hunger, nakedness, above all that poverty which ensured entry into Heaven. 'Hence the true sciences have flourished among us as in no other part of Europe.' Despite their natural wealth, Spaniards had laboured consistently for the victory of this true science until they had succeeded in reaching a nearly perfect state of poverty under Charles II, lowest point of the seventeenth-century Decadence. Unfortunately, with the coming of French Bourbons to Spain, false science was producing a detestable growth of commerce and agriculture. 'But let us console ourselves . . . we still have apologists to maintain our ignorance . . .'[2]

The Masson controversy delineated those celebrated Two (and more than Two!) Spains whose conflict was to assume fatal virulence after the outbreak of the French Revolution a few years later.

Castilla miserable, ayer dominadora,

Envuelta en sus andrajos, desprecia cuanto ignora . . .
wrote Antonio Machado, victim of a twentieth-century confrontation of two Spains.[3] It was this vision of a wretched Castile, stripped of power, wrapped in its rags, despising everything it was ignorant of, that the incoming Bourbons set themselves to eradicate. Their eighteenth-century achievement has largely escaped the attention of English-language historians. By the 1790s, the commercial renaissance of Spain was threatening to break the grip of English merchants on its empire. Pitt's Board of Trade grew alarmed and cold-bloodedly planned a war to stop it. The contradictions of Spain's Bourbon century were contradictions, not of decline, but of recovery.[4]

Contradictions they remained, and the paradoxical consequence of national recovery was a crisis of national identity.

The century of the 'lights' (*luces*) was shaped by the interaction between an intrusive and busy monarchy and the

pulses of European growth.[5] Demographic and economic
revival had in fact begun from the 1680s, at the trough of the
Decadence. In the early years of the century, under Philip V
(1700–46), progress was slow enough to be invisible.
An estimate of 1724 put Spain's population at about 7 million,
lower than it had been in the sixteenth century. By the reign
of Ferdinand VI (1746–59) an increase was registering and
the population may have topped the 8 million mark.
Under Charles III (1759–88) the upward curve began to turn
more sharply; by 1768 the total climbed to over 9 million.
It was from about 1770 that the rhythm of Spanish population
growth approximated to the European norm. The rate of
increase accelerated and at the time of the Napoleonic
invasion, Spanish population was probably approaching
12 million, though its rhythm of growth was being interrupted
by recurrent crises.

Growth in industry, agriculture and commerce followed
a similar pattern. Spanish rural life was imprisoned in
apparently insoluble problems: the low level of productivity
and general primitiveness, the crippling weakness of a
mule-based communication system in the second most
mountainous country in Europe, the arid wastes of 'dry
Spain'. Regions of peasant stability like the Basque lands and
Navarre were islands in a sea of insecurity, ranging from the
'Irish' over-population of the minifundia of Galicia, through
the rural proletariat and endemic banditry of the vast
under-developed latifundia of Andalusia and Extremadura,
to the depopulated misery of central Castile. Nevertheless,
pulses of growth registered from the 1730s; there was an
extension of cultivation and the introduction of new crops.
Between 1760 and 1775 there appears to have been something
of an agricultural price revolution which benefitted proprietors.
It was precisely this upsurge which directed hungry eyes upon
the vast mortmain properties of the Church and the entailed
estates of the nobility. It generated a climate favourable to
modernizers anxious to apply the physiocratic theories of
France, committed to the introduction of what were, in effect,
capitalist, individualist and bourgeois mores into a pre-capitalist
society through the agency of the state. The monarchy,
certainly, pressed for modernization as hard as it could in a
culture still rooted in the values of an older, Catholic, military
and aristocratic order. It clumsily intervened with settlement
and education schemes, fostered economic societies, gave
prizes for innovation, planted solid Germans in the Sierra
Morena (where they in turn duly produced their bandit

clans!). Modernization began to register by the end of the century. The archaic sheep-herders guild, the Mesta, crumbled; the livestock population increased fourfold, production rose. But with it rose crises of modernization, land-hunger, frustration. The failure of the state to modernize its revenues threatened it with bankruptcy, drove it into an attack on clerical wealth and privileges, into an abusive exploitation of its granary and loan services to the rural population. In the dislocations and wars of the revolutionary period, there were severe subsistence crises. By 1808 there seems to have been a pre-revolutionary situation in some regions.

It was the problems of a modernization which was too slow and tentative which engaged the attention of Gaspar Melchor de Jovellanos, archetype of the earnestly reforming lesser nobleman who was episodically a royal reforming bureaucrat. His celebrated Report on Spanish agriculture, the *Informe* of 1795, which pressed for the opening up of traditional sectors to a measured but remorseless advance of commercial farming in the interest of social hygiene, became the bible of nineteenth-century Spanish liberalism.

The contradictions in industry and commerce were even more striking. The monarchy intervened directly and continuously. Its state-sponsored industries achieved only patchy success, but it gradually began to loosen the mono-polistic grip of Cadiz on the America trade and to grind upon the clusters of interests which served as a comprador bourgeoisie to English and French capital. A slow process of opening up the America trade through the multiplication of companies reached a climax in the great *Reglamento* of 1778 which virtually threw open the colonial trade to all Spaniards. A parallel process of reform in the Americas began to recapture the trade for Spain, creating new economic polities – and new social stresses. After 1778 Spanish exports multiplied tenfold, Spanish merchants began to recapture their own trade in a second *Reconquista*. Already in the early years of the century Catalonia had begun to rebuild its economy, growing around the vine and the brandy trade; its strengthening connection with the Americas proved to be as vital as Lancashire's Atlantic focus. In the last years of the century, in parallel to Lancashire, there was something of an industrial revolution in textiles in Catalonia, as new life surged into the maritime centres, Barcelona, Valencia, Seville, Bilbao, in a thrust of modernization symbolized by the creation of the state bank of San Carlos in 1782.[6]

Modernization brought new contradictions, ran into its own

19

ceiling. During the Revolutionary and Napoleonic Wars periods of almost frenetic commercial expansion were punctuated by total stops as the British navy cut off the Americas. Remarkable though the commercial revival was, it could not escape sufficiently from the stranglehold of the great maritime powers, it could not create a fleet which could stand up to the English. The outbreak of war between the major powers of England and France reduced Spain almost immediately to the status of satellite, at the mercy of a desperate inflation and economic subjection.

Internally, growth shifted the economic centre of gravity of Spain massively into the peripheral provinces. Barcelona tripled its population to approach the 150,000 of shuffling Madrid. It was in the dynamic peripheral provinces that population growth focused, in Valencia, Seville, the ports of the northern littoral. The centre stagnated and declined. This development in economic and social life among provinces long celebrated for their particularist outlook ran directly counter to the strong centralizing thrust of the Bourbon monarchy bent on eradicating all archaic obstacles to its regenerating power. An artificial capital riveted an artificial political unity on a country where economic and social initiative had passed to the periphery. Political Spain had Castile as its hollow heart.

For there had been nothing resembling a 'bourgeois revolution'. Only in Barcelona, Cadiz and a few other mercantile centres did a structured bourgeoisie approximating the English or French model emerge. It was precisely the absence of that European archetype which gave Spanish modernization its peculiar climate. The commercial bourgeois was something of a solitary figure among the thickening 'middle orders', largely professional, military and bureaucratic, in Madrid and other cities. What elsewhere took the form of bourgeois modernization was in Spain a measured, monarchical innovation, grounded in a bureaucracy staffed from and supported by a lesser 'working' nobility and gentry, which tried to mobilize a 'public opinion' (in large part its own creation) around *bien-pensant* improvement societies and reform schemes. It inched forward its utilitarian 'enlighten-ment' among the directive classes and slowly forming middle and largely dependent sectors, tentatively probing at rooted and archaic interests warranted by what had become Spanish 'tradition'. Inevitably the major impact of this enlightened monarchy was precisely on 'tradition', on ideology, on notions of the *autentico ser* of Spain.

In the Spain of the 1797 census, with its 10 million inhabitants, the active population was a meagre 25 per cent of the whole. There were still 400,000 'aristocrats'; the ideology of the *hidalgo* was still hegemonic and found a populist echo in an urban plebs still largely inhabiting a pre-industrial, indeed pre-capitalist world of casual labour, semi-beggary and precarious artisans, with its heroes the strutting, picaresque *majos* and *majas,* to whom life was a *style* lived out on a knife-edge. There were still 170,000 clergy. There were still 2,000 monasteries, 1,000 convents and a small army of 85,000 monks and nuns. The great seventeenth-century Church with its democratic recruitment and ambience, its immensely popular Inquisition, was hardening into privilege and aristocracy, its stranglehold on wealth increasingly resented. But it was not until 1834, after the traumatic experience of war and civil war, that people began to burn churches. Church and nobility could still command large client proletariats; the mendicant orders were immensely popular in the cities; the Holy Office was feared and respected. And there were still 150,000 officially recognized beggars in a society racked by land-hunger.

Popular Spain was rooted in the 1,800,000 rural proletarians and peasants often not far removed from them. Among working people the largest formed group were, symptomatically, the 280,000 servants; artisans, in all their infinite variety, totalled perhaps 300,000. And among the middle sectors the 25,000 traders were dwarfed by 110,000 military and bureaucratic personnel.

There had to be a ceiling to royal reform in a stratified and under-developed country. The crown never got a sufficiently strong grip on local authority, the real focus of effective government, to force its measures through. Besides, no monarchy, however 'enlightened', could destroy its own social base. Nevertheless, Spain had been propelled into a slow shuffle towards modernization, was being dragged out of its 'traditional' identity. Between 1768 and 1797, as a result of royal restrictions on recruitment and promotion, the number of 'aristocrats' was cut by nearly half, that of clerics by a third. The effects of Charles III's reforms and the thrust of European development were generating crises of growth. The accession of his successor coincided with the outbreak of the French Revolution. Panic reaction brought royal reform to a full stop and revivified the restive forces of tradition. The reforms of Charles III probably represent the limit to which an enlightened monarchy in Spain could go. Further

'regeneration' would demand a radicalism which traditional Spain could not stomach. Tensions were already visible before Charles III died; at the 'ceiling' of regalist reform, informed opinion was already splintering. The challenge of the French Revolution immeasurably sharpened and deepened the conflict. As the Revolution spilled across Europe, Spain was caught between its force and the rival naval and economic power of England. Its satellite monarchy fell to a favourite, Godoy, as unwelcome as unexpected, whose mafia system affronted all classes. The concern for the *autentico ser* of Spain became an obsession among the literate classes as Spanish politics disintegrated into a dervish dance of factions around the court. The confrontation of 'enlightenment' and 'tradition' became mortal, in an atmosphere of deepening crisis, and when Napoleon took control in 1808, Spain lurched into that war of independence which was also the first of its modern civil wars, a war that destroyed its Old Regime.

The ideological influence of the Bourbon monarchy thus far outran its practical achievement. The early years were very French. The aim was administrative efficiency and political uniformity. The ancient *fueros* or regional privileges were eliminated. Valencia's went in 1707, to be followed by those of Aragon, Catalonia and Majorca by 1716. Only the Basque lands and Navarre, which had taken the winning side during the War of the Spanish Succession, were permitted their privileges. The conciliar system of government was eroded by ministries; Captains-General ruling the provinces with the aid of judicial-executive *audiencias* were strengthened by royal officers imposed upon spiky municipalities and a new official, the *intendant*, borrowed directly from French example. The royal power assumed unwonted initiative. Reality proved recalcitrant; Spain of the *patria chica* survived beneath this cold and somewhat alien structure, but royal absolutism was in legal terms virtually total.

Only one power retained a measure of autonomy: the Church with its Holy Office of the Inquisition, to many the very embodiment of Spanish identity, that purist, monolithic, hermetic, militant, military and at the popular level often deeply superstitious Catholic Spain of the Counter-Reformation. Ultramontanism was rooted in the Jesuits, who controlled the Inquisition and the elite *colegios mayores* of the moribund and routinized universities and who operated efficaciously in the upper ranges of society. Two thirds of Church appointments were in the hands of the Pope.

Central to this edifice of what the directive classes had

come to think of as Spanish tradition was the Inquisition. The Inquisitor-General with his Council presided over fourteen regional tribunals and their troops of under-paid but active agents. The Inquisition policed the Spanish polity, preserved its purity from any threat, from sodomy to Voltaire. During the eighteenth century, as the cult of Reason penetrated even the Hispanic fortress of faith, it grew less fierce; burnings and tortures became infrequent. Its monstrous apparatus of censorship and punishment, supplementing a close-knit royal machinery of preventive censorship, became less and less effective until the 1780s; Voltaire, Rousseau, Volney found their Spanish readers. The illegal book trade was profitable. The Spanish Index was in some ways more liberal than the Papal. But the apparatus *was* monstrous and it grated horribly on the sensibilities of the growing number of Spaniards who succumbed to the charms of enlightenment. By the end of the century, as the Inquisition's power grew again in reaction to the French Revolution, these *ilustrados* were seized by an obsessive hatred of the Holy Office in which shame was as much a motor force as anger. For around the Holy office clustered those hordes of popular preachers from the Orders, bigoted and ignorant charlatans whose farandoles held the *pueblo* immune to the rather clinical improvement preached at them by the best minds in Spain.

Moreover, the Inquisition's power was not restricted to the popular classes. It broke Philip V's official Macanaz. Even in the mid-century years of its eclipse, it could ruin the career of university teacher, lesser bureaucrat, publisher. In the late 1770s it began to revive, to ride the swelling opposition to royal reform. To break Pablo de Olavide, the radical royal bureaucrat who figured in Spanish legend as the first *afrancesado*, it deployed the full paraphernalia of its archaic ritual, with which it intimidated the plebs, against the governing classes. The trial of Olavide in 1778 sent a shudder of fear, shame and anger through the literary world and from the 1790s the Inquisition was once more a real, if limited threat.[7] No royal servant, however eminent, was safe – Aranda, Floridablanca, Jovellanos were menaced or punished and among the lesser *ilustrados*, it could work havoc. Goya's friends Bernardo and Tomás de Iriarte were among the sufferers. In Spain the fashionable late eighteenth-century interest in witchcraft assumed deeper significance among the enlightened minority [11, 13].

At first, however, the Crown made relatively easy headway against inertia. It was supported by opponents of the Jesuits

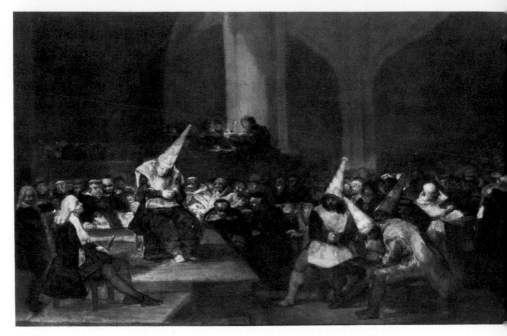

11. The Inquisition, *c*.1812–19

among the clergy whom their enemies nicknamed Jansenists.
The Spanish Jansenists in fact had little or no connection
with the French heretics of that name; the epithet implied a
readiness to deny papal infallibility and support regalist
control of the church, an openness to reform and a measure
of controlled enlightenment. As the Bourbons inched their
way forward, the battle between Jesuits and Jansenists grew
fierce in the universities. By the Concordat of 1753, the
Crown assumed power over the church, but the ultramontanes
offered resistance. The Esquilache riots of 1766 gave the
monarchy its opportunity. Charles III drove the Jesuits out,
moved into the universities to cleanse the *colegios mayores* and
imposed liberal-minded Inquisitors-General on the Inquisition,
which tried to prolong the struggle, under the influence of the
Dominicans.

It was this conflict which was the point of entry for the
Enlightenment into respectable Spain. Clearly that enlighten-
ment was selective.[8] Not even the most radical Spaniard
seriously questioned the Catholic faith. The royal administration
and the improvers it sponsored were concerned above all with
scientific and technical skills, with modernization. Their attitude
to the more sceptical and searching *philosophes* was ambivalent
or hostile. But enlightenment proved indivisible.

24

The tone of Spanish illuminism was set by the epic achievement of Benito Feijóo, a Benedictine who between 1720 and 1759 published his multivolume *Teatro Critical*. In pious but resolute style, Feijóo remorselessly exposed fallacies and superstitions by the light of the (carefully selected) advances of eighteenth-century science. The work scored a remarkable success. By 1780, fifteen editions had appeared; it won the weighty approval of the court. No less than thirty-seven replies were provoked by its attack on the medical profession alone. Only the ever-popular Don Quixote could rival it. 'Thanks to the immortal Feijóo,' wrote one admirer, 'spirits no longer trouble our houses, witches have fled our towns, the evil eye does not plague the tender child, and an eclipse does not dismay us.'

He was a trifle over-optimistic, but Feijóo set a fashion which was copied. The Jesuit Padre Isla brought out a novel, *Fray Gerundio*, which savaged popular preaching so mercilessly that the book ended up on the Index. By the 1780s scathing criticism of the Black Spain of ignorant bigotry was commonplace in the new periodical press. That press received its first fillip from *El Pensador*, published by Joseph Clavijo between 1761 and 1767 in direct imitation of the English *Spectator*. It developed the general *ilustrado* criticism of nobility and clergy as 'useless classes'.

Utility was certainly the guide-line of the monarchy. It subsidized periodicals to popularize the latest improving science, pressed forward the study of economics, medicine, modern philosophy. Among a minority of universities it achieved something of a breakthrough, establishing chairs of natural law. The University of Valencia went over solidly to the new learning; elsewhere it was a minority phenomenon, but even at the traditional elite university of Salamanca there was effervescence and the formation of a radical new generation.

Under Charles III this royal pressure intensified. The court was peopled by *ilustrados*, personified in the ubiquitous Campomanes, whose restless mind bit at every Spanish social problem. From the 1760s the crown began to build up an apparatus for the mobilization of public opinion, in the economic societies, the *Amigos del País*. The initiative came originally and appropriately from the periphery, from the Basque lands, where improvement groups coalesced into an economic society in 1765. From that point on, under royal encouragement, their numbers grew. By 1804 there were seventy-three of them. They recruited heavily from the lesser

nobility, the middle orders and liberal clergy. Their efforts
ranged from well-meaning but often comic amateur
'improvement' to serious plans for technical and popular
education. Urged on by Campomanes in his myriad pamphlets,
by royal encouragement and example, by the increasing
commitment of noble houses to the cause, they proved a
powerful propaganda instrument. In 1784 the society of Goya's
Saragossa founded the first chair of Economics in Spain.

Caroline enlightenment reached its climax in the 1780s.
Not only did a measured and prudent illuminism set the tone
at court. Households among the nobility succumbed to the
fashion of enlightenment, launched salons, presided over
economic societies, sent promising young men on scholarships
to France and England. In Salamanca and elsewhere clusters
of new men emerged, the generation of Jovellanos, men like
the historian Ceán Bermúdez, the radical banker Cabarrús,
the poet Meléndez Valdés, the dramatist Moratín—the
'European' Spaniard, the *afrancesado*. Their numbers must
not be exaggerated. A third of the meagre book production
of Spain was still devoted to religion; the majority of the
universities still trudged a dreary tramp around banality; it is
doubtful whether the *ilustrados* were more than one per cent
of the population. But they were concentrated at the growth
points and their ideology was becoming dominant. Resistance
there was: the Inquisition grumbled and growled and
sometimes hurled a bolt. In the 1770s it lurched clumsily
into action against Olavide. In the same decade Zevallos
launched a campaign against the new learning which found
an echo among popular preachers; Forner followed up in the
1780s. In that decade indeed, the argument was carried
increasingly to the *pueblo* and there appeared, for the first
time, denials of the value of the whole Caroline enterprise.

But before 1789 such arguments could not stem the advance.
The *ilustrados* were thin on the ground; they were dependent
on the benevolence of monarchy. But they were building up
strength among the peripheral bourgeoisie and there was a
scatter of them in every province. In the 1780s, in fact, this
minority enlightenment was naturalized in Spain, finding
characteristic expression in the small but lively periodical
press of Madrid and a few other cities. It was in 1781 that
the *Censor* appeared, edited by Luis Cañuelo, a lawyer with
friends in high places. 'All that departs in any way from
reason hurts me,' proclaimed Cañuelo, and he set out, in his
Discourses, to scourge the villains, the idle aristocrats and
obscurantist clergy. The *Censor* represents Spain's nearest

approach to a radical Enlightenment. The journal got into trouble with the Court. It was ultimately suppressed and Cañuelo was haled before the Inquisition. But it had recruited the (often anonymous) services of the strongest spirits in Spain and it celebrated the advent of a New Spain and the New Spaniard.

To the *pueblo* however, the new Spaniard was a Frenchman. In the late eighteenth century, the customary cleavage between popular and elite culture threatened to become an abyss. As the directive classes yielded increasingly to the imported styles and manners of *luces*, there was a visible hardening of a Spanish, a resistant and often an archaic personality among the popular classes. The popular theatre with its pantomime *tonadillas*, full of the grotesque, the fantastic, monsters, *duende*, flourished and attracted increasing support. So did the popular verse interludes, the *sainetes*, which built up a lucrative market for such writers as Ramón de la Cruz. The long underground tradition of the Spanish *pueblo*, stretching back to the *Celestina* and the *Libro de buen amor*, was not responsive to the rather clinical humanitarianism of those *ilustrados* who wished to serve it. A certain social radicalism implicit in it, which was to become explicit in the generation of the War of Independence, found expression in anti-authoritarian impulse and rebellious folklore: its heroes were the eternal bandit, the eternal smuggler, the bullfighter. The *tonadilla* on Francisco Esteban *el Guapo*, the celebrated Andalusian smuggler, was a stage success without precedent. And as these people made melodrama out of their theatre, so they made a theatre out of their lives. The tradition of the seventeenth-century *picaro* assumed new form in the cult of the *majo* and his *maja*, the plebeian aristocrats in their distinctive style of dress, slouch hat, cape, their strict but anti-establishment moral code, their counter-culture, their anti-authoritarianism, xenophobia, their simplist and ambivalent Church-and-King loyalty which could mask a social rebelliousness [10]. This was the world which broke Esquilache.[9] This world, interpenetrating with the world of the bullfight and the imported *flamenco*, the potent popular universe of the preachers, the *ilustrados* failed to penetrate. Moratín the dramatist, one of the few of them with any sense of or feeling for the popular, waged a long fight in the theatre but was deeply pessimistic. His friend the poet Meléndez Valdés was nearly killed by the plebs of Asturias in 1808 as a 'French traitor'. Most of the enlightened could only denounce the spiritual prison of *pan y toros* (bread and bulls).

Other sectors of society, however, proved remarkably susceptible. Through the last quarter of the eighteenth century a rising tide of *majismo* began to engulf much of the aristocracy. As in so many other instances, a European fashion – the shepherdesses of Marie Antoinette – acquired a deeper meaning in Spain. House after house among the nobility began to ape the styles of *majo* and *maja,* to talk their language, to cultivate bullfighters and flamenco singers. A classic case was the future Ferdinand VII himself, who cultivated Madrid cockney and mixed with the underworld through the agency of his low-born clerical camarilla (the clerics were old hands at turning out a mob). In Spain the process was a visible reaction against the French styles of the *ilustrados*. Ortega y Gasset goes so far as to assert that Castile, drowning in French influence, found a new identity for itself in Andalusia. Certainly this aristocratic cultivation of popular styles in which they detected an irreducible tradition of Spanishness (*costumbrismo*) interacted with an intensification of the cult of *casticismo,* national purity, originally racist in concept, in the eighteenth century expressing a species of cultural nationalism. From the 1780s onwards, as the Inquisition began to recover its nerve, there was a developing tension among the Spanish elite, a tension which the impact of the French Revolution and Napoleon transformed into a mortal socio-political schizophrenia. The tension was that between 'Reason' with a French accent and 'tradition' increasingly interpreted in populist and folklorist terms – the peculiar Spanish liberty. It was precisely this tension which was to stretch the mind and spirit of Francisco Goya on a rack almost as fearful as that of the Holy Office.

For Goya was a man of the *pueblo*.[10] He was born in 1746 in the village of Fuendetodos in Aragon, but his family seems to have lived in Saragossa. He is sometimes called a peasant. This is nonsense. His father was a master gilder, an artisan. His mother, Gracia Lucientes, came from the multitudinous petty 'aristocracy' of Aragon with their long pedigrees and extremely short purses. Goya's father was ultimately of Basque descent but the ambience of Goya's life was thoroughly Aragonese. Critics have detected in him the toughness, obstinacy, harshness, cold centre of those Aragonese whom their fellow-Spaniards nicknamed *baturros* – evoking the legendary and mulish obstinacy of the people of the parched and implacable sierra under the unremitting howl of their north-easterly *Cierzo* wind, a people whose houses turned their backs on the street and who were said to drive

nails into stone walls with their heads. . . .

The family was not rich. Goya's father died intestate in 1781. But he was an artisan, a man who 'knew the fine points', and he and his wife inhabited that amorphous region of pre-industrial society which in France, Britain and America was the nursery of a democratic ideology and spirit. This was Spain, where such artisans were enmeshed in a more traditional clientele system, but there is ample evidence that Goya shared to the full in the characteristic tastes of the *pueblo*. The legendary 'history' of his 'wild youth' is romantic nonsense, but he was evidently an *aficionado* of the bullfight. He adored the *tonadillas,* not to mention the *tonadilleras.* He was fascinated by *majos* and street life, revelled in pigeon-shooting and hunting. While court painter, he once confessed to his friend Martín Zapater that he got more fun out of hunting. His attitude to his painting before his personal crisis in 1792 at the age of forty-six often seems curiously off-hand to many critics. In fact he treated it as a job. From the beginning he displayed unusual and original talents. He was quite prepared to suppress them and work in a conventional manner in order to get on. His schooling at the *Escuelas Pías,* which he remembered in later life with some affection, seems to have been conventional. He was hardly a cultivated man in his youth and early middle age. By 1812 he had a library of several hundred volumes, but this was after many years of friendship with the leading *ilustrados.* Before his personal crisis of the 1790s there was very little of the intellectual about him. There never was much at any time. He was interested in his job, worked hard at it, took inordinate pride in it. But before his success, a job it was. He was, until his fortieth year, the quintessential artisan. This was an artisan, however, who made good, and in the 1780s he crows and boasts like any vulgar *nouveau riche.* 'Martín mío,' he wrote to Zapater, 'ya soy Pintor del Rey con quince mil reales!' – 'Martin boy, now I'm King's Painter with 15,000 reales!' He was probably an obnoxious young climber notable chiefly for the beady eye of ambition.

Even at the beginning, however, there was a certain distinctiveness. This artisan son of an artisan father climbed through a particular Aragonese network. The lord of Fuendetodos was Ramón de Pignatelli, a count immersed in the *bien-pensant* Caroline reform. He was a prime mover in the cutting of the Imperial Canal in Aragon, founder of the Royal Economic Society and rector of that university in Saragossa which created the first chair of Economics in Spain.

It was he who patronized the studio of José Luzan, which Goya entered at the age of fourteen. Another friend and patron was Juan Martín de Goicoechea, also of distant Basque descent, who became one of the most celebrated merchants in Spain. He founded an economic society and launched a spinning factory in Saragossa in imitation of that of Lyon. A favourite of Charles III, his cousinage supplied Goya's son with a wife. Men like Goicoechea found themselves Jacobins in the France of 1792. In Spain the Aragonese clans of Goicoechea, Galarza and Zorrilla with whom the Goyas were enmeshed became *afrancesados* almost to a man. Most of them rallied to Joseph Bonaparte after 1808 and trailed off with the French army into exile in 1814. Goya was to die among them in Bordeaux.

From a *pueblo* immersed in that *costumbrismo* which the anti-Enlightenment aristocracy was to embrace, the young Goya climbed, in the teeth of repeated failure, through an Aragonese mafia impregnated with the life-style of the *ilustrados*, to the court of Charles III. That court was inevitably the target. Charles III as part of his campaign to make Spain respectable in European eyes had imported the great Venetian painter Tiepolo with his sons together with the younger master Anton Raphael Mengs. It was Mengs who set the tone, with his strict adherence to the neo-classical principles of Winckelmann. Ambitious young aspirants had to adjust. Francisco Bayeu, a fellow *baturro* of Goya, did so without difficulty. He got to the court in 1763 and worked his younger brother in as well. Goya had more trouble. He failed to enter the Academy in 1764 and again in 1766. Leaving Madrid to the Bayeus, he lived through five years of obscurity. In 1770 he tried his hand in Italy, where he achieved some recognition from the Parma academy and in 1771 scored his first major success with some work for the Aula Dei in Saragossa. By now something of a local celebrity in Aragon, he promptly married Bayeu's sister and moved to Madrid. The marriage was presumably a calculation, but it seems to have been comfortable.

Prompted no doubt by Bayeu, Mengs called Goya to the service of the royal tapestry works in 1774. Buckling down to serious production, broken only by an illness in 1777–8 which first turned him towards engraving, he broke through to brilliant success in the 1780s. By 1786 he was King's Painter; by 1789, painter to the royal household. And the household he served was that of Charles III at the apogee of *ilustrado* achievement. It was in these years that Goya made friends

with the leading spirits of *luces,* notably with Jovellanos. Goya's career, in short, moved along the rising curve of *ilustrado* success,

Its moment of truth, no less, coincided with theirs. Symptoms of a change of direction, indeed of character, appear in Goya's work and life around 1790. In 1792–3 he fell victim to a desperate illness at the very moment of public crisis for the *ilustrados.* For in 1789 the Bastille fell and France was gripped by a revolution escalating towards democracy. In 1791 a Bourbon fled from the new order in France, was recaptured and paraded before an unforgiving plebs. In that same year Floridablanca, at a stroke, suspended the entire Spanish periodical press and tried to stop the inflow of French publications. In the following year the French monarchy was overthrown and the popular, republican, terrorist *sans-culottes* erupted into the French Republic. In 1793 Spain went to war with France in a crusade against atheist republicanism, the preachers unleashed a massive popular reaction; *ilustrados* went into eclipse.

The shock of the French Revolution disrupted the Spanish Enlightenment and set in train a process of dissociation in Spanish society which was to culminate in civil war.

The surface of Spanish political life in these years presents a scene of complexity and almost inexplicable confusion.[11] These were the politics of a regime which had been transformed into a satellite. The underlying and contradictory drives are, however, visible. In the first place, reaction to the French Revolution threw the official classes back from Enlightenment. The forces of traditional conservatism generated a new strength. The crusade of 1793 mobilized whole sectors of the middle and popular classes. In 1794 the reactionary Archbishop of Toledo became Inquisitor-General and the Holy Office ground heavily into confident action once more.

On the other hand, the war with France precipitated a severe economic crisis. By 1795 there was serious trouble in the universities and downright disaffection, enamoured of French example, found public expression in the streets. Spain was forced to make peace. But little could be done to stop the menacing polarization of opinion. France compelled Spain to join the war against Britain in 1796. This made more difficult the erection of a sanitary cordon against French ideas and at the same time exposed the Spanish empire to the power of the British. Economic disaster sharpened tempers still further.

To complete the disillusionment, there was an abrupt decline

in the quality of the Spanish monarchy. Power passed
in 1792 to a favourite of the royal family, Manuel Godoy,
a young guardsman, a *señorito* from Extremadura, the
'sausage-maker'. Godoy remained in virtual control of the
royal machine, overtly or covertly, for fifteen years. He packed
the administration with his nominees, picked up titles and
honours wholesale and erected what was virtually a semi-
dictatorial system. Every class in society was repelled.
It seemed like a reversion to the worst days of the Decadence.
Godoy himself was vaguely 'liberal'; he at least tried to
maintain the outward show of Caroline reformism after the
first shocks of the French Revolution had passed. But his
freedom of action was severely restricted by the power of
France, whose changing rulers looked upon him with a deep
and unchanging suspicion. Every effective political force in
Spain, from hidebound aristocrats, black clerics, xenophobic
plebeians to the most radical of the *ilustrados,* was driven into
opposition.

For the first time the regeneration drive of enlightenment
broke out of the framework of the Spanish monarchy.
Some began to call for the French to come, to finish the job
that Spaniards were incapable of finishing. Others retreated
to the deepest fastnesses of *casticismo*. In the circumstances,
a concern for the *autentico ser* of their homeland became
obsessional and increasingly focused on Spanish history.

In these years there was an upsurge of interest in the history
of Spain among the literate classes. The classic history of
Mariana was reprinted as were many texts from the sixteenth
and seventeenth centuries. Jovellanos wrote his historical play
Pelayo, following Nicolas Fernández de Moratín and
anticipating Quintana. Increasingly attention came to focus
on the establishment of absolutism in Spain and the loss of
those parliamentary liberties which had flourished in the
Cortes of medieval Aragon and Castile. Almost inevitably the
villain of Spanish history emerged as the Emperor Charles V
and his suppression of the Comuñeros in 1521. Juan de
Padilla, hero of the Comuñeros revolt, grew in stature in
minds revolted by the spectacle of the court of Charles IV
and desperate to establish controls over it. Reactionaries and
radicals alike found their refuge in this history – Forner,
yearning for a 'traditional' and balanced constitution which
would restrain unworthy monarchs and preserve the essence
of Spanish tradition; the liberal Quintana, addressing a poem
to Padilla in 1797; José Marchena, the radical linguist, running
to France in 1792 and from Bayonne calling upon his

compatriots to marry their 'democratic' past to their democratic future – 'Let Cortes, Cortes be the universal cry, Sons of Padilla!'

In the making here was a powerful historical myth, strictly parallel and in many ways analogous to the English myth of the Ancient Constitution, the Norman Yoke and the Freeborn Saxons. It set uneasily with the largely unhistorical thrust of much *ilustrado* thinking. Implicit in it was a revolutionary assertion of the sovereignty of the people which offended *ilustrados* reared in the traditions of Caroline bureaucracy. A complex of reactions and responses grew more complex as they grew fiercer. It was Karl Marx who was among the first to indicate the strength of this Padilla myth in the radically democratic Constitution of 1812 proclaimed from besieged Cadiz at the height of the war against Napoleon.[12] But a myth deriving from the same source powered the traditionalists who, in the service of their 'ancient constitution', overthrew that Constitution of 1812 and restored, unwittingly, the absolutism of Ferdinand VII.

The battle of the traditions grew heated as in book, pamphlet and sermon the protagonists appealed to a wider audience, itself trapped in the inflation and developing economic crisis of a Spain caught between the French and the English. Political fortunes were strictly dependent on the interplay between foreign pressure and native faction. In 1798, in the face of monetary crisis and the pressure of a French Directory which had just crushed its own royalists, Godoy withdrew and the leading *ilustrados* came to power, headed by Jovellanos himself. At once the old Jansenist-ultramontane controversy took on new life as Jovellanos moved to an attack on the Inquisition. In an occult and complex faction struggle around the court bedevilled by harangues from Abbé Grégoire and the Constitutional Church in France, the reformers were defeated in 1798. A momentary equilibrium between reformers and reactionaries was broken by further conflict precipitated by the election of a new Pope. In 1800 power passed decisively to the traditionalists. *Ilustrados* were ejected; many, including Jovellanos, were imprisoned; their *confrères* withdrew from public life.

But the brief and prosperous respite of the Peace of Amiens was soon ended by the resumption of war, and the disaster of Trafalgar in 1805 dislocated the Spanish economy as French troops moved in for a campaign against Portugal. In a last move to save himself, Godoy turned once more to the liberals; but it was too late. The prince, Ferdinand, working

in collusion with military conspirators, rebelled against his father and mobilized the Madrid plebeians in his cause. The divided Spanish royal family appealed to Napoleon. His solution was to throw them all out and to impose his brother Joseph as king, complete with radically regenerative constitution. A massive popular insurrection, directed in the first instance at the Godoy system, turned on the French in 1808. The heroic and horrifying war of liberation, as complex and as contradictory as the crisis which precipitated it, plunged Spain into six bloody years. The travail of the Spanish people began – that travail which Goya was to make universal in his *Disasters of War*.

The first paroxysm of this national crisis was the sudden reversal of direction in the 1790s. This too, marked the onset of Goya's own personal crisis. After premonitory symptoms in 1790 Goya collapsed in 1792–3. In the years which immediately followed he, too, took a new direction and shaped a new vision. That new vision achieved a certain permanence in the first of his great series of engravings, made ready for publication in 1797, but postponed as the *ilustrados* were given their last chance, thrown into the public arena after the defeat of Jovellanos. In those engravings Goya found himself, found what was to be his historic identity. The historic identity of Goya crystallizes in the *Caprichos* of 1799.

12. And still they won't go! *Caprichos*, 59, 1799

3 The Caprichos

On 6 February 1799 the *Diario de Madrid* carried an announcement which filled its front page. It advertised for sale, at the current price of 4 *reales* an engraving, a collection of eighty prints in etching and aquatint by Goya 'censuring human errors and vices'. The Duke of Osuna had already bought four sets in January. On 19 February a shorter advertisement appeared in the *Gazeta*. According to Goya the *Caprichos* were on sale for only two days; twenty-seven sets were bought. They were suddenly withdrawn. In 1803 Goya made over the plates to the royal Calcografía in return for a pension for his son. It is possible that an edition was prepared in 1806 during Godoy's final lurch into 'liberalism' before the cataclysm; isolated impressions occasionally came out; but in fact a second edition did not appear until the middle of the nineteenth century.

Guillemardet, the regicide French ambassador whom Goya painted in 1798, took a set back to France, where they were to be studied by his godson, the painter Eugène Delacroix; it was in France in the next generation that the *Caprichos* made their first impact. When they finally reached England they were duly burned in the street by Ruskin.

Reaction in Spain was more immediate. The final advertisement in 1799 appeared on 19 February. On 21 February (the 'two days' of Goya?) the liberal minister Saavedra was abruptly dismissed. According to later statements by Goya, the prints were withdrawn under threat from the Inquisition. In 1803 clerical and reactionary pressure was intense and the plates were handed over to the royal printer in self-defence, apparently at the prompting of Godoy.

The prints were fierce enough to provoke suppression. A score or so were searing attacks on monks, friars, the Church and 'superstition', direct or in the guise of satires on witches and goblins, 'duende'; a dozen were transparent jibes

at hereditary aristocracy and at least thirty carried a potent charge of satire on sexual mores.

They are a brilliant technical achievement. Goya deploys a mastery of tone and texture and an inventive genius. Superb control of light and shade pinpoints subjects against a graduated and sombre background; the style is expressionist. Passion and unreason effectively distort form and face, shape a bone-hard realism to visual satire and twist it to the edge of caricature. The witchcraft series pullulate with hags, terrifying monsters, black sabbaths, ghastly faces and scatological paraphernalia; they are shattering in their grotesque naturalism. Monsters of sick fantasy come to 'human' life with all the fleshiness of a medieval nightmare. The series appears to escalate from satire into a satanism conjured up by a spirit sick in the sleep of reason which was Spanish society.

The sequence is in fact controlled and directed by Reason. 'The sleep (or dream) of reason brings forth monsters' runs the only engraved caption, to the scene of the author asleep at his table while creatures of night scrabble about his head. The intention is to rake the irrational, the superstitious, the anti-human in social life, but Goya himself talks of these monsters coming into his drawings as if he had no control over them. The device of witchcraft tends to assume a human reality and to create an anti-world of spirit which rivets a reeling imagination on the withering truth that the inhuman is all too disgustingly human. It is precisely this tension between Reason and Unreason, *both* essentially human, which gives the engravings their power and compulsion.

That power had in fact been muted. Goya had first considered publication in 1797 and grouped drawings in sequences under the title of Dreams, *sueños*. For the *Caprichos*, these sequences were broken up. Some run in pairs or trios, but few in series. The original frontispiece for the Dreams, the Sleep of Reason engraving, forms No. 43 of the *Caprichos*. Witchcraft and supernatural subjects are found everywhere in the set, but tend to thicken after No. 43. Only one run seems complete, a series of *Asnerias*, engravings using asses and donkeys to satirize profession and status, Nos. 27 to 42. A number of attacks on the clergy, thinly veiled as jibes at 'goblins', were evidently a coherent series, their captions mounting a devastating onslaught, culminating in the final *Capricho* of evil-visaged, stretching monks in a grey dawn captioned Time's Up (*Ya es hora*) [21]. Had these remained in intensifying sequence, the impact would have been yet more destructive.

The captions are essential. Far from clarifying the picture, many of them serve to deepen ambiguity and sharpen paradox. They mobilize quotations from satirical writings by *ilustrados*, the opening phrases of proverbs, puns with *double entendre*, catch-phrases, references to well-known events and popular beliefs, and all act as a stone thrown into a pond, sending ripples of satire out from the drawing in widening circles of meaning and perception.

For example, a vivid presentation of a victim of the Inquisition in the conical hat of the guilty with the 'crime' blazoned across the chest, seated on a platform while an

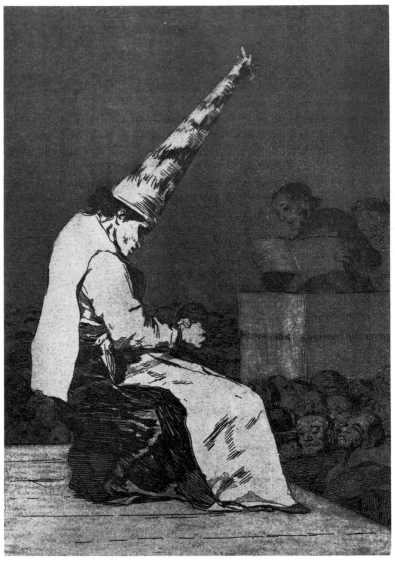

13. That dust . . . (from that dust comes this dirt). *Caprichos*, 23, 1799

official intones the sentence to a huddled, mindless, grimacing mob, is captioned *Aquellos polvos*, That Dust. Apart from its intrinsic force, this caption recalls a celebrated public spectacle of 1784, when such humiliation before imprisonment was inflicted upon some wretches convicted of selling corpse-dust as a magic potion. But the words are also the first strophe of a popular proverb which, completed, ran – From that dust comes this dirt – pillorying the Inquisition as the Other Face of brute superstition.[1] In lighter vein, a rather erotic drawing of two girls, scantily clad, flaunting their bottoms before grinning males and carrying chairs on

14. Now they're sitting pretty. *Caprichos*, 26, 1799

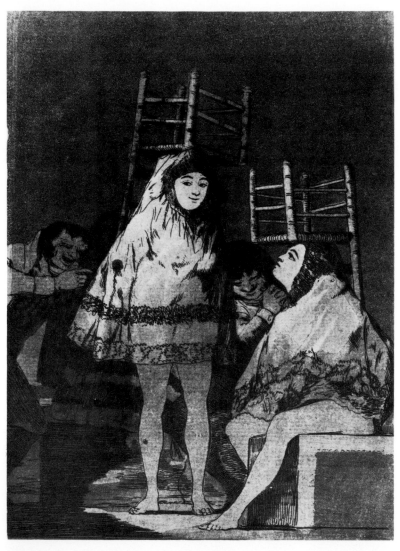

their heads, is captioned *Ya tienen asiento*: a play on *asiento*, with its meaning of 'seat' as well as 'judgement' and a further play on the idiomatic meaning of *tener asiento* – to be sitting pretty [13, 14].

Directed at particular customs in origin, the *Caprichos*, through Goya's magic, are often transformed into permanent statements, transcending time and place. Several of them in the witchcraft mode are now incomprehensible; clearly many of these were directed at particular individuals or events familiar to the readers. The Osunas seem to have taken the *Caprichos* primarily as farcical squibs of this character.

15. The chinchillas. *Caprichos,* 50, 1799

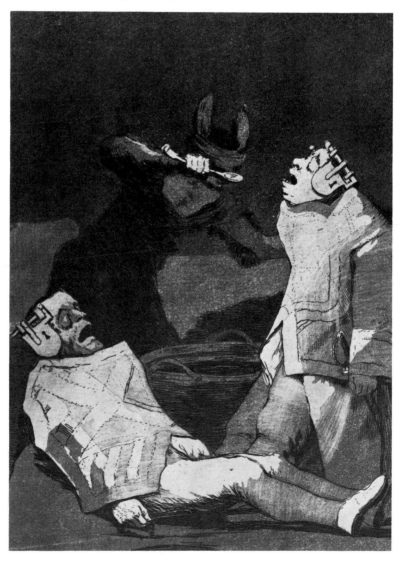

Nevertheless, it is possible to trace many back to their proximate source. Edith Helman, in a sustained and scholarly enterprise, has been able to place or to suggest the original inspiration of many.[2]

Take the celebrated print, Los Chinchillas (No. 50). Spotlit are two effete male figures, pinioned in costumes blazoned with coats of arms. One lies on the ground, clutching a rosary; the other sags, half upright, carrying a sword. Every line in their flaccid bodies indicates the torpid, the inert, the useless. Heavy padlocks are clamped over their ears; their eyes are shut and their mouths gape. A dark, thrusting figure, charged with power and menace but in fact servile, with asses' ears and eyes blindfold, ladles sustenance from a cauldron through a highlit spoon into the mindless mouths [15].

The piece is obviously an attack on hereditary aristocracy, but the caption, *los chinchillas,* is enigmatic, especially since the American rodent of that name is feminine in Spanish. The name in fact derived from a character in a popular play by Cañizares which mocked, in fairly genial terms, the obsession with nobility, blood and status. In a preparatory drawing Goya sketched in the two central figures, but included characters from the play in a theatrical setting. This was his first response, little more than theatrical illustration. In a second preparatory drawing, creative genius is at work in splendid simplification, and the final *Capricho* is a powerful and evocative statement which transcends time and place.[3]

Nevertheless the *Caprichos* were rooted in a very particular *Spanish* time and place. In fact they are an ideology made graphic.

The *Asnerías* of course were a fairly common and obvious style of satire. Gabriel Alvarez de Toledo had brought out his *Burromaquia,* and Forner in his *El asno erudito* had used the ass figure to lash literary rivals. Some very striking parallels may be traced between Goya's *burro Caprichos* and a series of (much cruder) engravings which served as illustrations to a satirical work published in exile in Bayonne in 1792, *Memorias de la insigne Academia Asnal* by a so-called Doctor de Ballesteros; this was circulating in Madrid at the time of Goya's convalescence. The distance travelled may be judged from a comparison between the *Asinus Musicus* of this compilation, a simplist fiddle-playing donkey, and *Capricho* No. 38, *Bravísimo,* which has a monkey playing a guitar with no strings to an applauding ass. A similar relationship seems

to exist between *Memorias* crudities and such splendid
lampoons as that against doctors in *Capricho* No. 40 [16] and
the ass tracing a family tree of asses in *Capricho* No. 39.
In a satire on education in *Capricho* No. 37, one ass teaching
another, with the motto – might not the pupil know more? –
there seems to be an echo of a famous scene from Padre Isla's
novel *Fray Gerundio*.

Isla's *Gerundio* had shredded the absurdities and farandoles
of popular preaching in Spain to such effect that the
Inquisition tried to ban the text in 1760 and 1776; a new
edition of 1787, together with all writings for and against it,

16. What will he die of? *Caprichos*, 40, 1799

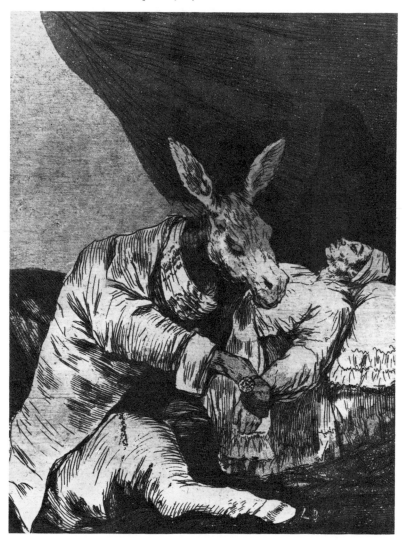

was listed on the Index in 1790. This mockery touched a raw nerve. The term 'gerundios' passed into common parlance and Goya's *Capricho* No. 53 – What a Golden Beak! – a farcical clerical seminar held spell-bound by a parrot – was squarely in an Enlightenment tradition and may well have been directed personally against Fray Diego de Cadiz, a preacher madly popular at the time and anathema to *ilustrados* [17]. Such satire bucked a very strong tide among the Spanish *pueblo;* non-rational, indeed anti-rational preaching was a formative feature of popular culture. Men like Fray Diego were not only active in the first 'crusade' against

17. What a golden beak! *Caprichos,* 53, 1799

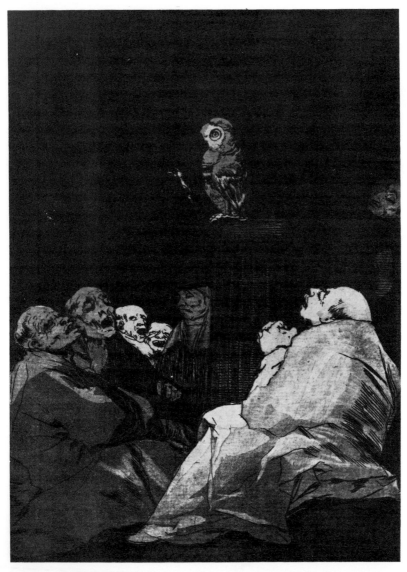

revolutionary France in 1793; they were often central to the heroic and traumatic national resistance after 1808.

More populist perhaps were the attacks on the *cortejo*, the inseparable male companion of society wives and their often complaisant husbands, since the institution seems to have been actively disliked by a *pueblo* more given to the modes of *majismo*. Attacks on the *cortejo* ran through a range of styles; in 1788 they produced a veritable manual, with illustrations, in the *Optica del Cortejo*. This, in turn, opened up the entire world of arranged marriages and led into the labyrinths of sexual–social intrigue and prostitution.

18. Can no one untie us? *Caprichos*, 75, 1799

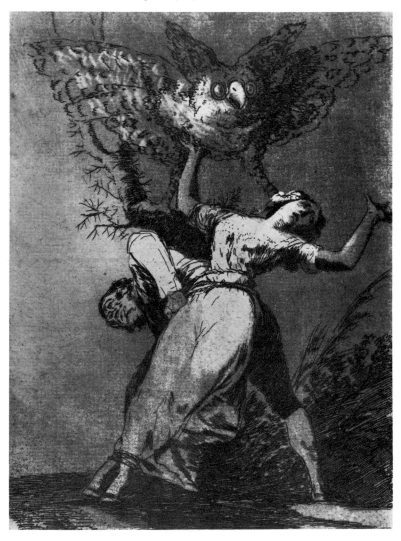

Nothing looms larger in the *Caprichos*. The pretty, blank-faced girl, trained and directed by the duenna-cum-chaperone-cum-procuress, the *celestina* of Spanish tradition (who in Goya's hands is invariably a grotesque, repulsive and cunning old hag), the prancing *petimetres* (petits-maîtres), the corrupt and mercenary marriages, the endless jockeying and fencing for social–sexual advancement on the Paseo del Prado, run parallel to the more direct jeers at prostitution, the plucking of bird-men by merciless whores and the complementary chewing of bird-whores by greedy officialdom. These engravings run from direct statement, sometimes pathetic and sentimental – far more often heartless and chill – to deeply cynical and utterly bleak comment. They can produce very striking work, as in No. 75 – Can no one untie us? – a man and woman lashed together and imprisoned by a monstrous bespectacled owl [18]. They can produce bitter personal comment on the Duchess of Alba [43]. They overflow into and interpenetrate with the hideous universe of witchcraft and the black supernatural. In a sense the sexual satires are central to the *Caprichos;* their spirit drenches the collection. Woman frequently figures as the vehicle of that corruption and unreason which is making a grotesque tragi-farce out of a Spanish society presided over by Queen Maria Luisa and her *cortejo* Godoy.

The tone of the engravings echoes that of much Enlightened literary comment on the same themes. Nicolas Fernández de Moratín, father of the dramatist who was a close friend of Goya, produced an *Arte de las putas* which was banned by the Holy Office in 1777 but circulated in manuscript. It built on Ovid's *Ars Amatoria* but also on the medieval classics of Spanish bawdy, *La Celestina* and *Libro de buen amor* which had recently been revived in a work whose publication Jovellanos had recommended to the Academy. It is now known that Goya's bull-fighting prints began as an illustrative series for Moratín senior's history of the ritual, and its companion piece was certainly known to the painter.[4]

Through even this sexual satire, however, there are direct echoes of Jovellanos himself, leading light of the *ilustrados,* whose *Informe* of 1795 was the foundation text of Spanish liberalism. A friend and patron of Goya's, he had just been driven from office by clerical reactionaries.[5]

Capricho No. 2, given the place of honour after Goya's self-portrait – They say yes and give their hands to the first comer – takes its title from the first two lines of a satirical poem *A Arnesto* published by Jovellanos in the *Censor*.

Helman is able to point to a probable source in Jovellanos's writing for up to a dozen of even the 'merely' sexual prints. Even in these, Goya tends to return in a hypnotized disgust to the suspect monks and friars, not least in the horrifying *Trágala, perro* – Swallow it, dog (No. 58) – in which grotesque monks advance with a monster syringe on a cowering man [19]. A play on words (to syringe could also mean to plague or vex) it may refer to a popular tale of the rivalry of a monk and soldier over the same woman, in which

19. Swallow it, dog. *Caprichos*, 58, 1799

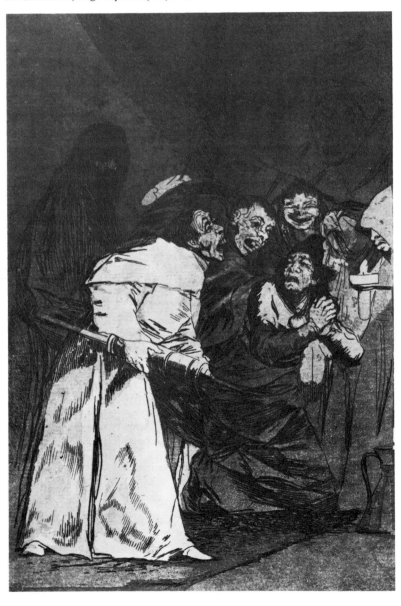

the clerics monstrously abuse their spiritual power, but it
clearly has much wider implications.[6] In the nineteenth
century the words *trágala, perro* figure as the refrain of a
radical political song as the Constitution of Cadiz is forced
down recalcitrant reactionary gullets. The most savage attacks
on black clerics are those which manhandle them as 'goblins',
building up from caricatures of them as gluttons for food,
drink, power and sex, as parasitic drones who consume better
men's substance into stark portrayals of them as creatures of
darkness and night whom the approaching dawn will disperse
[20, 21, 26]. Closely connected are the attacks on that popular

20. No one has seen us. *Caprichos*, 79, 1799

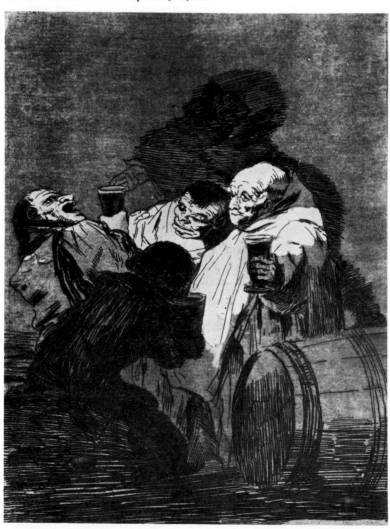

superstition which buttresses their power, notably in the
shattering No. 52 – What a tailor can do! – a tree dressed up
in monk's habit which forms a threatening cross before which
people cower while witches hover overhead (a theme which
appears in Southey's letters on Spain) [22]. These attacks,
which bite very close to the bone indeed, possibly got their
initial impetus from a satire on a Bilbao convent produced in
1791 by the fabulist Samaniego, a close protégé of Jovellanos.

In the more general social and political satire, the influence
of Jovellanos is everywhere, notably in two attacks on the
dead weight of church, state and landowners on the backs of

21. Time's up. *Caprichos,* 80, 1799

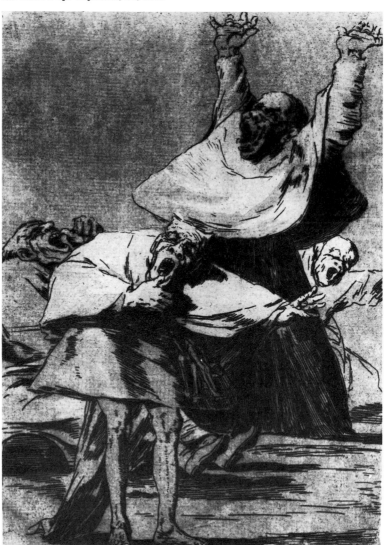

the Spanish peasantry [8, 9], in the onslaughts on the
Inquisition (the second Auto da Fe print, No. 27, carries the
caption *No hubo remedio* – nothing can be done about it –
which words were used by Jovellanos himself in a description
of his dismissal at the hands of clerical reactionaries in 1798)
and in the satires on government and establishment (which
probably cover most of the impenetrable 'witchcraft'
engravings as well): all echo Jovellanos's biting analysis of the
corruption and irresponsibility of court and governing classes
in the face of mounting discontent. If any one man's mind
can be said to direct Goya's hand in the *Caprichos*, that man
is Jovellanos.

The most direct parallel to the *Caprichos*, at least in terms
of content and corrosive quality, is the journal *El Censor*.[7]
Under the guidance of Luis Cañuelo, it fought its way
through a brief, brilliant life in the 1780s. In a sense it
represents a certain climax of the Enlightenment in Spain.
That Enlightenment never was and never could be the
radical affair it was in France, and, in a different style, in
Britain. But in a Spain conditioned by its history to the most
intransigent forms of religion, hierarchy and discipline, in a
Spain where the long underground tradition of populist
resistance to establishment assumed anarchic and distinctly
'un-enlightened' form, the *Censor* and its generation of the
dissident *were* a radical Enlightenment.

It could exist only because a form of enlightenment,
practical, measured, bureaucratic and politic, had become
official doctrine under Charles III. In the shelter of court
and establishment enlightenment, in the teeth of the
majismo adopted by recalcitrant notables and of the persistent
counterattacks of clericals and the Holy Office, journals like
the *Censor* could carry the attack on 'Black Spain' with a
vigour and passion hitherto unexpressed. It was precisely this
world which was disrupted after 1789 by the unexpected
horrors of the Revolution of enlightened France, by the
power of the conservative reaction within Spain, by the
degeneration of the Spanish monarchy under Godoy. It was
precisely this world which was confronted by an agonizing
dilemma of divided loyalty in the usurpation of Joseph
Bonaparte in 1808 countered by a populist uprising often
deeply 'black' in inspiration. It was precisely this world,
afflicted with political schizophrenia, which was dispersed in
Spain's national crisis.

It was to this world that the *Caprichos* belonged. The *Censor*
published *Discursos*, often scorching, often written by leading

22. What a tailor can do! *Caprichos*, 52, 1799

ilustrados under pseudonyms, including Jovellanos and the poet
Meléndez Valdés, against the distortions of unreason in society,
false learning, false marriage, duels, torture, unequal justice.
Three themes were central: the defective education of children,
a major Enlightenment preoccupation; the parasitism of a
swollen hereditary aristocracy; above all the crippling weight
of ignorance and superstition which bent the minds of the
pueblo in subjection to a charlatan clergy. The *Censor* was a
fervently proselytizing sheet, clear and sharp in its confronta-
tion with reality, direct in its approach, always looking for new
force to punch home its message. It was directed at a new
reading public, revelled in irony, passion and indignation and
was often bitter and violent. By 1785 royal edicts were being
issued against satirical papers, themselves often the weapon
of faction warfare about the court; the *Censor* did not survive
the reign of Charles III.

In content and intention the *Caprichos* were the manifesto
of *ilustrados* of *Censor* breed. In tone, however, they differ
significantly. In the *Caprichos* there is none of that ultimate
optimism which underlies the *Censor's* fury, no sense of riding
the wave of the future. On the contrary, the prints radiate an
unredeemed pessimism. Goya seems to despise everyone and
everything; there is a cynical detachment, a sense of despair.
In part, this is an optical illusion; the function of the prints,
after all, *is* to satirize; several are obviously 'comic' in original
intention. The bleakness, however, is much more than a
function of a strictly rational critique; it invades the very
heart and being of the work. It is precisely the dialectic
between light and darkness, mirrored in the very technique
of the prints, which is their creative power.

Immediate causes are not difficult to find; Goya's desperate
illness of 1792, his deafness, the harsher vision of reality he
was developing in his paintings, the miserable ending of his
affair with the Duchess of Alba. In public life there were the
multiple shocks of a panic reaction to the French Revolution,
the horrors of the Revolution itself, the degradation of the
court, the resurgent power of clerical and conservative Spain,
the oscillations of politics under the shadow of Godoy.
Bitterness and disillusion were common; it was appropriately
from the street called Desengaño that the *Caprichos* were
sold – recalling the *desengaño*, despair, disillusion and loss of
self-confidence of the seventeenth-century Decadence.

This mood was identified with a distinct shift in sensibility
which may be detected at this time elsewhere in Europe, the
shift that has been labelled 'pre-romantic'. Helman draws an

instructive parallel with the work of the writer Cadalso. *Ilustrado* and, like Jovellanos, a student at Salamanca, Cadalso wrote typically enlightened satires in a modish 'French' style in his *Cartas Marruecas,* echoes of Montesquieu and all the other critical writers of 'Letters'; his *Eruditos a la violeta* was a very influential satire on pseudo-intellectuals. But parallel to his rationalist style there ran a more individual, more free, less rational exploration of the imagination, steeped in disillusion and sadness. His *Noches lugubres* were directly influenced by Edward Young's *Night Thoughts* and in the 1790s there was something of a Spanish vogue for Young, translated (characteristically from a French version) by Juan de Escoquiz. The young poet Meléndez Valdés was introduced to Young's work by Cadalso and wrote to Jovellanos regretting his own failure to achieve 'the magnificent and terrible style . . . of the inimitable Young'. Moratín the younger, too, wrote sentimentally to Ceán Bermúdez about their admiration for Young from the site of his daughter's grave.[8]

Cadalso himself explored the possibility of 'capricho' in its twin senses of caprice and a free exercise of the creative imagination, of those 'monsters' which classical orthodoxy, Luzan and Ponz with their endless citing of Horace, so rigorously excluded. Goya in his engravings was employing 'capricho' and 'monsters' in precisely this sense. He belonged to a group centred on the playwright Moratín who called themselves *Acalofilos,* lovers of ugliness, who steeped themselves in all the irrationalities, monstrosities and absurdities of the day, primarily to mock and puncture, but also to take cognizance of them, to incorporate them in their rationalism. In revolt against the aridity of neo-classicism, painfully aware of the insecurity of Enlightenment and appalled at the rising tide of Spanish *costumbrismo,* these men wrote and drew Spanish society as a theatre of the absurd.

For of all the *ilustrados,* it was the dramatist Moratín who was closest to Goya in the *Caprichos.* Leandro Fernández de Moratín, son of Nicolas of the bulls and whores, was fourteen years younger than Goya.[9] He was a complete *afrancesado* and perhaps the most successful of them. For his plays, while thoroughly French in inspiration, with Molière a particular influence, were also thoroughly Spanish in spirit. The plots were simple, the dialogue sharp and brilliant, the comedy often exuberant. His last play, *El si de las niñas,* became perhaps the most popular of Spanish plays. They are all studies of character; they are all ultimately

didactic in good Enlightenment style, but informed with an insight and a comic power which makes them live.

He spent much time abroad. Jovellanos got him a post in the Paris embassy under the radical Cabarrús in the 1780s; the patronage of Godoy and the success of his second play won him five further years abroad in 1792. During his year in London, he translated Hamlet and was struck by the English stage, which seemed to him similar to the Spanish, and by the power and popularity of English caricatures, which he compared to Spanish popular farces. At the crunch of 1808, like so many of his friends, appalled at the virulence of the popular rising and committed to French values as civilized values, he joined Bonaparte, and after 1814 went into exile. He died within a few months of Goya in Bordeaux.

Particularly from 1797 on his return to Spain, he was a close friend of the painter, who made two superb portraits of him. He shared Goya's last years in France. His influence on Goya at the time of the *Caprichos* was personal, direct and decisive. They were both great theatre-goers. Goya had a taste for the *tonadillas* and *sainetes;* Moratín was hypnotized by the sheer horror of it all. His play *La comedia nueva* of 1792 was an attack on the Spanish stage, that monster which consumed a play a week, which was devoted to melodrama and the grotesque, the totally irrational, which enlisted the services of superb artists like the actress Rita Luna and which ranged its passionate plebeian partisans in rival gangs of *Polacos* and *Chorizos* (literally Poles and Sausages). This, no less than the sermons of charlatan monks, thought Moratín, was the populist stronghold of Black Spain, which had to be reduced. *Y aun no se van!* – wrote Goya as caption to a *Capricho* (No. 59) of grotesque yet 'human' creatures warding off a monolith threatening to crush them – And still they won't go! [12] Black Spain seemed impregnable, rooted not least in the hearts and minds of the *pueblo*. Goya's intention in the *Caprichos* strictly parallels that of Moratín in his *Comedia* and other writings: it is to purge that spirit. No less than Moratín's plays and his extended commentary on witchcraft, Goya's engravings were literally a Theatre of the Absurd.

It was from Moratín, further, that Goya drew the form and frame of his theatre. Edith Helman has demonstrated beyond doubt that the witchcraft theme in the *Caprichos*, not merely in conception and scope, but in minute detail of iconography and comment, is drawn from one work of Moratín's, his mocking commentary on the Inquisition's Auto da Fe against witchcraft in Logroño in 1610.

The Logroño Auto da Fe of 1610 was one of the most celebrated of all witch-hunts, in which the Inquisition deployed its full power and ritual. The account of the proceedings, the *Relación*, was so packed with picturesque and grotesque detail that it could serve virtually as a guide or handbook to the cult. To *ilustrados*, it was a veritable tragic farce, an appalling documentation of the depths of unreason and superstition to which their people could sink, in both the disease and its 'cure'. The interest in the supernatural and the occult which was general in the late eighteenth century acquired a particular intensity in Spain, more especially

23. There's plenty to suck. *Caprichos*, 45, 1799

among its small but passionate minority of *luces*: the tension
between an imported Enlightenment and an increasingly
assertive and xenophobic *costumbrismo,* the failure of hope and
loss of confidence after 1790, the darkening political scene,
focused their minds sharply on the central problem of what,
to them, was the hag-ridden psychology of Spaniards.

Moratín became obsessed with the *Relación.* A man diffident
to the point of self-strangulation in public, he found himself
in small private gatherings, those *tertulia* conversation parties
which Spaniards cherish and which tapped in him an

24. Blow (reference to Inquisition informers?). *Caprichos,* 69, 1799

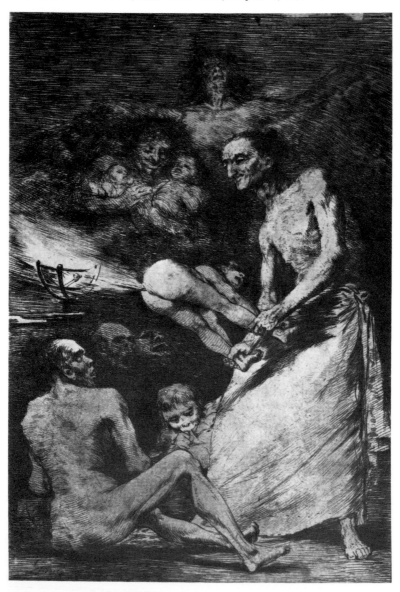

effervescence of wit, mockery and ridicule. Ridicule was perhaps the last weapon left in their armoury and ridicule was the *raison d'être* of the *Acalofilos*, as they met to rake over the latest buffooneries of stage and pulpit. It was in such circles that the word 'duende' – ghost, spirit, goblin, those 'monsters' who peopled the Spanish theatre – was used as a nickname for monks and friars. And to these *tertulias* Moratín would declaim the *Relación* in fullblown and flyblown rhetoric, lacing it with his own pungent commentary. Ultimately he worked these comments up into editor's notes and fashioned a book

25. They spruce themselves up. *Caprichos*, 51, 1799

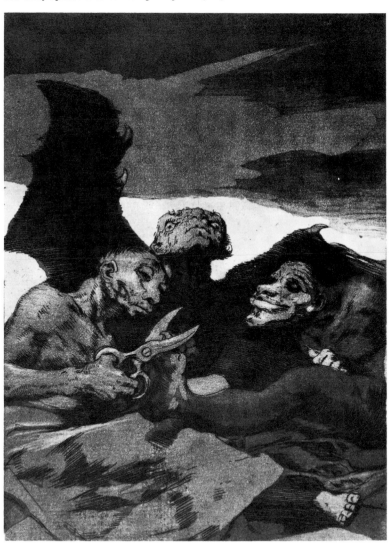

which was a weapon. Significantly, the book found a publisher
at the rare moments of liberal success: it came out in 1811 in
a Madrid under French control, in 1812 in that Cadiz where
patriot Spaniards were shaping a democratic constitution, in
1820 in the Madrid of Riego's revolution.

And almost every detail of iconography, of comment, of
reference in Goya's witchcraft engravings can be traced to
Moratín's notes on the *Relación*. It was this which gave form
and an organizing principle to the *Caprichos*, as Goya's
preoccupation with sexual relations in the aftermath of the
Alba affair gave them bite [23, 24, 25, 26].

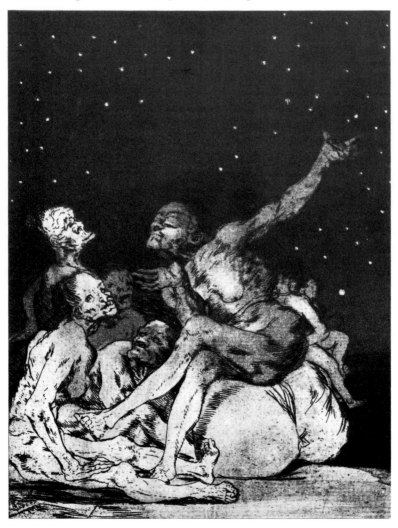

26. If dawn breaks, we go. *Caprichos*, 71, 1799

It is in these *Caprichos* that Goya's distinctive personality as a creative artist first realizes itself; they are the first effective crystallization of his special talents. Under the compulsions of his mind and the drive of his genius, his theatre of the absurd bursts out of its satirical frame; it becomes virtually a theatre of life, a kind of cockpit for the Spanish spirit. In Goya, the only one of them who *was* a man of the *pueblo* with an instinctive response to its tastes, the ingrained ambivalence of the *ilustrados'* attitude towards that *pueblo* acquires a creative intensity. The incipient and what was to prove the endemic Spanish civil war fought itself out within his own mind. It is this dialectical tension which characterizes his most personal and most effective work from this moment on. In *The Disasters of War*, which are in a very real sense a second instalment of the *Caprichos*, it generates elemental and unforgettable force.

Two of the *Caprichos* in particular focus on this ambivalence towards the *pueblo*, both of them echoes of Jovellanos, who was distressed sometimes to the point of distraction by the miserable servitudes of the Spanish peasantry [8,9]. *Capricho* No. 42 shows two of the *pueblo*, drawn in sympathy and compassion, humping spurred and gross *burros* on the bleak central meseta. The caption runs *Tu que no puedes* – the first phrase of the proverb, Thou who canst not, lift me on thy shoulders. The message is clear. But in *Capricho* No. 63 a similar scene registers a significant change. With an angry and gesticulating crowd in the background, two monstrous figures straddle two *burros* who stand humanlike on two feet. The riders are 'witches', grotesque: one has the figure of a man with the beaked face and claws of a bird of prey; the other is a gross and stupid beast with asses' ears, his hands folded in prayer, his ugly face creased in piety. The forces of church and state ride the *burro-pueblo*. But what *burros* these are! Bent like men under burden, they have the devil snouts, bestial and repellent, of medieval gargoyles. The *burro-pueblo* is as brutalized and inhuman as its riders.

Here in these *Caprichos* a painter of genius finds a distinctive voice. But the man who found his voice in 1799 was a man of fifty-three, the King's Painter with twenty years of social and professional success behind him. What brought him to it?

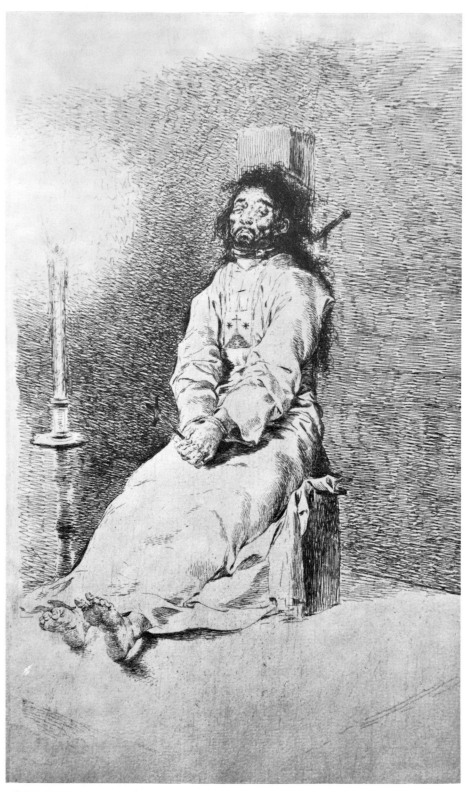

27. The garroted man, *c.*1778–80

4 The Historic Identity of Goya

In the autumn of 1786, Goya went to the Escorial to present sketches for a new series of tapestry cartoons destined for the dining room of the Pardo palace. As well as the celebrated four Seasons, these included the first serious social paintings to appear in his work; the Poor at the Well and the Injured Mason. The subjects are bleak, the treatment clinical; both are related to the magnificent Winter cartoon, which has wind-whipped peasants and their *burro* battling against a snowstorm. The Mason, in particular, has often been taken as evidence of that humanitarian, populist, even democratic drive within Goya which was to explode into the unforgettable drawings and engravings of his later life [28].

This belief is mistaken. Edith Helman, quoting Ortega y Gasset to the effect that there is a chilling emptiness at the core of many of Goya's paintings, an emotional distance between author and subject, an absence of commitment to anything other than the solution of a painter's problem, is able to make summary execution of this masonic mythology.[1]

The cartoon, impressive in its handling of distance, physical posture and nuanced greys, is striking in theme but cool to the point of neutrality in sentiment. She plausibly suggests a proximate source in the famous edict of Charles III which drilled the building industry in worker safety, inflicting prison sentences and fines on negligent employers. Promulgated in 1778 and re-issued at intervals, it had been eulogized as recently as 1784 in the *Memorial literario*; the *ilustrados,* who were increasingly shaping Goya's word of social intimacy, hailed it as a very model of enlightened legislation. In 1786 Goya was appointed *Pintor del Rey* (King's Painter) and, with his brother-in-law, granted a monopoly at the Tapestry. Far from being a social protest or even comment, the cartoon was a courtly gesture in fashionable taste. There was, further, its notorious twin the Drunken Mason, a smaller sketch which

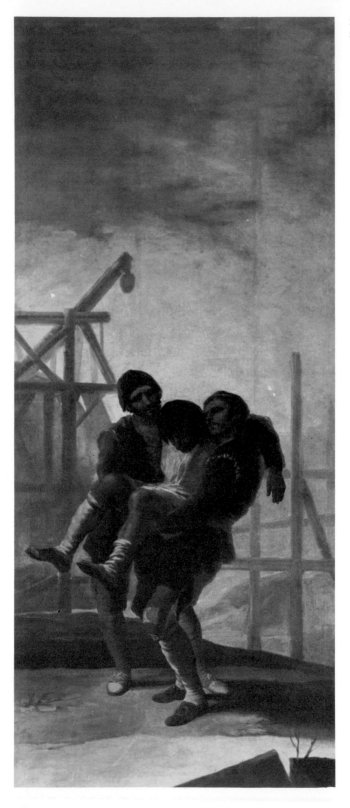

28. The injured
mason, 1786–7

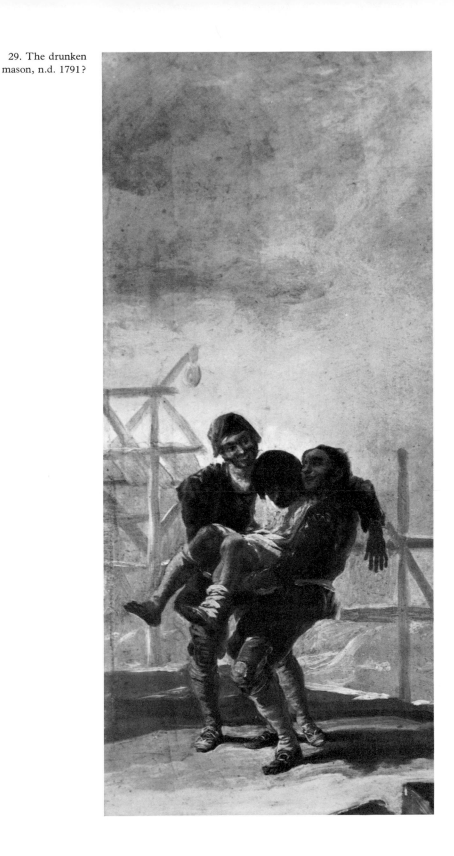

29. The drunken mason, n.d. 1791?

Goya later sold to the Duke of Osuna [29]. Virtually identical in pattern, this plastered grotesque and rather sinister grins across the faces of the workmen lumping their sagging comrade from the scaffolding, drove out dignity and drove in that sardonic black humour which recalls the *Caprichos*. What sort of 'social commitment' engaged the mind and spirit of a man who could touch up the one into the other?

Crushing though Helman's deployment of the drunken against the injured mason may appear, the argument is insecure. We do not in fact know which came first. The drunk appears in a clutch of works sold to the Duke of Osuna; Goya presented his account for some of these, together with later sketches, in 1798. His editors believe these little paintings to have been (as most of them clearly were) preliminary sketches for the original royal cartoons, but the Osuna order for payment is ambiguous in its wording, which seems to suggest that some at least were made for the Duke.[2]

The suggestion that the *drunken* mason was prepared as a cartoon, presented to the King, rejected and then reformed, is difficult to accept; the piece would have been grotesquely, even insanely, out of harmony with its companions. Several interpreters see it as a later composition. If José Gudiol was correct when he once placed it in 1791, the sketch would not only take on the aspect of a parody, it would fall into significant alignment with two royal cartoons which Goya drove himself to produce in that year of deepening personal, professional and political crisis – the Manikin and the Wedding, in which the preoccupations, and to some extent the style, of his post-1792 travail are already reflected and which, without doubt, register an important change in his published attitude towards the *pueblo* [34, 35]. The drunken-mason sketch, in fact, might serve as evidence, less of Goya's social indifference in 1786 than of a profound change in outlook which began to grip him on the very lip of his most desperate personal crisis.

This leaves Helman's central argument unscathed: the 'populism' of the Mason, the poor at the well and the peasants in suffering season, is factitious. With the ambiguous exception of his solitary original engraving at that time, the Garroted Man of 1778–80 [27], prophetic in its remorseless realism, there is no trace of any social feeling in Goya's work before the 1790s. The many popular themes in it were common and merely fashionable; several may be traced directly and all indirectly to the familiar world of the *sainetes* of Ramón de la Cruz, the popular verses of such as Gregorio

de Salas and so many others; the earlier pieces steeped in
that picturesque *majismo* which the aristocracy were beginning
to adopt, the later in the more serious but still essentially
bien-pensant modes of the Enlightened climax of Charles III's
reign.

If Goya had died from his illness in 1792 he would have
been counted unremarkable except in occasional promise.
The occasions of promise, however, register *before* the
personal disaster struck and they raise, very sharply, the
central question of identity. Goya was forty before he broke
through to success, to the possibility of realizing himself.
The whole thrust of his first forty years was towards the
establishment of himself and his work in autonomous identity
and integrity. The historian, in confronting an original
creator, confronts in some measure the transcendental which
puts the creator ultimately out of reach. If he is to incorporate
the creator into the historical record in any meaningful way,
he has first to try to take seisin of his historical identity.

Most interpreters point to a break, a divide, an abrupt and
qualitative change in Goya's career. Even Ortega is disposed
to grant him a certain human engagement in his War
drawings and the generality punctuate Goya's life with the
illness of 1792–3 which broke him and left him permanently
deaf. In the first complete *catalogue raisonné* of his work,
Pierre Gassier and Juliet Wilson sketch out five phases:

1746 – 1792	his first forty-six years, rich in production after 1774 and in success after 1784, cut by the illness which nearly killed him in 1792.
1792 – 1808	the years of the Sanlúcar and Madrid albums of drawings, the *Caprichos* and some of his most brilliant portraits.
1808 – 1819	the years of the War and the reactionary Restoration, years of the *Disasters* engravings, again cut by serious illness.
1819 – 1824	the *Disparates* engravings and the staggering Black Paintings, years of the liberal revolution and its defeat, ending in Goya's departure into exile.
1824 – 1828	the final years in France, ending in death.

Of the 1900 works they catalogue, 700 were produced
between 1808 and 1819 (between Goya's sixty-second and
seventy-third years) and four fifths of these were drawings
and prints. In fact, graphic work accounts for two thirds of

the catalogue, drawings alone representing nearly a half of
his entire output. Before 1792, drawings and prints were only
a sixth of his work, while half his known portraits were
painted between 1792 and 1808. Central to the shape of his
life, then, is the crisis of 1792. After 1792 there is a decisive
shift away from commissioned work into the personal
statement and into the black-and-white. It was the break-
through into freedom which he himself recorded in a letter
to his friend Bernardo de Iriarte.

Edith Helman argues that this break-through into freedom
was less an *escape* than a *conquest*. She buttresses her argument
with a perceptive analysis of his self-portraits.[3] At moments
important to him, he tended to paint himself into his pictures.
These self-portraits, taken with the long series of revealing
personal letters he wrote to his friend Martín Zapater of
Saragossa, constitute a kind of diary. What the diary
chronicles into the 1780s is an obsession with success, a drive
to establish himself, both personally and as a painter.
Personal ambition, in fact, often seems to outweigh the artistic.
A man of sanguine temperament, a lover of bullfights,
chocolate, *tonadilleras,* he sometimes told Zapater that he
preferred hunting to painting. In earlier years at least his
attitude to his painting seems strictly professional in the
narrow sense. In his late thirties he was ready enough to
paint in styles and within limits which were not his, to
accommodate himself to fashion. To a certain extent, this
remained true all his life; in public affairs he was always a
politique, even his exile may have been forced on him by his
mistress. This particular form of adaptive egoism may help
to account for both the periodic weakness in his work and for
its increasingly 'schizophrenic' character.

For every one of the major illnesses in his life seems to
coincide with a crisis in his development as a painter; every
one strikes with an almost psychosomatic precision at a point
where he was struggling against a sense of imprisonment,
trying to break out into new explorations of skill and
sensibility. As he matured, the problems, preoccupations,
obsessions central to an original painter trying to realize
himself seem to have taken possession of him; it is very
probable that his gnawing hunger for the tangible esteem of
others, for *success* in terms material and above all in terms of
status, was identified with and incorporated in this demon
drive for liberty of the self. What must command the
historian's mind as he approaches the crisis of 1792 is the

utterly egocentric thrust of Goya's life at that point; everything outside himself was secondary, an instrument.

His first illness, in 1777–8, for example, came after he had been working for a few years on tapestry cartoons under the direction of his brother-in-law, Bayeu. After an almost anonymous start the cartoons for the Pardo in 1776–8, with their demand for popular scenes, diversions and costumes in picturesque style, unlocked his talents. A brilliant decorative success, these works were still essentially subordinate. Already, in his first essays, Goya had displayed a striking originality. Helman has acutely analyzed these earliest paintings, notably the monumental compositions for the Carthusian monastery of Aula Dei in Saragossa of 1774, a portrait done in Italy in 1771 and a self-portrait made before 1775, and has demonstrated convincingly that many of the features considered characteristic of a later Goya were present at this early date. The self-portrait in particular, non-linear, a minor masterpiece in graduated light and shading, clearly belongs to the same order of creation as the infinitely more celebrated and sombre self-portrait of 1815, executed several lifetimes later. The face is young and unformed, the familiar eyes stare out, penetrating but cautious, suspicious, almost afraid; it is the face of a man stubborn in awareness of talent but notably insecure in its realization and recognition [30,1]. At this date Goya had won no clear success in Italy and had twice failed to gain admission to the Academy. In 1774 came Mengs's invitation to work for the Tapestry. A powerful and original talent disappears to run underground through commissioned work in accepted style. And in 1777 the painter, thirty-one, married and with family, falls ill.

His response anticipates in a striking manner his reactions to later and more serious illnesses; he turned to engraving. In 1778 he made his celebrated and crucial studies of Velázquez; the cartoon of the Blind Man with guitar is said to be the first unmistakably to register the influence of Velázquez, henceforth paramount. Equally striking in its anticipation, he may have been pointed in this direction by the leading *ilustrado* Jovellanos, called to court in 1778. The reformer, elected to the Academy within a month of Goya, was always his warm admirer; he made the seventeenth-century painter the focus of his art teaching and counted Goya his true heir. It is known that Goya 'delighted' in Jovellanos's conversation and that most of his Velázquez studies ended up in the collections of Jovellanos and his

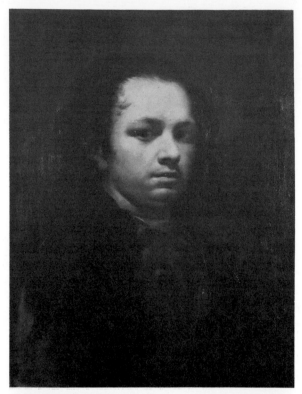

30. Goya, self-portrait, c.1771–5

31. Goya, self-portrait, in portrait
of Floridablanca, c.1781–3

protégé the historian Ceán Bermúdez. The Blind Man cartoon, which Goya also engraved, was submitted in April 1778 but returned for correction in October; it is possible that Goya discussed it with Jovellanos. At all events, this concentration on Velázquez resulted in Goya's first original engraving, the stark Garroted Man [27], and in a clear renewal of energy and naturalistic vigour, in cartoons, genre paintings and the charming series of children's games.[4]

The crucial years were those between 1780 and 1783.[5] In June 1779 Mengs died and Goya immediately applied for the position of court painter; he was rejected in favour of a nonentity. In May 1780, on the advice of Bayeu, he turned instead to the Academy, presented a heavily derivative Christ on the Cross and finally won admission. At this time, he told Zapater, he had scarcely 5,000 *reales*. In that same May he was commissioned to paint frescoes for the cathedral of El Pilar in his native capital of Saragossa. The commission brought humiliation. The committee of works found some of his panels too original for their taste and insisted that he repaint them under the direction of Bayeu; despite a dignified memorial which pointed to his membership of the Academy and work for the court and defended his independence as a painter, Goya was forced to surrender in 1781.

It was to escape from a morass of insecurity, therefore, that he threw himself into work on a San Bernardino altarpiece for the Madrid church of San Francisco el Grande which the Crown had made into a competition. In what had become a make-or-break enterprise for him, he laboured in total dedication from October 1781 to January 1783. His first commissions came through from the aristocracy, the rather naive and stiff portrait of the minister Floridablanca and the more genial series for the prince Don Luis de Borbón; into both, at this tense moment, he painted himself. Before the tall and icy Floridablanca who seems hardly aware of his existence, the painter appears small, uncertain, ingratiating, a *pintorcito* [31]; in the Don Luis family group, with its echoes of Velázquez, the atmosphere is less chilly, but the self-portrait equally supplicant.

Not until he completed the San Bernardino at the end of the year does the tone of his self-portraits change; in that work he stares boldly out, self-confident and challenging [32]. He had good reason; in 1784 the altarpiece was acclaimed and he broke through. He was made deputy director at the Academy; in 1786 *Pintor del Rey*. Commissions flowed in.

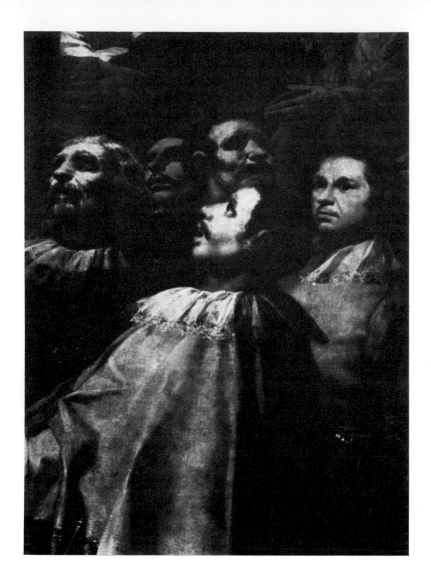

Jovellanos got him work at a Salamanca college, Ceán
Bermúdez a series of portraits for the new national Bank of
San Carlos; there were jobs in Valladolid and Valencia.
He established his vital connection with the household of the
Duke of Osuna, whose Duchess ran the most celebrated salon
in the capital. The nobility queued before his brush, and
when Charles IV succeeded, Goya was made painter to the
royal household in 1789.

His self-portraits acquire presence and dignity; he is the
complete painter, the complete courtier, the complete
success [33]. His letters to Zapater become an almost childish
howl of triumph. He cannot breathe for commissions; the
greatest in the land – and their names thunder out in a roll

33. Goya, self-portrait. *Caprichos*, 1, 1799

of honour – crowd his waiting room. His court salary is
15,000 *reales*; the Academy and shares in the Bank bring in
another 12–13,000. He buys an English two-wheel car
whose driver can do the Neapolitan turn; there cannot be
three like it in Madrid and the crowds gather wherever he
goes. He kisses the hands of royalty, he is feted at the
Osunas, where the rough shooting is so good. He buys a new
English car, with four wheels this time. Zapater must be told
every detail, the world must be told – particularly the world
of his own Saragossa, where they don't know a painter when
they see one.

At the time of his 'social' cartoons, therefore, Goya was
utterly absorbed in his own success; little else counted.

Yet, after five years of continuous personal, professional and social triumph, he ran into the most serious crisis of his life. This was the crisis which, in effect, *fixed* the Goya of history. Central to it was the crippling illness which decisively altered his manner of living. But devastating though that illness was, no less than those of 1777 and 1819 it seems to have been at least in part psychosomatic. The 'noises in his head' in 1793 echoed the beat of multiple frustrations on his brain. On few occasions has Aneurin Bevan's aphorism been more apt: there is no immaculate conception of disaster.

In the first place, he began to feel strangled. As early as July 1788 he was complaining to Zapater about the crippling burden of commissioned work. Every assignment left him less satisfied; he began to long for freedom, for the personal statement, the *capricho* which would liberate him. A new pulse of enterprise and exploration was beating within him and his very success became a jail. After a wave of royal orders to celebrate the accession of Charles IV, a 'disorder' which appears to have been psychological hit him in 1790, the year in which, as an immediate reaction to the French Revolution, the government having imprisoned Cabarrús, exiled Goya's friend and patron Jovellanos to Asturias. Partly to get rid of his load, partly to maintain that dignity which was now a preoccupation of his, the King's painter refused to work on any more tapestry cartoons. By April 1791 the director of the Tapestry was petitioning the King; Goya, though painter to the court, 'does not paint and does not want to paint'. His salary was threatened and Bayeu intervened as arbiter. By June Goya was confessing to a spirit of rebellion and announcing himself at work on the sketches.[6] The cartoons were being produced during 1792 as Spanish authority writhed before the threat from over the Pyrenees. In February Floridablanca was thrown out, to be replaced by Aranda, who relaxed the pressure. But in August came the overthrow of the French monarchy, the eruption of the *sans-culottes*, the first Terror. Moratín, in letters from France circulated among the *ilustrados*, voiced revulsion and despair; the enlightened were thrown into confusion. In November Aranda was out and an unbelievable Godoy, the Queen's twenty-six year old *cortejo*, succeeded, to the shock, dismay and disgust of the Spanish public. In that same November Goya mounted his own untidy personal rebellion. He voted with his feet and left Madrid without permission.

His departure was without doubt a delinquency and he took pains to disguise it. He was at the Academy in September

and on 14 October delivered a report on the teaching of painting. He then disappeared. A letter which Zapater wrote to Sebastián Martínez of Cadiz in January 1793 reveals that Goya was then seriously ill in Martínez's house and had been there for some time. Goya, through Martínez, asked Bayeu in Madrid to get him two months' official leave; this was granted in January 1793 'so that he may go to Andalucia to recover his health'. At the same time the painter wrote to the Duke of Osuna to beg money; he pretended to be in Madrid, having been bedridden two months with 'colic', and asked for the money to be paid in Seville, where 'he was going on leave'. The extraordinary pains which Goya took to blur the truth about his departure from Madrid were presumably designed to protect his position and salary.

The truth appears to be that Goya abandoned the tapestry work and a Madrid whose public climate had suddenly turned icy for *ilustrados,* probably early in November. He headed for Andalusia. He may have been going to Cadiz, where he did work for the Santa Cueva church some years later. He certainly went to Seville to stay with Ceán Bermúdez, who was then reorganizing the Archives of the Indies; he seems to have painted fairly freely in the city. Illness first struck him there, but he went on to the house of Sebastián Martínez in Cadiz.[7]

Martínez was a wealthy merchant, another liberal and an official of a liberal city. A great collector, he was said to own 300 paintings and several thousand prints, including Piranesi's *prisons,* and some English caricatures. Goya's journey looks like an act of liberation, semi-clandestine, a search for new sources and new energy. It is also notable that he moved along and maintained himself in a thin network of liberals who were entering a dark time. Probably the last painting he completed in 1792 was his superb portrait of Martínez, elegantly dressed in an appropriately French fashion. In his friend's house the disturbed painter went down into the valley of the shadow of death.

To this evidence of change and disorientation *before* the onset of illness must be added that of two of the last tapestry cartoons themselves. The King had decided that the themes should be 'rural and humorous': Goya's interpretation was idiosyncratic. He completed seven. Three were of children at play, one showed stilt-walkers in a *majo* context; the fifth was the beautiful and *bien-pensant* Maids at a Well. Two however were radically different in kind from either picturesque or paternalist populism. The Manikin, a straw man tossed by grinning girls, anticipates in some respects

34. The manikin, 1791–2

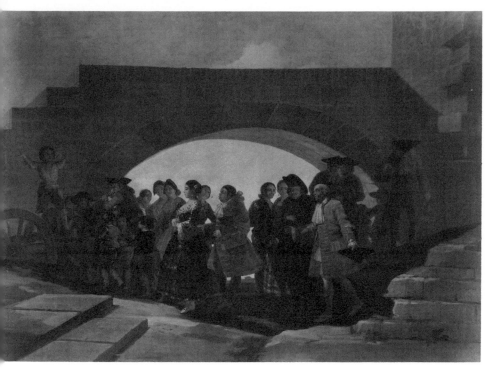

35. The wedding, 1791–2

the style of his post-1793 work and generates tension and unease, while the finely executed Wedding is sardonic [34, 35]. In it there appear the characters who loom so large in the *Caprichos*: the beautiful bride, the gross and repulsive husband, the smugly smirking and conniving priest and the hypocrite father. The humour is urban and black; in both one already senses the preoccupation with woman as the vehicle of corruption which runs through the graphic satire which occupied Goya's mind two years later. Here, already, before succumbing to his illness, the painter is entering the world of the *Caprichos* – and if the Drunken Mason in truth belongs to 1791, the impression is strengthened.

This important change in Goya's public attitude to the popular brings into sharper focus his relations with the radical *ilustrados*, whose response to the *pueblo* was necessarily ambivalent. Most of our evidence comes from the years immediately following Goya's illness. Then there is no doubt. The *ilustrados* people his portraits; Moratín and Meléndez Valdés are his close friends and his allies. His paintings reflect the latter's work on lunatic asylums, the preoccupation with witchcraft which affected them all in confrontation with

75

a resurgent Inquisition. The ideology of the *Caprichos* is that of Jovellanos. The first foreigner Goya paints is the envoy of the regicide French republic. When the break comes in 1808 many of his friends rally to Bonaparte; in 1814 they join the exile exodus. Goya's private drawings after Ferdinand's restoration are explicitly, indeed harshly, *liberal*; their anti-clericalism is ferocious. The painter's intellectual conversion to a radical Enlightenment proved permanent.

One strongly suspects that it was his very ambition, his egocentricity, which took him into their ranks. In the last years of Charles III's reign the drive for enlightened reform reached its climax; a lively and, in Spanish terms, relatively uninhibited Madrid press, led by the *Censor*, lived a time of hope, joyously pressing home the attack on the irrational, the archaic, the 'barbarous' in Spanish life, bringing the light of Europe to play on the hunched habit of that Black Spain so visibly in retreat. They had some warrant in the more prudent and bureaucratic Enlightenment which had captured the court and the administration, with men like Cabarrús and the more ambiguous Aranda perhaps providing the connection. The discourse, the manners, the attitudes of Enlightenment drenched many establishment houses even as others clutched at *costumbrismo,* at the *majismo* of the plebs in an assertion of Spanish identity against the incoming French tide.

Goya's success carried him in the first instance into the orbit of the Osuna household. Here presided La Peñafiel, the Countess-Duchess of Benavente, the most remarkable and original woman of her day. Neither beautiful nor eccentric like her rival the Duchess of Alba, she was highly intelligent, a wit, and elegant in an entirely French style, which Goya caught in his splendid portrait of 1785. A friend and patron of actors, artists and bullfighters, she never succumbed to *majismo,* but served as president of the women's section of the Royal Economic Society of Madrid. Her husband was *improver* enough to gladden even an English heart and he sent promising men into France on scholarships. This household and its patronage was central to Goya's establishment.[8]

Into the more effervescent world of extramural *luces* he soon made his entry but at every important point his initiation was associated with prestige, respectability, success. It was Ceán Bermúdez who got him the commissions (and the shares) from the Bank of San Carlos, where he painted Cabarrús. Above all there was Jovellanos himself, established at court in 1778, preparing his reports on the theatre and on

Spanish agriculture, working from the centre to purge and revivify the 'corrupted' national spirit. Jovellanos joined the Academy a month after Goya; his Eulogy of the Arts, with its homage to Velázquez, singled out the aspiring painter. At every stage Jovellanos was helpful and interested; he placed Goya in the Salamanca University commission, bought his prints, sponsored and nurtured him. Goya's admiration was as warm and as generous as his portrait.

It was from Jovellanos without doubt that Goya derived an intellectual perspective on Spain. That perspective however was not achieved without travail and contradiction. Edith Helman pointed to one example which may be developed.[9] In 1780 Goya painted a cartoon of the Tobacco Guards or excisemen which focused on a strutting central character in full brag who might have stepped straight off the boards of one of the popular comedies. In fact the cartoon is almost certainly grounded in one of the most popular *tonadillas* of the day, the *Tonadilla del Guapo* which celebrated the Andalusian exploits of Francisco Esteban *el Guapo,* a famous tobacco and salt smuggler who made a farce of authority. Smuggling has never been counted a crime by anybody except governments, and the piece, set squarely in the universal Robin Hood idiom, fitted well into a long and extra-legal Spanish popular tradition. Jovellanos, when he saw it, was affronted, as affronted as the magisterial Floridablanca, by its vulgarity and its flouting of the law. His disgust parallels that of Meléndez Valdés at much of the popular culture of the day. The *ilustrados'* enmity towards the Inquisition rested as much on shame at the degradation of the Spanish people who accepted it – those huddled depersonalized crowds in Goya's *Capricho* engravings – as on revulsion from its principles of action. These enlightened Spaniards, who drew their enlightenment from France and, to a degree, from England, were confronted by a sheer weight of native tradition which seemed weightiest of all among the very *pueblo* they wished to serve. Populist resistance to laws they too found unacceptable assumed forms which were equally unacceptable. This was a minor irritant. But it was a symptom of a deeper alienation, which in the end was to scatter them across the frontiers of treason and civil war.

No one would feel the tension more than Goya who had so much of the old Spanish Adam in him. Reminiscences of the Tobacco Guards cartoon flit through his 1790s drawings of smugglers, the 'rustic traders' of his Dream sequence, and the Boys on the Job *Capricho*: an entertainment edgily

converted into a charged and highly ambivalent moralism in the context of fierce social satire. The ambiguity, the paradox bit as deeply as his acid in more elemental matters. The sheer power of his graphic work derives from this very tension between intellectual conviction and a gut sensibility towards human realities, a dialectic which for the Spanish Enlightened was peculiarly searing.

What is certain is that before the French Revolution, adherence to the *ilustrados* implied for Goya a raising of his sights. He who so loved the bulls and the *tonadilleras* wrote to Zapater enclosing some popular music but pointing out that he rarely heard such stuff nowadays because he felt a man should cultivate a certain dignity.[10] How much greater then were the shocks of the 1790s on both sides of the Pyrenees which plunged the *ilustrados* into disillusion, cynicism and, for many, a despair which led them to Bonaparte? The first shocks were in some ways the worst. The official and respectable world suddenly jammed on the brakes and went into reverse. In 1790 Floridablanca banned the import of French writings; in 1791 he suspended almost the entire Spanish periodical press; in 1792 power passed to Godoy. To a stupefied public the 'unholy trinity' of queen, *cortejo* and complaisant king seemed an appalling reversion to the worst days of the Decadence. Only yesterday Goya had been the climbing, crowing Goya of the Zapater letters, the Goya of the English car and the Osuna household, the Goya of the delightful and elevating conversations with that Jovellanos now bundled ignominiously back to Asturias. To such a Goya the shock must have been peculiarly unhinging.

His response, as his work of the 1790s makes clear, was a strong, indeed passionate identification with the rationalist ideology of Enlightenment. But this commitment was now shot through with a sardonic alertness to chaos and the irrational. It could be morbid, even sadistic, particularly at the popular level. This was the tension which generated creative power. Its force derived without doubt from the change in his personality which the dreadful illness of 1792 effected. But the tension itself in its particular form was shaping earlier. It ran parallel to, was probably identified with, his increasingly intolerable frustration as a painter; these strains derived from basic drives in his character. They drove him into his inept, instinctive 'escape' from Madrid. They were surely a contributory factor to his total breakdown in Cadiz.

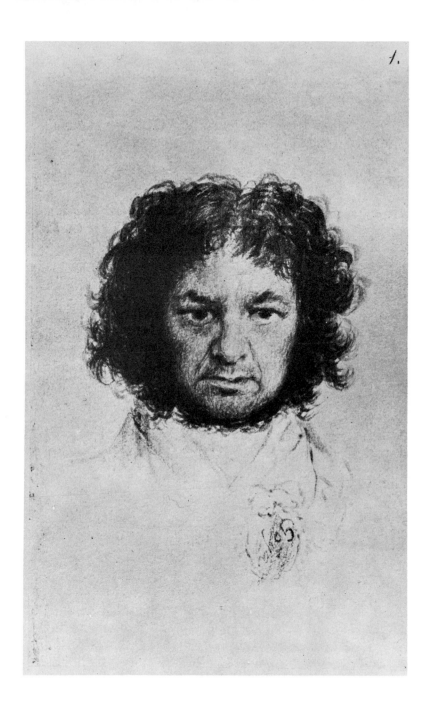

36. Goya, self-portrait, *c.*1795–7

What that illness was we have no means of knowing; long-range diagnoses are contradictory. Zapater's comment that the breakdown was brought on by Goya's own 'thoughtlessness' has been used by those who, inevitably, suggest syphilis (the more charitable make it 'hereditary'), but the painter's longevity and his survival of later disorders, one at the age of seventy-three, make this unlikely. We know that there were loud noises in his head, that he was for a while prostrate and paralyzed, for long unable to walk up and down stairs. There was 'turbación', disturbance which was mental in character, and he was left permanently deaf.

His self-portraits in the mid-1790s are ravaged and arresting. To his enforced isolation from the world (which, of course, can be and has been exaggerated) his compulsory 'detachment' and vulnerability to his own morbid fantasies many have attributed the searing and nightmare realism of his often horrifying drawings, the fleshy actuality of his monsters, the violence, tragedy, diabolism of much of his work. That the breakdown and the deafness immeasurably deepened and sharpened the new vision beating at his brain can scarcely be denied [36].

The new vision found first expression in a set of cabinet paintings which Goya, recuperating in Madrid in the last half of 1793, sent to Bernardo de Iriarte at the Academy. 'I have managed to make observations', he told Iriarte in a letter of 4 January 1794, 'for which there is normally no opportunity in commissioned works which give no scope for fantasy and invention.' They are now identified as fourteen small paintings on tinplate. Eight are bullfighting scenes and six of these can certainly be located in Seville; they seem to have been painted before his illness. The remainder were done after it; the Yard with Lunatics Goya was still finishing when he wrote.

The Yard is dramatic and terrifying; in a lurid atmosphere of sharply contrasting light and shadow, naked lunatics struggle while an overseer whips them; there is passion, tension, distorted face and limb, a sense of mindless anarchy [37]. Three others deal with disaster: a fire at night, a shipwreck [39], brigands attacking a coach; two could be called genre studies, a marionette seller and strolling players. Evidence accumulates that the scenes were memories of Aragon. And the style has abruptly become that of the Goya of later life; even the marionette seller calls to mind the Black Paintings. Line is renounced, so largely is depth; all is ambience formed in flashes of light and shade shrouded in mist. Intuitive skill and bold execution shape volume,

distance, light to a dramatic and expressionist purpose. Modelling is sometimes dense enough to be plastic. And in the subject matter, realism and deformation, violence, tragedy and unreason dominate.[11]

A group of eight small paintings which Goya kept in his house and which are difficult to date are now thought by

38. Shooting in a military camp, 1793–4? 1808–12?

José Gudiol to belong to the 1793–4 period. They certainly are similar in character; significantly they were called 'horrors of war' and critics have related them to the *Disasters* engravings. One, a scene of soldiers firing on women in an encampment, may well be [38], but in truth these studies occupy a dark hinterland common to both the *Disasters* and the *Caprichos*. Most of them belong in the same world as Iriarte's cabinet pictures. All have sharply focused spotlights against a dark and lurid background; four are interiors, prisons, plague hospital, cave; three are more violent bandit scenes, the shooting of prisoners, the stripping of a woman and the murder of one [40, 41]. It is possible that some horrifying scenes in very similar style of savages at murder and cannibalism belong in the same series.[12]

Goya's new vision was a dark one, a realism twisted by manic passions, ferocious struggles spotlit in a sombre world, an inhumanity which was all too human, an explosion of violence and unreason into the world of tapestry and portrait and enlightened discourse. One further ingredient finished the witches' brew his private painting had now become.

82

There is a touch of sadism in the woman central to his
Shipwreck; in the woman stripped and murdered by his
brigands, caught and raped in a hard sensual light, it is
naked [39, 40, 41]. And in the albums in which he found free
expression at Sanlúcar and Madrid in 1796 and 1797, his
drawings are drenched in eroticism.

39. The shipwreck, 1793–9

40. Brigand murdering a woman, 1793–4? 1808–12?

The eroticism stems from his celebrated association with the Duchess of Alba, which has become legendary. There is no evidence of any lasting association before 1795, when he painted a dazzling portrait of her in a white dress. At this time, recovering his strength if not his balance, he was turning out some of his most brilliant portraits, particularly of women. In May 1796 Goya left for Seville; he did not return to Madrid until March 1797. The Duke of Alba died in June 1796 and the summer Goya seems to have spent with the Duchess at the Alba residence in Sanlúcar de Barrameda; he may not have left before the following spring.

The experience was devastating. According to a French traveller, every hair of the Duchess's head excited desire. She was a passionate, wilful, demanding, often eccentric woman, ringed with actors and bullfighters and given to *maja* styles. Bold and independent, she was a social rival to both the Queen and the Duchess of Osuna, flamboyant in her tantrums as in her humour. In 1796 she was thirty-four and Goya at fifty was inflamed, succumbing to one of those 'violent and anguished passions of a man's fiftieth year, the overwhelming love which one imagines will be the last'. About his feelings there is little doubt. He gave her his most harrowing self-portrait [36] and in his house kept the magnificent portrait of her he painted under the Andalusian sun, in her black *maja* dress, wearing two rings inscribed *Alba* and *Goya* and pointing to her feet where are traced the words *Solo Goya* (later carefully overpainted by him) [42]. Whether she responded is uncertain. The motto was appropriately written in sand, for by 1797 Goya's passion had turned sour. Two of the nastiest drawings for the *Caprichos* were directed against her in a peculiarly personal manner, pillorying her for lies and inconstancy and caricaturing her as a witch with an escort of literally hagridden bullfighters [43]. The destructive disillusionment and jealous fury in which the affair ended probably informed much of the sexual satire which burns through the *Caprichos*.[13]

The *Caprichos* themselves seem to have grown directly out of the albums of drawings which Goya began to keep in Sanlúcar and continued in Madrid.[14] This was in fact his first known passionate spasm of drawing, which became the characteristic mode of his intimate self-expression. The delightful little Sanlúcar album is devoted wholly to girls. The Alba herself is recognizable at least five times, tearing her hair, nursing her adopted black girl Maria de la

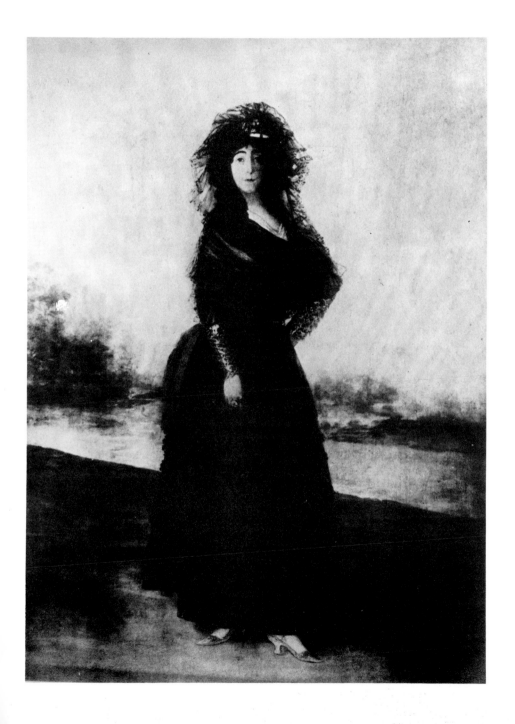

Luz, raising her hand and writing at her desk. The other
figures may or may not represent her. In an intimate *paseo*,
black-haired girls swirl and sway across the pages, caught by
deft and delicate touches of the painter's hand in an evenly
diffused light, a summer siesta of girls bathing nude, standing
nude (or to be just to Goya's style, naked), dancing, arranging
hair, weeping, fainting in an officer's arms, sprawling across
beds in poses which authors persist in calling 'ambiguous'
though there appears to be no ambiguity whatever.

43. Gone for good. *Caprichos*, 61, 1799

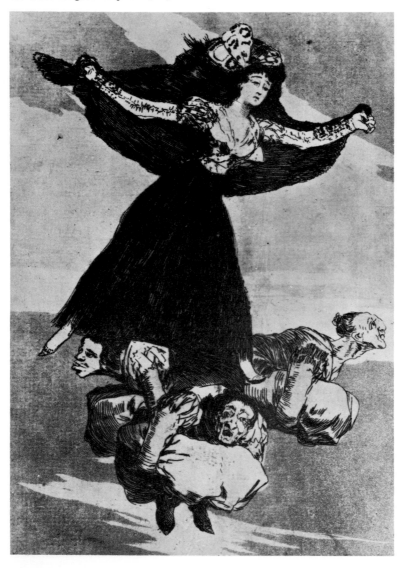

One of these drawings – of a girl pulling up her stocking –
became the preliminary sketch for a biting *Capricho*. For in the
Madrid album which ran into 1797, there is a change.
At first, the parade continues (some of the earlier drawings
may in fact have been done in Sanlúcar) but the album is
larger and more ambitious; drawings are numbered and
become compositions, the even light gives way to the dramatic
contrasts of spotlight and shadow he had used in the 1793–4
paintings. The girls acquire companions and the *paseo* is

44. Masquerades, Holy Week 1794,
drawing B80, 1796–7

45. They're sawing up an old woman (for Lent),
drawing, B60, 1796–7

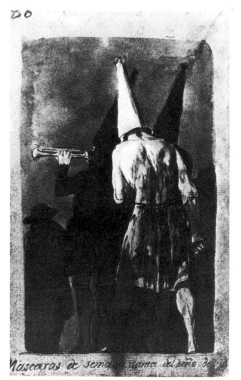

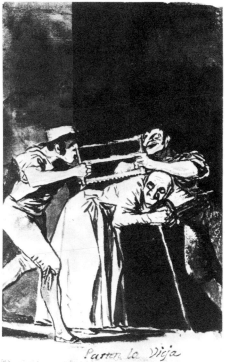

peopled with *majos, celestinas,* procuresses, the whole
panorama of Spanish sexual relations with which Goya had
become obsessed and in which he clearly saw an analogue to
the corruptions of Spanish society. Scenes become comments;
the future *Capricho* against the duel is foreshadowed.
And suddenly at No. 55 (of 74 drawings) captions appear in
full-dress *Capricho* style, sardonic counterpoint to the
drawings, deepening the ambiguity and sharpening the thrust.
At once, the witches enter; two men saw an old woman in

46. Good priest, where was it celebrated? drawing B86, 1796–7

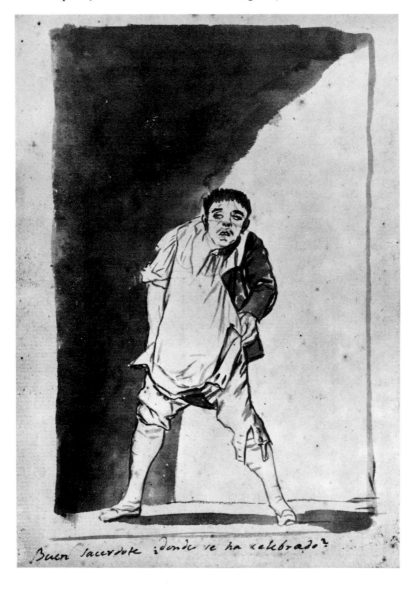

half for Lent [45]; the style becomes biting and effective caricature. The Tobacco Guards flicker in, transmuted into smugglers – *What good folk we moralists are!* The Church is lashed in a sickening portrayal of flagellants [44], in greedy, guzzling monks, in a young priest pulling up his breeches in priapic obscenity and greeted – *Good priest, where was it celebrated?* [46]. We are in the immediate hinterland of the *Caprichos* [47].

47. And his house is on fire. *Caprichos,* 18, 1799

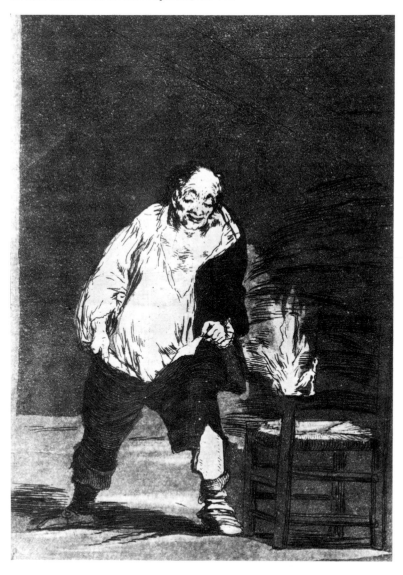

It was in 1797 that Goya was commissioned to paint six studies of witchcraft for the Osuna palace, black humour in his new style [48]. At the end of the century witchcraft was a fashionable topic; among the *ilustrados* it was something of an obsession, not least to Goya's friend Moratín, in whose mind it was linked directly to its other self, the Inquisition, and in whose hands the *Relación* of the *Logroño* auto da fe of 1610 was being shaped into a weapon of Reason. And it was Moratín who now, as the liberals seemed to be shuffling back into government favour, began to work closely with Goya to turn his private drawings into a public satire. Witchcraft gave them a thread around which to weave it.

And surely this reflects a deeper reality for Goya? The preparatory drawings for the *Caprichos* grew directly out of those inspired by the Alba affair; it was the exploration of Spanish sexual hypocrisies which was his point of entry into wider social satire. The Sanlúcar passion had hit him on the very morrow of his devastating illness and his convalescent groping after a new and darker perception in painting. His exorcism of this particular demon seems to have been a catalyst. It was the sorcery of women and the deception of sexual relations which at once symbolized and knit together the multiple hypocrisies and deceptions of a society which was aristocrat-ridden, priest-ridden, superstition-ridden; witchcraft was peculiarly apt. What could be more appropriate in a Spain ruled by Maria Luisa and her *cortejo* Godoy? In his *Caprichos*, Goya pilloried a society which was literally and metaphorically hag-ridden.

In this private exploration driving into public satire Goya seems to have achieved catharsis; in 1797 there is a sense of equilibrium in him, even if an equilibrium of tensions. In the following year, in complete freedom, in his new style and in a new populism, too, he painted the superb frescoes in San Antonio Florida, today his mausoleum. The self-portrait he prepared for the *Caprichos* displays his new vision of himself: stern, sardonic, top-hatted bourgeois profile, the austere observer of the dismal theatre of Spanish life [33].

The launching of his satire was a question of politics and political timing. During his illness and personal travail Spain had entered the war of 1793 as a crusade and had reeled out of it in disarray and disaffection. A momentary lull in 1795 preceded re-entry into war, this time as France's ally and shortly as her satellite. In 1797 came naval and economic disaster; Godoy went into temporary eclipse. At this point

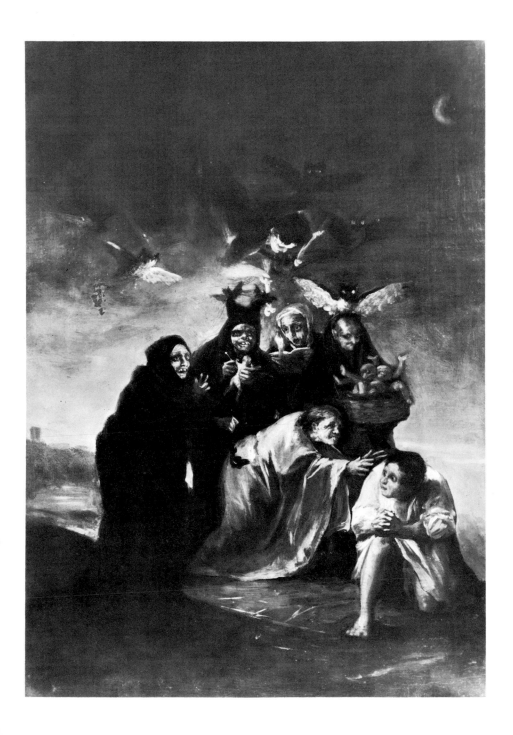

Goya, with Moratín's help, shaped a series of seventy-two satirical etchings for publication.

He called them a Universal Language; he adopted the dream device of Quevedo. He prepared some cautious disclaimers, sugared the pill with an opening flourish of some rather playful 'witches' before leading into the satirical sequences.[15] They were not published. In November 1797, with Godoy shadowy in the background, government passed to the *ilustrados*. Jovellanos himself became a key minister and set about his reform projects, with the Inquisition a central target. And at this point Goya's portraits become a political statement: over two years he made intimate studies of his liberal friends. They are all there, Jovellanos as minister, Urquijo, Iriarte, Moratín, Meléndez Valdés, Saavedra – and with them the French ambassador, appropriately, for so many of them were destined for Bonaparte.

But resistance thickened around Jovellanos. His friends feared poison attempts on his life. Political initiative shifted to his enemies. By the summer of 1798 he was broken; in August he was disgraced and exiled. Godoy returned to the forefront, to hold a momentary balance between reactionaries and the surviving liberals, which began to slip swiftly towards the former.

It was then that Goya, as a new cycle of disillusionment and tension opened, turned to re-work his engravings. He cut out attacks on the Alba and the Queen which seemed too personal, but toughened and sharpened the rest. The finished *Caprichos*, in February 1799, he threw into the arena. Within two days, as the liberal minister Saavedra was dismissed, they were suppressed.

With the *Caprichos* and the parallel achievements in his painting, the distinctive creative personality of Goya crystallizes. In a decisive, creative rupture, he achieves his historic identity. He still had thirty years of life and work ahead of him and creative crises in abundance. His work and experience over those thirty years, however, deepening and enriching though they were, represent in essence a *development* of that personality which took shape in the travail of the 1790s. This is particularly true of the *Disasters of War* and the great series of drawings and engravings. Poignant and transcendental though these are, they are recognizably further expressions of a perspective formed in the *Caprichos*. They are further instalments of caprichos. They make graphic a precisely similar dialectic of tensions.

94

'Genius', of course, defies historical analysis. But even 'genius' is located in time and place and works with its time and place. It is possible to disengage and delineate the components which Goya fused into creative achievement. They all derive directly from the character of the painter and the character of his Spain. Central to his character was a driving self-regard which led him into creative rebellion and into Enlightenment, which determined his reaction to public policy and private disaster. Without his commitment to Enlightenment, and to Enlightenment in its peculiarly Spanish form, his work would lose half its power. The major tension within him was precisely that between Reason and his painful, living consciousness of the darker forces of the human, not least at the roots of that Spanish *pueblo* from which he had come, so many of whose instincts he shared. Nowhere else did that conflict take the form it took in Spain; nowhere else did the corpses of so many dead generations weigh with quite so particular and peculiar a heaviness on the minds of the living.

The *Disasters of War* are what they are because they were created by a Spaniard at a particular moment, and a particularly tortured and self-tortured moment, in Spanish history. Goya's 'genius', it can be argued, would have found expression wherever he lived. This may be true but it is in fact beyond conception. The form of its expression, its very power, owe everything to the fact that Goya was a particular kind of Spaniard trying to live in a particular Spain.
If the historian pays proper regard to the frontiers of the possible and proper respect to the immunities of individual identity, the travail of Goya admits him to the travail of the Spanish people.

49. Allegory of the City of Madrid, 1809–10

5 Perspective on a Public Crisis

The travail of the Spanish people was unforgettably recorded in the *Disasters of War,* engravings which comment on the war of 1808–14, the famine of 1811–12 and the clerical reaction of the Restoration. When Goya finished the series, probably around 1820, he gave a set to his friend Ceán Bermúdez, in a finely bound volume. That volume bore, in gold, the title *Capricho.*[1]

As he was finishing these plates, he was also working on his celebrated *Disparates* engravings, left unfinished when he went into hiding and exile after the overthrow of the regime established by the Revolution of 1820. These baffling and often startling 'proverbs' re-work in dark and fantastic manner many of the themes of the original *Caprichos,* and of the drawings which fill his private life after 1800. On his recovery from a desperate illness late in 1819 (recorded in a striking portrait of himself near death in the arms of his doctor) he set to work to cover the walls of his newly acquired and isolated house, Quinta del Sordo (House of the Deaf Man), with the unnerving Black Paintings. All these works, running through the Restoration into the Revolution of 1820 and punctuated (as in his personal crisis of 1792–3) by severe illness, bear a strong family resemblance to each other. None of them were published in his lifetime. They represent a kind of climax to the long and rich series of private drawings, with their parallel uncommissioned paintings, in which Goya found full self-expression. In the engravings he surfaced, for after 1800 the real Goya goes underground, into his caprichos.

This dichotomy, implicit in the *Caprichos* of 1799, became explicit after 1800. Power at court was shared between the reactionary Caballero and the reformer Urquijo. The patronage of the latter secured Goya's appointment, in October 1799, as First Court Painter, with a salary of 50,000 *reales.* There were still to be moments of financial anxiety. Goya

received no salary under Joseph Bonaparte; at the end
of his life, alienated and in exile, the painter took infinite
pains to make sure of his pension from Ferdinand VII.
But, in effect, 1799 witnessed his achievement of financial
independence. In 1803 he bought a second and spacious
house which he gave to his son; inventories made at the
death of his wife in 1812 register him as a solid bourgeois,
comfortably placed, with a heavy investment in jewellery.[2]
Some of the engravings he made during the terrible Madrid
famine of 1811–12, with their acute awareness of the literally
lethal consequences of class differentiation, seem to reflect a
certain self-consciousness. From 1799, within limits, he
could choose.

By 1801 he had made his choice; royal and commissioned
work dwindles, the drive of his enterprise is into the private
and the graphic. Throughout 1800, he was busy about the royal
family. The preliminary studies for his appallingly candid
Family of Charles IV, with its echoes of Velázquez, earned
the complaisant commendation of that disconcerting clan.
He was fairly close to Godoy, whom Moratín counted a
friend, and who, safely ensconced in exile later in life, preened
himself on his 'enlightenment'. Goya painted the 'sausage-
maker' Prince of the Peace as a war hero; ran off several
commissions for his public persona and the celebrated *Majas,*
clothed and unclothed, for his private parts.

But in 1801, rather abruptly, his living connection with the
Court broke. The family of Charles IV may have liked their
portrait, but Goya painted no more for them. His services to
the successor, Ferdinand VII, were formal, official, rather
perfunctory and distinctly remote, as indeed they were to be
to the intruding French king Joseph and the intruding
English liberator, the Duke of Wellington. From this moment
to the end of his life Goya's official duties, unless susceptible
to free interpretation, seem to have been a formal chore.[3]

The moment for withdrawal was probably chosen for him.
At the end of 1800 the ultramontane offensive against the
'Jansenists' carried the court, which turned savagely on the
ilustrados. Urquijo was dismissed and jailed. Jovellanos was
plucked from Asturias and flung into prison in Majorca,
where he was to remain until 1808. Reaction triumphed, save
for one brief moment before the cataclysm when Godoy,
trying to wriggle free from the grip of Napoleon, flirted with
'liberalism' again. With his patrons in jail, the author of the
Caprichos needed to tread delicately. In 1802 the Duchess of
Alba died in suspicious circumstances and her characteristically

eccentric testament was challenged; possibly another argument for caution. It was in 1803 that Goya, to protect himself from the clericals and at Godoy's prompting, made over the plates of the *Caprichos* to the royal Calcografia in return for a pension to his son.

He withdrew, but not into silence. His portraiture, now that he could pick and choose, becomes an often breath-taking study of character. And his canvases are suddenly invaded by the middle class and even the *pueblo*. In 1805 his son married into the potent family of Giocoechea, a thrusting clan of merchants. Juan Martín Goicoechea, merchant of Saragossa, Goya's earliest patron, was virtually the epitome of that species which Spain so signally lacked – the enlightened, improving bourgeois. Javier Goya married the daughter of

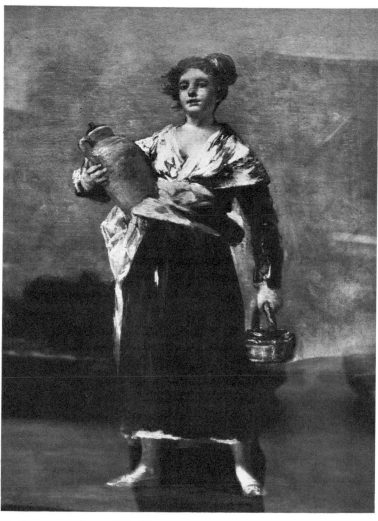

50. The water-seller, *c*.1808–12

Martín Miguel Goicoechea, and his wife Juana Galarza, from another dynasty of Saragossa merchants. At the wedding Goya met Leocadia Zorrilla, who was to marry a German merchant but was to comfort the painter's later years. Leocadia became notorious as a fierce and outspoken enemy of absolutism; her son was to serve in the radical militia after the Revolution of 1820. Martín Miguel Goicoechea ultimately went into exile as an *afrancesado*; Goya was buried beside him in Bordeaux. In 1805 Goya's son married into what would have been an elite of the Spanish Revolution, had it ever happened.[4]

And the good bourgeois of Madrid come under his brush, in the drawings, paintings and miniatures of the Goicoechea

51. The knife-grinder, *c*.1808–12

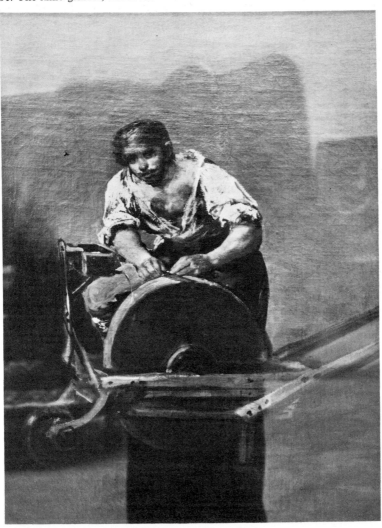

and Galarza families, in a strong series of portraits, The Bookseller's Wife and her kin. He turns to elaborate themes first sketched out in the *Caprichos* and the cabinet paintings of 1973–4; vivid, realist and genre paintings, the spotlit violence and drama of his bandit and cannibal sketches. In the Water-Carrier and the Knife-Grinder, painted sometime in these years before 1812, to be followed by the magnificent Forge, the worker takes his place as a person in art, in superb and monumental achievement [50, 51, 52]. In 1806–7 there were the six small panels, almost a strip cartoon, recording the popular story of Friar Pedro's capture of the bandit Maragato in a style the world was to learn only from the

52. The forge, *c.*1812–16

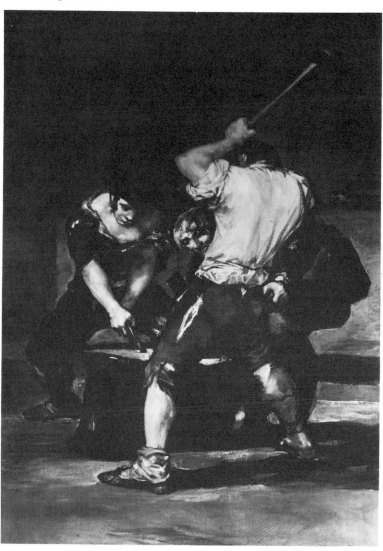

Disasters of War sixty years later [53]. In these compulsive works we enter a universe remote from the picturesque and paternalist 'populism' of the tapestry cartoons.

He turns above all, as in 1796, to his drawings. The first of the new albums began where the Madrid album stopped, using the same paper. It proved inadequate, so he started another, ruling black borders to make the drawings little paintings, carefully weaving the essential captions into the final product. On and on they run, from this point to the end of his life, marvellously executed and often brilliant drawings, in which he commented ceaselessly on life and found himself; Goya's permanent capricho. The world of the official and the commissioned painting he still inhabited and frequently graced with talent. But it was in his drawings that the essential Goya, the Goya of the *Caprichos* tension, realized himself. Out of those drawings grew his great paintings and engravings.

From this point on, Goya public and Goya private co-exist in a species of schizophrenia.

No less schizophrenic was the reaction of his friends, the *ilustrados*, when Napoleon in 1808 overthrew the Bourbons, set up his brother as king and ordered the 'enlightened' regeneration of Spain, to be confronted by an enraged Spanish populace ferociously at war for their Church and King. Through the fall of the *ancien régime*, the public Goya moved goat-foot and hooded-eyed like the instinctive *politique* he was; in his personal drawings the private Goya moved through war and restoration to the *Disasters* and the Black Paintings.

Goya public found an almost comic exemplar in his notorious Allegory of the City of Madrid [49]. In December 1809 the city council ordered a portrait of 'our present sovereign' – Joseph Bonaparte – and by February 1810 Goya had duly painted the king's head (from an engraving) into the medallion which is the focal point of the painting. In 1812 the French withdrew and Joseph was displaced by *Constitución*, in honour of the democratic constitution of the radical patriots of Cadiz. Within months the intruder King was back. Out went the Constitution and in went his face, only to be obliterated yet again in 1813 when the Constitution returned to its rightful place. In the following year, Ferdinand returned from France and abolished the Sacred Text at a stroke, to much popular acclamation. Goya had to dig out his six-year-old sketches of The Desired One. In 1823 after the revolution of 1820 had been crushed, Vicente López made a better portrait of the Bourbon, but twenty years later, during one

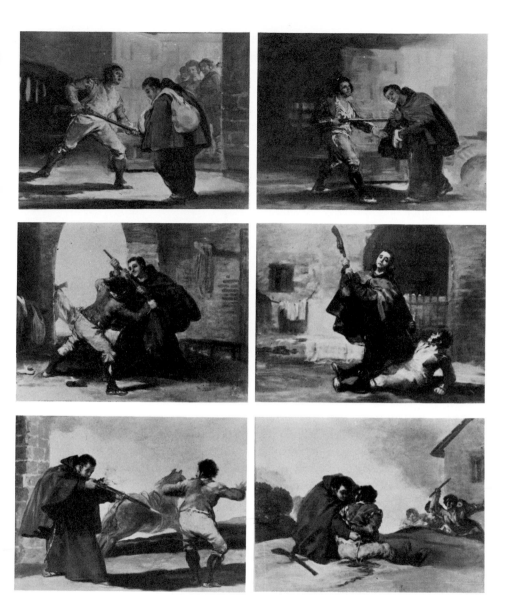

53. The capture of the bandit El Maragato by Friar Pedro de Zaldivia, 1806–7

of Spain's now customary civil wars, out it went again, to be replaced by *El libro de la constitución*. Finally after a futile attempt to recover Goya's original portrait of Joseph Bonaparte, the Madrileños, no doubt by this time desperate for a measure of patriotic permanence, settled on the *Dos de Mayo*.[5]

The Dos de Mayo, which became Spain's National Day, celebrated the rising of the plebeians of Madrid on 2 May 1808 against the French garrison. French troops had entered Spain for a campaign against Portugal. They were greeted with joy since it was widely assumed that they had come to overthrow Godoy. By this time dislike, indeed hatred, of the favourite had become universal: displaced aristocrats, frustrated reforming bureaucrats in the Charles III tradition, newer radical patriots hungering for a representative constitution, militant clericals angered by the increasing fiscal pressure on the Church, *ilustrados* and other respectable citizens despairing of their country, a conservative peasantry and a traditionalist urban artisanry ravaged by an economic crisis precipitated by war, inflation, the English destruction of the colonial trade, state bankruptcy and possibly the working-out of Caroline reform—all found a scapegoat in the 'sausage-maker' and the system of patronage he had created.

Ferdinand, Prince of Asturias, focused the discontent, and in 1807 the rivalry between him and Godoy broke into open conflict. Godoy's last desperate intrigues to escape from Napoleon's power were betrayed to the Emperor, and his attempt to remove Charles IV to Seville out of French control precipitated the Tumult of Aranjuez on 17 March 1808 when, at Ferdinand's prompting, a military coup supported by the Madrid plebs terrorized Charles IV into dismissing Godoy and, two days later, into his own abdication. Ironically Ferdinand VII and his father became the first official *afrancesados*, for both appealed to Napoleon.

The Emperor had lost patience with Spain. In April both were summoned to Bayonne and both were deposed. Ferdinand VII, The Desired One, passed to a comfortable and sycophantic exile as Joseph Bonaparte took the throne and proclaimed the regeneration of Spain in a constitution and a political regime which, no less ironically, embodied most of the measures for which the enlightened had long yearned—a modernized administration, the Code Napoleon, civil liberties, reconstructed and 'rational' provinces, the abolition of the Inquisition and aristocratic privilege, and the secularization of monasteries. 'I appeal to you to save our

country', wrote the *ilustrado* Azanza to the like-minded
Jovellanos, 'from the horrors which threaten it if you support
the mad idea of resisting the orders of the Emperor of the
French, which, in my opinion, are directed to the welfare of
Spain.' In vain: Jovellanos, released from prison, was to
serve on the Central Junta which tried to organize the popular
resistance.[6]

It was the 'lower classes' of Madrid, protesting against the
removal of the royal family on 2 May, who gave the signal
for insurrection. At the height of the struggle in Madrid,
members of the governing Junta, in full regalia, rode around
the city, trying to restore order. They cooperated with the
French general Murat in the pacification. Government refused
to acknowledge Ferdinand's abdication without consulting
'the nation' but it refused to recognize 'the nation' in the 'low
people' of Madrid. Ferdinand's last word had been an
instruction to obey French orders. Joseph's first ministry and
household were staffed by familiar figures; his constitution
was signed in July by ninety-one Spaniards of the highest
distinction. At this critical moment official, establishment
Spain stammered.

The rising was a rising of 'the people' with students and
clergy active in the leadership. The French saw the entire
movement as one of the 'black' *canaille* led by bigoted fanatics.
This is far too simple. As in all traditionalist Church-and-
King popular movements, the rising was ambivalent.
In a similar anti-French revolt in Naples the popular rebels
defined a Jacobin as 'a man in a carriage' and in some parts
of Spain the rising of 1808 took on the character of a
jacquerie, had the makings of a Spanish 1789. The Godoy
establishment was attacked, and if traditional authorities
hesitated to join the struggle, they were attacked too.
The Captain General of Castile decided to join the war only
after his colleague in Badajoz had been killed and students
had erected a gallows in his courtyard. When the ragged
popular army of Valencia came storming into Madrid with
holy relics in their caps, the respectable classes were frightened
out of their wits.

The national revolt began in mountainous Asturias in the
north, where crowds of peasants and students forced authority
to declare war on the French.[7] Traditional notables quickly
took control of the movement and canalized its revolutionary
potential, but Goya's friend Meléndez Valdés was saved from
death at the hands of a crowd only by the intervention of
priests with the exposed Host. Similarly a revolt in Galicia

led by a saddler threatened to get out of hand until 'untainted' notables took control. Generally speaking, the risings in the north rapidly took on a 'unanimous' character, but later conflict between the revolutionary juntas, the older authorities and the militant people in some places killed patriotic zeal. In Bilbao a popular and patriotic rising was bloodily suppressed by Spanish authority. As the rising moved south, generally triggered by an official refusal to commemorate St Ferdinand's day, social conflict became more severe, particularly in the richer and more populous maritime provinces, Seville, the Andalusian cities, Valencia, Catalonia. Valencia was the authentic French nightmare: massacres by crowds led by Franciscans and Jesuits, artisans sitting beside nobles in the Juntas. In Cadiz only the Capuchins could control the people. But this 'black' populism masked a real threat to traditional order. There was a vague but widespread yearning for a patriotic 'regeneration', an unformed radicalism, behind the violent Catholicism and the cult of Ferdinand. In Catalonia the popular militia waged a social as well as a national war and officers sent in to control them played the role of revolutionary and Caesarist tribunes.

Replies to the revolutionary authorities in 1809 reveal a widespread desire for 'a constitution' and an end to privilege. The revolutionary movement splintered in conflict between juntas, Central Junta, generals and popular militants. General Romana suppressed the juntas in Asturias and Galicia, and all the fight went out of them. Andalusia and Valencia were convulsed by faction. Seville nearly went to war with Granada. When the French swept through the area in 1810 they were greeted as liberators. The intelligentsia of Seville went over to the *afrancesados* en bloc; guerrilla activity was restricted to bandit areas like Ronda and a proletarian-smuggler fringe of the latifundia. The conflict in Valencia was diverted; the city remained quiet under the French, the only successful guerrilla was led by a monk, and popular action revived only to support the restored Ferdinand VII against the liberals.

The radical capture of the Cortes in Cadiz and the proclamation of the democratic Constitution of 1812 added a further contradiction. To many peasant communities and many client urban proletariats, liberalism meant economic death, and its natural enemy was a militant, conservative and political Catholicism. Nationalism, to a degree created in the struggle and focused on the guerrilla tradition, opposed a Catholic and conservative Spain to the 'atheist' and 'liberal'

French and *afrancesados,* to whom patriot radicals were rapidly assimilated. On the other hand, the new nationalism focused on the guerrilla precisely because official, traditional Spain had collapsed so ignominiously. The guerrilla experience itself, particularly during the harsh years of famine, terror and counter-terror, tended to cut guerrilleros from their roots, in a sense to 'professionalize' them; there was a visible process of radicalization. Major legacies of the war were the 'Caesarist liberalism' of officers bred in the guerrilla tradition, the spread of Freemasonry, the beginnings of radicalization among the urban plebs and some rural provinces of high social tension. In 1808 the *pueblo* in arms turned instinctively from discredited authority to the friars and monks, but an underground tradition of radicalism generated during the war survived the Restoration to explode into *sans-culotte* militias and clubs after 1820. The guerrilla tradition was shared by extremists of left and right. Many a guerrilla leader was like *El Pastor* of the Basque lands, a militant, bloodthirsty and 'black' cleric; but many were not. The crowds might follow the Capuchins in 1808; within a generation some of them were burning churches. It is precisely the contradiction, the dichotomy, the dialectic which Goya caught in his twin engravings of the *burro-pueblo* in the *ilustrado Caprichos* [8,9].

The guerrilla, of course, was a response to the collapse of official Spain. In 1808, Spain, the land of the *patria chica,* shivered into fragments. Juntas acted like sovereign powers. The mayor of the village of Móstoles formally declared war on Napoleon Bonaparte. The national resistance was a chaos of juntas, generals, militias. It was saved by the defensive heroism of the people, immortalized in the siege of Goya's Saragossa under Palafox, where the citizens fought to the death and women like Agustina of Aragon manned guns amid a heap of corpses. The lucky victory of Bailén forced a French withdrawal behind the Ebro. The Central Junta, joined by Floridablanca and Jovellanos, could not resolve the conflict between traditionalists and the preachers of national sovereignty, could not control the generals, could not surmount tradition or circumstance. The generalship of the Spanish army was inept to the point of lunacy. In 1809 the French came back and the Spanish army was shattered. In 1810 the French swept the south, and independent Spain shrank to the city of Cadiz, where a conservative Regency, caught between the French, the traditional Councils and the urban democracy of a mercantile city and its Americans, called a Cortes to mobilize a nation largely under French control.

The struggle fell to the guerrilla. At first whole communities
took arms against the French – 'They have behaved worse
than a horde of Hottentots. They have profaned our temples,
insulted our religion and raped our women.' Bloody lessons
taught them to act in partisan bands. In the early days men
(and women) simply sought to recreate an army; the debris
of the official armies was constantly forming and reforming.
They learned the lessons of guerrilla war the hard way.
The guerrilla was shaped not only by the exigencies of
conflict but by topography and social formation. Navarre was
one classic *foco*: a stable peasant community built around the
ten-acre family holding, mountain communities, the only
serious tension that between country and town. The guerrilla
here was almost a function of community, staffed by younger
sons, with women and priests acting as couriers. The Minas,
'kings of Navarre', enjoyed total security in their home
province; when they ventured into Aragon, they were
betrayed. In the end Espoz-y-Mina could lead out a small
army of 8,000 men against the French.

Elsewhere, apart from a few officers and clerics, guerrilla
leaders tended to emerge from those sub-cultures already in
conflict with authority. Along the French road to Burgos
through mountainous and wooded country, with its rich
booty, smugglers took the lead, reinforced by the odd officer,
monk, artisan. There was a similar smuggler concentration to
the north-west of the central Meseta near Portugal. Ronda was
a bandit and smuggler community in arms, and elsewhere in
Andalusia bandits changed sides with a bewildering rapidity.
On the central plateau, classic fish-in-water guerrillas
materialized, peasants by day melting into small bands of
partisans by night. The leaders tended to be drawn from local
worthies – village doctors were active around Toledo and
Cuenca – or from the mobile, semi-independent fringes of
peasant society – horse-dealers, charcoal burners.
El Empecinado himself, most famous of the guerrillas, a
brilliant technician of irregular warfare, was among other
things a charcoal burner, a trade with a tough reputation.

The struggle developed in its own remorseless logic.
By 1811 the bands, which may have numbered 30,000 in all,
were harassing the French into madness, serving as
indispensable auxiliary to the field army of the Duke of
Wellington. Counter-action was swift and merciless. Wholesale
reprisal decimated local populations. During 1811, as Cadiz
tried to send out officers to control and direct guerrilla
operations and showered commissions on bandit chiefs, the

French developed serious and effective counter-insurgency tactics. Aragon was quartered with forts and protected roads; an urban militia was organized to beat off raids, as famine stalked the land and gripped Madrid itself. El Empecinado's right hand man El Manco (the one-armed) was bought off to form an anti-guerrilla guerrilla, the contra-Empecinado.

The process was repeated elsewhere and achieved a measure of success. With guerrillas and the local population competing for scarce supplies, with the peasantry caught in the terrible vice of guerrilla terror and French counter-terror, the survival of the guerrillas depended on a very fine balance of emotions. Numbers of the bands managed to survive, to embody the new myth of Spanish nationalism, to grow into small armies as Wellington's troops finally turned the tide, and to express in themselves the basic contradiction of the national struggle, the dialectic between a black populism and a social radicalization.

The contradiction reached breaking point in Cadiz. In this miniscule free Spain, the radicals, supported by the self-interested action of the deputies from that America which was now breaking away into independence, won control of the Cortes and forced through the democratic Constitution of 1812 which, while acknowledging the special position of the Church, in effect rehearsed the regenerative constitution of Joseph Bonaparte. Clericals and traditionalists, alarmed at the developing threat to Church power and property from legislation in the spirit of Jovellanos's *Informe*, organized resistance. *Liberales* (it was now that the word assumed its current meaning) confronted *serviles*, and when the French were driven from Spain in 1813 the struggle intensified.

When the French left, no fewer than 12,000 Spanish families left with them, drawn largely from the elite, the first of those exoduses of the intellectuals which were to characterize modern Spanish history. The motives of these *afrancesados* were mixed. In essence they shared the ideology of the patriot *liberales*, but there was perhaps a difference in temper. The *afrancesados* were more directly in the tradition of the bureaucratic enlightenment of Charles III; the *liberales'* commitment to popular sovereignty was alien to them. In Joseph's regime they saw the opportunity to carry reform through to its natural climax. Before the Russian campaign, in any event, who could hope to resist Napoleon? Their efforts, like those of Joseph, were sincere; it was the devastating character of the war, the rule of generals, the guerrillas, terror, counter-terror, massacre, rape, famine which rendered

nugatory all their reforms. The tragedy of the *afrancesados* symbolizes the political schizophrenia which destroyed the Spanish enlightened. In 1814 the Spain of Ferdinand VII spewed them out.

For with the return of The Desired One in 1814 the *serviles* triumphed. In May Ferdinand annulled the Constitution and, with massive popular support, launched a witch-hunt against *afrancesados* and patriot liberals alike. Crowds baying through Madrid smashed the stone of the Constitution. Their alleged motto 'Long live our chains !' may be a myth, but to dismayed liberals it expressed their spirit. Liberals were hunted down, jailed, killed, driven into exile. The Inquisition was restored, the Jesuits returned. A stifling conformism settled over public life. Many of the *serviles* had hoped for a 'constitution' of some more traditional kind than that of 1812 ; Ferdinand seemed bent on ministerial depotism and the undoing not merely of the work of Josephine Madrid and Constitutional Cadiz but of that of Charles III as well; 'reform' had opened the gates to 'atheism'.

In fact Ferdinand himself was no fanatic, though his populist *camarilla* of advisers, through which he kept in touch with the Madrid plebs and underworld, often were. He was a survivor. Survival however proved difficult. The struggle to retain the American empire was failing, the country was bankrupt, ministers followed each other with bewildering rapidity. Survival demanded modernization, but modernization meant the *afrancesados* and the liberals; and how could they breathe in a society whose official ideology was the ferocious clerical reaction of the *apostólicos* and the Society of the Exterminating Angel ? Ferdinand was trapped, lurching from one expedient to the next as disaffected officers who found no place in the shrunken post-war army plunged into Masonic conspiracies and launched repeated *pronunciamentos* against the regime.

In 1819 a conspiracy against the regime by the respectable failed, but on New Year's Day 1820 Major Riego led a mutiny in an army about to be shipped to the American War, and proclaimed the Constitution of 1812. After an agonizing pause, with revolts in a few cities, army officers refused to move against him, and Ferdinand's autocracy collapsed. Amid wide-spread rejoicing, the king swore to the Constitution. *Trágala, perro* ('swallow it, dog', compare Goya's *Capricho* No. 58 [19]) sang the crowds in the streets. The *Hymn of Riego* was to become the anthem of liberalism and the Spanish Republic.

What happened pre-figured the pattern of most revolutions

in nineteenth-century Spain. With the Constitution, there was
an immediate lurch into liberalism, modernization, European-
ization in a society which lacked the social structure which
could sustain and develop a bourgeois polity. The first
leadership was moderate, anxious to revise the Constitution
in a conservative direction but driven by its own logic and
necessity to press home the attack on clerical property and
privilege. The Church and the militant *apostólicos* at once
moved into intransigent opposition, rallying the support of
threatened and conservative peasant communities. At the same
time the novel and militant radicalism of the urban
democracy, intensifying with every shuffle towards liberalism
and a capitalist economy, bubbled with impatience. The radical
populism of the *exaltados* mushroomed in the urban militia,
political clubs and journals, a virulent anti-clericalism.
Caught between these polarities, wrestling with the hostile
and cunning king, holding aloof from the 'traitor' *afrancesados*
who repaid them with a withering and demoralizing fire of
criticism, moderate liberals stumbled into conservatism and
were confronted by an insurrectionary explosion of the
exaltados; weathering a royalist coup, they lost power in 1822
to an *exaltado* ministry. At once the *apostólicos* and their
peasantry took to the hills, in the guerrilla of the royalist
Volunteers. The *exaltados* countered with a Jacobin terror.
The European powers, alarmed at the revolutionary example
of the Spanish Constitution, which had become a palladium
to Latin liberals, authorized France to intervene. The Hundred
Thousand Sons of St Louis marched to restore legitimacy;
the Spanish army was paralyzed and the constitutional regime
collapsed.

The restoration of 1823–4 witnessed a bloody and ferocious
White Terror, a murderous hunt after liberals and *exaltados*
alike. There was another wave of refugees. The repression
was savage but short. Ferdinand, with America now hopelessly
lost and the country trapped in bankruptcy, shifted away
from the partisan fury of the *apostólicos,* who turned instead
to his brother Don Carlos. The king in the last years of his
reign groped after a measure of consensus, took up again the
measured 'enlightenment' of the Caroline tradition, appointed
modernizers to ministries, opened the Prado, put out feelers
to the *afrancesados*. In a final complex spasm of intrigue and
conflict he tried to secure the succession for his daughter and
to keep out Don Carlos; the court opened to the liberals and
afrancesados, exiles returned, the *exaltados* stirred into life,
their enemies put on their canvas shoes and picked up their

rifles. Spain braced itself for another lurch towards the liberal and bourgeois society, another Riego cycle. In 1833, on Ferdinand's death, liberals came to power, Carlists rose in arms, the first churches burned.[8]

What this generation experienced was the political disintegration of the Hispanic world and a crisis of Spanish identity. The 'Two Spains', which so haunt Spaniards writing their history, emerge from the fragmentation of the Caroline enlightenment in the crisis of the French Revolution.

When the First Carlist War broke out, Goya had been dead for five years. He finally broke with Spain during the White Terror of 1823–4 and joined the *afrancesados* in exile. The 'Two Spains', yoked together not least within his own mind, are prefigured in his *Caprichos* of 1799. They find reflection in the dualism of the public and private Goya which persisted through the crisis.[9]

After the Tumult of Aranjuez, the First Court Painter was commissioned to paint Ferdinand VII. The king sat for him briefly twice before leaving for Bayonne; he never sat for Goya again. The 1808 sketches had to serve for all future portraits. Goya was in Madrid during the street fighting of 2–3 May. After the first French withdrawal he worked to complete an equestrian portrait of Ferdinand VII but was summoned by Palafox to record the heroic defence of Saragossa. Goya journeyed through war-torn Spain in the autumn of 1808, and this may well be the source of some of his earlier *Disasters* engravings and the paintings of guerrilla war scenes he made later [54]. When he returned to a Madrid re-occupied by the French, however, he took the oath to that Joseph Bonaparte who had abolished the Inquisition and closed two thirds of the convents.

During 1808–10 Goya painted a French general and many of the leading *afrancesados*. Among the latter were most of his friends. Moratín himself took office under Joseph, so did Meléndez Valdés, Urquijo, Bernardo de Iriarte and a host of others. He painted the Goicoechea family, who were *afrancesados* to a man; one of them wears Joseph's Royal Order – the 'aubergine'. He painted the celebrated Minister of the Interior, José Manuel Romero, and Llorente, the former secretary of the Inquisition who wrote a scathing liberal indictment of it; the Llorente painting is one of the most alive. In 1810 he executed the Allegory of the City of Madrid; he helped to choose the paintings removed to France. In 1811 Goya was awarded the Josephine Royal Order himself. He behaved, in short, like a complete *afrancesado*.

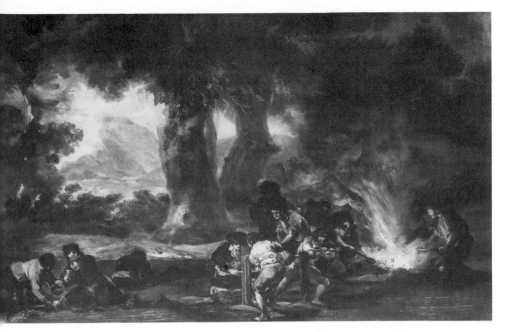

54. Making shot in the Sierra de Tardienta, c.1810–14

Evidence presented on his behalf after the restoration of Ferdinand VII stressed that he had held himself aloof from the Intruder, had selected poor paintings for the French, had never taken salary from Joseph and had never worn the 'aubergine'. It is perfectly true that it was during 1810, while he was painting the pro-French *ilustrados,* that he started private work on the engravings which became the *Disasters of War.* But poignant though they are as a commentary on war, these earlier plates are in no meaningful sense 'patriotic'. Those plates in which a certain patriotism is evident were made later, quite possibly after the final withdrawal of the French.

Clearly, he could hear news of the war easily enough – his house was so full of chairs that scholars have suggested that it might have been a centre for *tertulias* – but Goya was snug enough in the capital throughout the conflict, though he had to sell some of the jewellery. He had to endure the dreadful famine of 1811–12, which gives some of its most moving plates to the *Disasters* series, but could welcome the entry of Wellington in August 1812 – 'Long live Wellington and the peseta loaf' shouted the crowds – and celebrate it with a couple of portraits.

It was in 1812, however, that he experienced a personal crisis. In June his wife Josefa died and on 28 October the

113

family property was divided in rather a remarkable manner. Goya's son Javier, a colourless and mercenary man, already owned a house, but Goya made over to him his own house in the Calle de Valverde together with all his paintings and prints, his library of several hundred volumes, and some cash. Goya himself retained all the furniture, linen, silver, most of the 170,000 *reales* of jewellery and 126,000 *reales* in cash. Several of Goya's paintings bear an X with a number, and it has been suggested, plausibly, that these numbers were the inventory numbers which Javier (Xavier) wrote on paintings he left in his father's studio to secure his share of the division. This careful possessiveness in turn has been related to Leocadia Weiss.

Leocadia Zorrilla, one of the Goicoechea circle, had married a German merchant, but in 1811 the marriage began to break up. It seems to have broken down completely in 1812. Leocadia was to be Goya's inseparable companion in Spain and in exile during the Restoration. Her daughter Maria del Rosario was born in 1814 and Goya's devotion to the girl was paternal.

Evidence presented after the Restoration by the Postmaster General now makes it clear that Goya tried to run away from Madrid. At sixty-five and stone-deaf he was trying 'to make his way to a free country'. He got as far as Piedrahita on the way to Portugal, where he was stopped by the pleas of his children and a threat from the Minister of Police to confiscate the entire family property. This flight, remarkable in itself, cannot be dated, but the coincidence of the division of the property and the form it took, the break-up of the Weiss marriage, the jealous application of Javier's inventory numbering (alarm that Leocadia Weiss might collar the Goya property was expressed right up to the painter's death) might suggest that it was in the late autumn of 1812 that Goya made his break for freedom. Some scholars claim to detect signs of the Leocadia liaison in paintings of *majas* which Goya made some time around 1812. His painting of Wellington was on public display during September 1812 and the French returned to Madrid in November.[10]

Early in 1813 however they had gone for good and Goya could paint *Constitución* into his Allegory medallion. He submitted a request to the Council of Regency for financial aid to paint 'the most notable and heroic actions and scenes of our glorious insurrection against the tyrant of Europe' in February 1814. The plea of poverty rings rather false; it may well have been pardon he was after. He was given an

allowance, and on this he painted the magnificent Second and Third of May [3, 4].

About this time he was finishing the later war and famine plates of the *Disasters* engravings, and the great paintings grow out of the world of these private drawings. They were not well liked, however. Paintings of similar scenes by José Aparicio were rapturously received and were prominently displayed when the Prado museum opened. Goya's masterpieces were stuffed away into the Prado's reserves and did not figure in its catalogue until the 1870s.[11] The royal taste favoured such as Vicente López, but there was a more serious threat. In May 1814 the purges began.

Goya's circle of friends had already been devastated by the mass withdrawal of *afrancesados* in 1813; now there was another exodus. Moratín and Meléndez Valdés had gone; another friend, the actor Máiquez, was imprisoned and went mad. Goya's private drawings suddenly fill with chained prisoners, tortures, the viciousness of the Inquisition. A plan to group early and late plates on the war and the famine into a series of engravings for publication was abandoned. In May 1814 the painter had to subject himself to the process of 'purification', which dragged on for months. In November the Inquisition joined in and summoned him to explain the 'obscene paintings', the *Majas,* he had done for Godoy. Not until April 1815 was he cleared.

In 1815, marking his rehabilitation with his most powerful self-portrait [1], he painted many portraits and the striking Royal Company of the Philippines. The studies of Ferdinand VII were commissioned works and rather lifeless, but many of the others, on the black background which pre-figures the Black Paintings, are remarkable. At seventy Goya seemed to be brimming with life and vigour.

This production of 1815 however was the last burst of public painting. After 1815 he withdrew into his drawings and engravings. Early in 1819 he withdrew physically to the Quinta del Sordo, an isolated house outside Madrid. There at the end of the year illness nearly killed him, and throughout the tumult of the Riego revolution he seems to have been obsessed with his Black Paintings. With the final crushing of the Constitutionalists, however, the outside world could no longer be shut out.

On 7 November 1823 Riego was executed and six days later twenty-four young men dragged Ferdinand's chariot through Madrid to shouts of 'Death to the Nation!' Arrests, hangings, tortures multiplied, and in January 1824 military commissions

115

were set up to purge the country. Leocadia Weiss, an impetuous young woman, violent in her politics, was threatened; her eldest son Guillermo had served in the *exaltado* militia.[12] She seems to have gone into hiding before 1823 was out, leaving the little Rosario with the architect Tiburcio Pérez, whom Goya had painted. Goya, who had already made over his house to his grandson, went into hiding in January in the house of an Aragonese, José Duarto y Larte. On 1 May 1824 an amnesty was proclaimed and on the very next day Goya petitioned for leave of absence to 'take the mineral waters at Plombières'. Ferdinand VII expressed surprise but granted permission. Late in June Goya reached Bordeaux, to be joined by Leocadia and Maria del Rosario. Moratín was there, to greet 'the young traveller'.

55. The colossus, *c.*1808–12

6 Perspective on a Private Painter

The Goya who left for France in 1824, there to fill four more years with a creative intensity that defied his eighty years, left behind him the plates of his *Disasters* and *Disparates* and the Black Paintings. It was in these drawings and paintings made for himself, his caprichos, that he spoke freely. To anyone trying to locate Goya in the crisis of the Spanish nation, they pose very severe problems. They are very difficult to date and yet, at times, they clearly reflect a particular reality. What one can say is that the modes of his private creativity through these years can be traced back to his personal crisis of the 1790s but no further. The historical identity of Goya crystallized in that moment of 1792, in the cabinet paintings he sent to Iriarte in 1793–4, in the drawings at Sanlúcar and Madrid in 1796–7 which debouched into the *Caprichos*.

The great bulk of his personal work henceforth falls into the three broad categories established then –

Drawings considered as works of art in their own right, their captions an integral element of the enterprise, constituted into series in which the creator talks to himself and anybody who cares to eavesdrop, in a running and often sardonic commentary on the human.

An exploration of violence and unreason, dramatic in its experiments in technique.

An exploration of realism in genre paintings which, like the other two enterprises, take ordinary people as subject, develop character study in depth and ultimately approach the monumental.

His drawings run into the hundreds.[1] He began on them seriously at Sanlúcar in 1796; in the Madrid album of the following year, captions in his peculiar style find their anchorage. The drawings end for a while after the *Caprichos*; it was not until his 'withdrawal' from court in the face of clerical reaction after 1801 that he returned to the brush and wash.

The drawings before his departure for France have been grouped into four 'albums'. Album is a misnomer: there is no evidence that they were ever bound; but they certainly ran in the *series* to which he had become addicted. The most significant is the series labelled Album C, for this proves beyond cavil that in 1820 Goya was a committed, indeed passionate liberal and anti-clerical. There is no trace of Ortega y Gasset's 'coldness' here. So fierce are the drawings on prisoners and the Inquisition, so explosive the joy at the Revolution of Riego, so merciless the exultation at the unfrocking of monks during the secularization, that the inner Goya seems as much of an *exaltado* as his mistress's son.

The earliest series is Album D, a small group numbered up to 22. It uses the same paper as the Madrid album, the same upright format, the same technique. It is evidently a continuation of the *Caprichos,* in a light mocking style, figures disporting in an even light, nearly all women, witches floating in the air, drooling over babies, with sidelong comments on marriage. They seem to have been done around 1801–3.

He abandoned them for the series known as Album E. This was a very serious enterprise indeed. They were drawn on very fine-quality Dutch paper which must have been a luxury in Madrid at the time. Every drawing is carefully surrounded by a frame of a single or double ruled line, making it a 'picture' in its own right. Numbers and pencilled captions are inscribed outside the line. These are the largest drawings; the technique is handled with complete mastery and the scenes, very sparse in background, focus on figures drawn in robust realism. Every drawing expresses a particular idea, illustrated by the interplay between the often brilliantly executed figure and the caption; a moral commentary on men and women. The most finished of Goya's drawings, they resonate in the mind. Precisely because they deal with 'human' attitudes, they seem almost 'timeless'. One or two however can be related to a historical context. A cripple is shown with the caption, Hardships of the War; the series evidently straddled 1808. The style is that of the *Maragato* paintings and his proletarian pictures, done between 1806 and 1812 [50, 51, 52, 53]. One drawing on child education may reflect Godoy's founding of a Pestalozzi institute in Madrid in 1806.

There is only one, however, which carries a direct reference to current events. To despise insults (No. 16) shows a Spanish bourgeois snapping his fingers at two dwarfish characters in Napoleonic uniform. Not far from it at No. 19

is a very striking drawing: 'He doesn't know what he's doing'.
A man of the people on a ladder, eyes shut, points at the
statue whose classical head (generally a symbol for Truth or
Liberty in Goya) he has just severed with his pickaxe [56, 57].
This drawing, which Picasso directly imitated in his *Dream
of Franco*,[2] immediately conjures up a vision of the *servile*
crowd smashing the Stone of the Constitution in 1814, but
if it is in fact a reference to an actual event, it must surely be
a comment on the popular rising of 1808 itself. This would
not touch the message (the coupling with the bourgeois
contempt for the French calls to mind the *burro-pueblo*
coupling of the *Caprichos* and the *Populacho* coupling of the

56. To despise insults, drawing E16, n.d.

Disasters) but would reinforce an impression of Goya as *afrancesado*. Another drawing of victims has been related to his paintings of banditry and war. The fact that banditry and war are often indistinguishable in his work before 1812 is itself significant, for in Album E war and politics are not subjects in their own right. They are simply included in a series of comments on the human predicament. They furnish more raw material for a capricho. But in truth, for all their stark directness, the *Disasters of War* do precisely the same.

57. He doesn't know what he's doing, drawing E19, n.d.

If the series in Album E can be placed roughly between 1806 and the early days of the war, that in Album F is evidently much later. This seems more preparatory in character; there are no numbers. The style is more varied, much freer, more dramatic, the chiaroscuro effects are often striking. One of the drawings is clearly related to the painting The Forge, which was done some time after 1812 [52]; another is the first idea for a lithograph which was made in 1819 and the figure of Truth which appears in the late *Disasters of War* prints around 1820 also appears here. There are series on the duel and on Goya's favourite sport of hunting, but there is no coherent pattern, except for the recurrent and hostile drawings of monks, violence and official torture. The collection is Restoration in tone.

The most informative series is that in Album C, which is the largest and which some think spans twenty years. Numbers run to 133, and 124 drawings are known. Goya numbered them very carefully. Up to number 84 it is difficult to get any sense of coherence. The themes are deformity, women, love and marriage, violence and prisoners, and satire on the religious orders. There are themes reminiscent of the original *Caprichos,* but the treatment is more vivid, free. The grotesque – and many are grotesque – remains *human.* It has been suggested that the anti-clerical satires – O Holy Breeches is perhaps the most blistering – reflect the earlier secularization measures of Joseph Bonaparte, but they could equally reflect the Revolution of 1820. In fact the slightly manic distortion of realism in many of them, the distinctly idiosyncratic humour – A blind man in love with his hernia, Auntie Gila's poove – are strongly reminiscent of the *Disparates* and the Black Paintings. There is a series of nine representing comic visions seen in a dream in a single night. This is very much *Disparates* country. Most of them seem to be late.

All doubt vanishes with the mind-racking series which begins at No. 85, a remorseless, driving display of victims of the Inquisition. This is Goya's explosion of rage, his *J'accuse!* Seven of them parade in the conical hat, the *coroza,* and the *san benito* tunic of enforced penitence, hands bound and heads bowed. Their 'crimes' are listed, For this, for that . . . Por . . . Por . . . Por . . . For being a Jew, for speaking another language, for having been born elsewhere [58,59]. They run into harrowing scenes of torture and chained prisoners (parallel to his gripping engravings of prisoners of the same period) punctuated by cries of rage. Some of the historically

58. (Above left) For being a Jew, drawing C88, n.d.

59. (Above right) For having been born elsewhere, drawing C85, n.d.

60. (Below left) For being a liberal? drawing C98, n.d.

61. (Below right) You agree? drawing C97, n.d.

62. Many widows have wept like you, drawing C104, n.d.

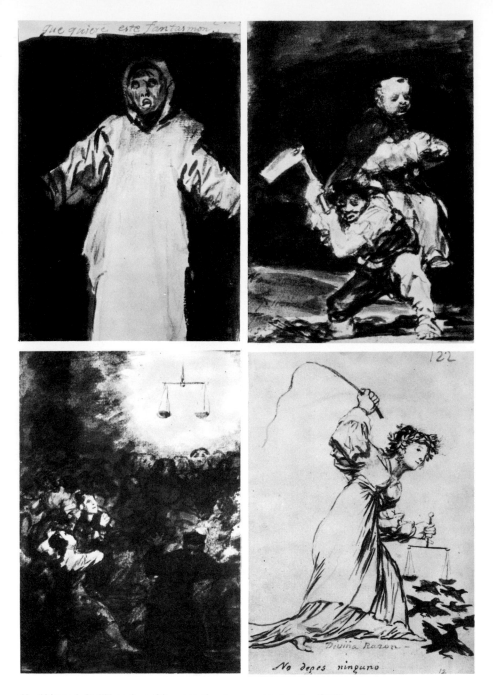

63. (Above left) What does this great phantom want? drawing C123, n.d.

64. (Above right) Will you never know what you're carrying on your back? drawing C120, n.d.

65. (Below left) The light of justice, drawing C118, n.d.

66. (Below right) Divine Reason, don't spare one of them, drawing C122, n.d.

celebrated victims are named – *Zapata, your glory will be eternal! Don't eat, great Torrigiano!* For discovering the movement of the earth (Galileo). But most are anonymous. For being a liberal? to one woman chained by the neck [60]. You agree? to a man under torture [61]. *Don't open your eyes . . . It's better to die . . .* and to a huddled woman with her child outside a building bearing the arms of the Holy Office – *Many widows have wept like you* [62]. It is a massive and crushing indictment which can stand comparison with any of the great angers recorded in literature and art.

Then without warning, at No. 111, a note of optimism creeps into the dungeons . . . *don't grieve, wake up, you'll soon be free* . . . and at No. 115, a blaze of light: a man, pen and ink and paper before him, kneels, face to the sun and arms outstretched in the pose that recurs constantly in Goya's secular and religious work at this time . . . *Divine Liberty!* [68] Truth blazes in justice through the next drawings [65], and from No. 119 we are into a series of scorching jeers as monks and nuns disrobe. *Will you never know what you're carrying on your back?* shouts Goya at a peasant hammering with a hoe, bent under the monk who squats on his shoulders (the *burro* again) [64]. A skeletal figure snarls out of his cowl – *What does this great phantom want?* [63]. And as the convents disgorge and their inmates strip, a fierce yet classical woman, scales of justice in her hand, whips mercilessly at a flock of black crows . . . *Divine Reason, don't spare one of them* [66].

There can be no mistake: it is the coming of Riego. This Restoration-Revolution of 1820 series leaves one breathless and *fixes* the Goya of 1814–23. If one looks more closely at this *oeuvre* of drawings, it seems to fall into two sectors. Albums D and E more clearly belong in the world of the *Caprichos,* are more detached (though not necessarily less committed) in their commentary and appear to be early, certainly pre-1812; they probably end in the early years, if not months of war. Albums C and F seem distinctly later. They are fiercer, freer, more direct, more grotesque and evidently rooted in the Restoration. There is something of a gap spanning the central years of the war. That the experience of war would have an effect, no one would deny. But the anger and exultation of the later drawings stem *not from the war but from the Restoration and the Revolution of 1820.* And it was in that state of anger that Goya completed the *Disasters of War* themselves.

The gap in his drawings was filled by his work on the first two of the three series of plates which made up the final

Disasters. We know that he began on the first series in 1810 and worked in some dedication. Faced with a shortage of materials, he broke up two of his older engravings to use the plates. This was when he was at his most *afrancesado,* painting the Josephines and receiving the Royal Order from Bonaparte. His commitment to the engravings was real, but it may well have been the commitment of an artist to a challenge to his craft.

Move now to his personal paintings. Two themes emerge from his *Caprichos* crisis of the 1790s – the exploration of violence and the realist exploration of the *pueblo*. The violence in his paintings has clouded analysis. It first appears in the bandits, shipwreck, madhouse of the cabinet paintings of 1793–4. A whole cluster of personal paintings chronicling violence, however, seem to run into the war years and, with the *Disasters* and the Second and Third of May paintings in mind, many critics have simply labelled these paintings 'horrors of war'. In fact, there is considerable doubt.

In the inventory of paintings in Goya's house in 1812, a dozen were listed as 'horrors of war'. The collection of eight paintings owned by the Marquess of Romana have been identified as some of them. In fact, these Romana paintings seem to bear precious little relationship to any war. Five of them are roughly 40 × 32 cm. Two of these, interiors, a monk visiting a woman and what looks like a prison, are in fact reminiscent of the *Caprichos*. The other three, with figures spotlit in general gloom, are of brigands shooting a prisoner, murdering a woman and stripping a woman [40, 41]. With their erotic overtones, they are very similar to the cabinet paintings of 1793–4. José Gudiol in fact now places them in the earlier period, while Jutta Held, on stylistic grounds, dated them around 1810. The other three, roughly 56 × 32 cm and lateral, are similar in style. One shows men shooting at fleeing women and is certainly reminiscent of the *Disasters* [38]. The other two are interiors, a cave and a building, with huddled figures and the common spotlight effect. One of them strongly resembles a late *Disasters* engraving of the famine, but if there was a model, it is this Romana painting which must have provided it, since it is certainly earlier than the *Disasters* plate. Despite the uncertainty of the shooting scene, the whole group seems stylistically similar to the 1793–4 paintings. Perhaps one can detect a development in technique. The emphasis is far more on 'bandits' than on 'war'. The fact that the later war prints resemble these earlier ones may carry its own significance. The cannibal and savages paintings

(which were once related quite without warrant to the martyrdom of French Jesuits in America) clearly belong in the same family.[3]

Another group of six paintings (one of which has disappeared) were numbered X9 in the 1812 inventory and were labelled 'horrors of war' by a visitor to the house of Goya's son. Again, the connection with war is dubious. There is a prison scene, a religious procession; the missing painting showed monks burning books. There is a group carrying a dead man, labelled by someone 'The hanged monk', and two scenes of rape. One of these shows no soldiers; it is more in the bandit mode. The other is labelled 'Women attacked by soldiers', but in truth it is very hard to tell whether the assailants are soldiers or not. It is certainly true that the style in which the figures are painted is strongly reminiscent of the *Disasters* and has been placed in 1810; on the other hand the pattern of light and dark is equally strongly reminiscent of the earlier 'bandit' series. The muscular realism of the modelling of the figures is that of the paintings of Friar Pedro capturing the bandit *Maragato* of 1806–7, which no less anticipates the manner of the *Disasters* [53]. Moreover the figure of the woman being carried off in 'Women attacked by soldiers', while anticipating a famine scene from the late series of *Disasters* plates, is also very reminiscent of one of the drawings Goya made, before 1808, after Flaxman's illustrations of Dante's *Divine Comedy*.[4]

It is possible to overemphasize the war as an agent of change in Goya's work. In truth he was painting and drawing 'disasters' long before war broke out. All these paintings of violence which are difficult to place belong to a dark hinterland common to both the *Disasters* and the *Caprichos*. They are *developments* of the perspective he achieved in the 1790s, working through the 'bandit' scenes and the *Maragato* paintings. The *Disasters* represent a logical extension of this exploration.

One painting done before 1812 which does register on the mind is the enigmatic Colossus [55]. A towering giant with clenched fist looms over a horizon and behind his back, in the foreground, men and beasts flee in wild disorder. Its symbolism has been discussed at length. It seems to symbolize war itself. With its thick slabs of paint floating on a background that is almost black, it anticipates the Black Paintings.

Certainly, the earlier plates in the *Disasters* series could be considered an expression of such an outlook. By and large they concentrate on victims. There is not a trace of

129

conventional patriotism in them. Moreover, at about the same time Goya executed a series of still-lifes of dead fish, birds, game, several of which bear a strong resemblance to the still-lifes of dead human bodies in the early *Disasters*.[5]
The impression is strong that in the earlier plates of the *Disasters* Goya was conducting an exercise, making another capricho. There is no evidence that he was a *witness* of his scenes; his uniforms are often indeterminate. On two prints and two prints only (and they relatively 'harmless' scenes of flight) does he write 'This I saw'. The war of course made more elemental and direct the kind of vision he had been cultivating since 1793; the pity and the horror are there. But in essence, he built on his exploration of violence and realism which had grown through the personal paintings from the 1790s and the *Maragato* series, built it up and incorporated it in a new capricho, much as he incorporated references to 1808 in his black-border drawings in Album E.

In the second series of *Disasters* plates there is some change. The famine is their major subject, but in the war plates there is a frenzy of stomach-churning atrocity, largely French, and an emphasis on Spanish initiative, particularly by ferocious and heroic women. A touch of populist patriotism enters. These were made through and after the famine of 1811–12, possibly at the time of the liberation of Madrid.

It is about this time that his association with Leocadia Weiss, who was to become such a fierce *exaltado*, probably began. In the same period his realist genre paintings reach something of a climax. He returned to some of the themes of the *Caprichos* and re-worked them in his new breadth and vigour. The result was the series Majas on a Balcony, Maja and Celestina, Time and the Old Women, and Young Women with a letter (in which Leocadia may figure) – some of his most effective work. More striking, he produced what was evidently meant to be a series of working men and women. Three survive, two done before 1812, one after it. These three, the Water-Carrier, the Knife-Grinder and the Forge, represent a moment in the history of modern European painting. Far more than in the paintings of the French Revolution, far more than in David's Maraichière, here the proletarian assumes full stature. And what a stature it is! In these paintings, three of Goya's masterpieces, he becomes monumental [50, 51, 52].

For whatever reason, the famine, Leocadia, his flight to Piedrahita, a new and different perception of the *pueblo* finds expression in Goya's work. It carries the work he had been

doing on violence, realism, capricho since the 1790s to a new
plane and informs the changed tone of his later war and
famine *Disasters* plates. This thrust of personal creativity ran
into confluence with his public performance as a *politique*.
For at this time, Madrid was liberated and the French
expelled. Goya had to re-establish himself. This, then, was
the root and source of his superb achievement in the Third
of May.

With this achievement, he thought of publishing a new set
of caprichos on the experiences of the war and began to group
the plates in series. The restoration of Ferdinand and the
victory of the *serviles* put a stop to that. Struggling out of the

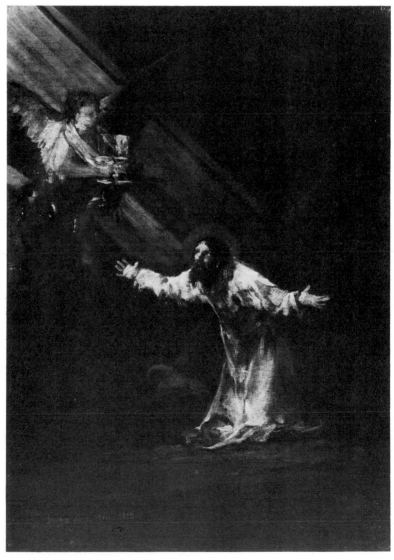

67. Christ on the Mount of Olives, 1819

purification process and producing his portraits during 1815, he abandoned the war series, bought a new set of large plates and engraved the *Tauromaquia*. Originally conceived as illustration to Moratín senior's history of bullfighting, the sequence became a work in its own right, clever and accomplished. It was published in 1816 but was not a success.[6]

So Goya withdrew into a private world. In 1819 he withdrew from Madrid itself, into the Quinta del Sordo. The only serious forays outside were to churches, on commission. And interestingly enough, it is at this point that his religious paintings acquire an intensity which is rare (it is not religious feeling that gives the San Antonio Florida frescoes their power). Visible in the *grisaille* he did for the royal palace in

1817, it is vivid in the Last Communion of St Joseph of
Calasanz of 1819, which he painted for the Escuelas Pías de
San Anton, the religious order which had taught him as a
child in Saragossa. Less finished but perhaps even more
moving was the Christ on the Mount of Olives which he gave
the teaching fathers as a gift: a haggard and human Christ, a
Disasters Christ, face upturned and arms outstretched, bent to
the light [67].

This figure, which recurs constantly in Goya's work in
these years from the Crucifixion motif in the Third of May
and some of the execution scenes of his war engravings, sets
the tone [68, 69]. It re-appears in the Gethsemane of the
prisoners in his drawings. For these are the years of the

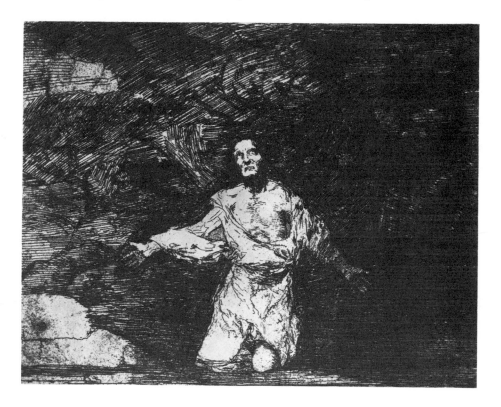

68. (Opposite) Divine Liberty, drawing C115, n.d.

69. (Above) Sad forebodings of what is to come. *Desastres*, 1, c.1820

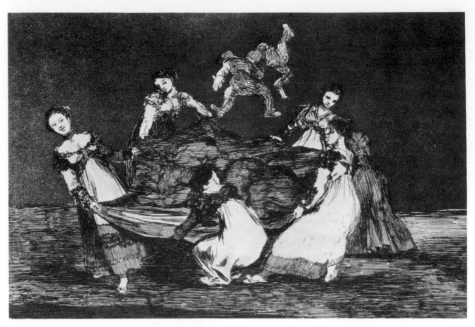

70. Feminine Folly. *Disparates* 1, *c.*1815–24

powerful drawings of Albums C and F; the crucifixion of
hope, the numbness of despair, the frustration of rage.
Through them runs a sense of betrayal grounded in a deepen-
ing, darkening, but still often wryly humorous familiarity
with men and women. To judge from the quality of much of
his work at this time, the humour, black though it often was,
was a barrier against madness.

In essence, Goya at this time returned to that dialectic of
reason and unreason which he had first explored in the
Caprichos of 1799, the tension which had destroyed his
friends the *ilustrados,* which the reign of Ferdinand made
poignant. By this time his comprehension of it had been
immeasurably enriched and it could not be kept locked within
himself. So, almost simultaneously, he launched on two major
enterprises in engraving, shortly to be followed by a third, in
painting.

He began a new series of engravings as a blistering
commentary on the Restoration of Ferdinand VII. Monsters
and witches in the style of the *Caprichos* point the satire.
And on the same set of plates as he had used for *Tauromaquia*
(the series in fact overlapped) he began on the *Disparates*.
The *Disparates* are perhaps the most impenetrable of his

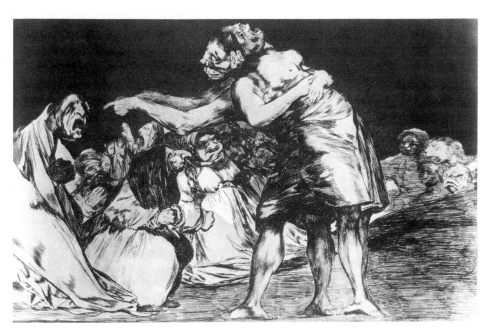

71. Disorderly Folly. *Disparates* 7, *c.*1815–24

works.[7] Goya seems to have cultivated a vision which is incommunicable. He worked hard on the preparatory drawings, often altered them considerably to clarify, or possibly to obscure the design. He wrote titles on the many proofs he made; these always included the word *Disparate,* folly or absurdity, but not used in any hectoring sense. When eighteen of the twenty-two known plates passed to the Academy along with the *Disasters* in 1863, the institution gave them the title *Proverbs.* Tomás Harris suggested suitable proverbs to fit them all, but few seem very convincing.[8]

Some of the earlier plates echo the *Tauromaquia* and the war drawings. In Fools' Folly, for example, the bulls of the *Tauromaquia* go flying through the air, and the soldiers frightened by a phantom recall the war. The latter, however, also recalls the *Caprichos.* In fact through these Follies flit memories and allusions to almost every stage of his career right back to the tapestry cartoons – the Manikin is tossed again in Feminine Folly but in curiously distorted form [70]. Disorderly Folly, in which a Siamese twin of a couple resembles one of the *Caprichos* on marriage, also confronts them with a misshapen and twisted crowd straight out of the Black Paintings [71].

135

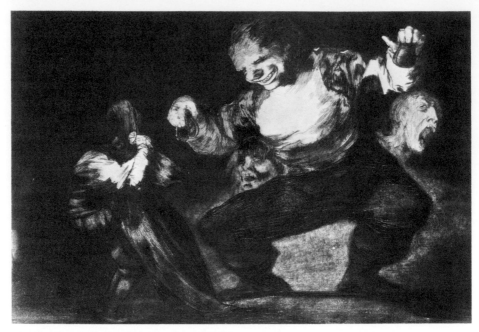

72. Simpleton's Folly. *Disparates* 4, *c*.1815–24

There are clearly elements of satire. A huge giant clicking
his castanets over two cowering figures originally clicked
them in the preliminary drawing over a priest half-embracing,
half-hiding behind a nun [72]. Animal Folly in which an
elephant confronts tiny figures trying to read the laws at him
has been construed as a political satire on the People and
Power.[9] But, in truth, they are difficult to decipher, possibly
because the series was never finished. They are crowded
with 'memories' and quotations of his earlier work, but what
loom largest of all are clearly the *Caprichos* of 1799. On the
large *Tauromaquia* plates the difference in scale is striking.
There is a feeling of limitless space, and with the reduction
in the number of figures the engravings become monumental.
But it is the *Caprichos* that the *Disparates* 'quote', though in a
style which, in parallel to the last plates of the *Disasters*,
anticipates the Black Paintings. It is the mood that matters;
and to the reader, the mood hovers uncertainly – and
characteristically – between terror and black comedy.

The Black Paintings themselves almost certainly followed
Goya's illness. For, as the middle-class conspiracy against
Ferdinand crumbled in 1819, Goya in his isolated house fell
seriously ill and came near to death. As he recovered in 1820,

he set about covering the walls of his house with paintings which are quite horrifying in their intensity and breathtaking in their genius. He painted in oils straight on to the plaster, filling up the space between doors and windows, sometimes six metres square, probably dashing them on to the walls in a burst of violent inspiration.

They are a nightmare. Hideous distorted faces and figures, the devil-goat, parodies of religious *romerias* and processions, remote, cold Fates and alein humans fill the picture. They are infinitely disturbing in a way one cannot quite understand. There is nothing quite like them. Endless attempts to 'explain' these paintings have run into endless failure. At the entrance to the ground floor of the house stood one painting distinct from the others: it is not horrifying. A young and graceful woman, in black, leans against what appears to be a tomb. Across the way from it are two skeletal portraits of old men. This confrontation of age and youth is certainly one element. One painting shows two young people laughing at an old man masturbating.

Pierre Gassier suggests one interpretation that seems plausible.[10] On his return to life from the brink of death, Goya painted a 'testament'. The young woman, the first painting to be seen on entering the room, is Leocadia, his 'widow'; beyond this real scene, the other paintings represent a horrific vision of a descent into hell. Next to Leocadia, a huge black goat, the Devil, confronts a hideous crowd of acolytes while an elegant young woman with a muff sits spectator in a chair (Leocadia again?). Opposite, a terrifying Saturn devours his sons, and Judith is at her slaughter. Many of the other paintings upstairs are distorted echoes from the past. The grotesque Pilgrimage of San Isidro parodies the tapestry cartoons [73]. In Asmodea the soldiers of the *Disasters* fire at demons; the Fates brood in a chill and ugly silence. Two men fight with clubs unaware that they are both sinking to their deaths in quicksand. In quicksand, too, sinks an utterly enigmatic dog, his pathetic and appealing head snouting upwards towards a damaged area where there was once, apparently, a huge demon head (*trágala, perro?*).

Whether they are a vision of death and hell or not, the paintings are terrifying, haunting and profoundly disturbing. They would surely suggest madness (they do to some) were it not for the fact that at the very time when he was hurling these paintings on his walls, Goya was drawing the joyful symbols of welcome to the Revolution of 1820 and crowing

over the discomfiture of the clericals. In France his work was
to be immensely sane, often happy and essentially peaceful.[11]

It is the *Disparates* and the Black Paintings which create
the climate in which Goya finished the *Disasters of War*.[12]
He engraved a series of plates in this climate, bunched them
at the end of his war and famine scenes, and consciously
inserted several of them into earlier sequences in what was
obviously a carefully constructed plan. It cannot be said that
he succeeded. To readers remote from Goya's time, the last
prints seem too distinct in style; attention rivets on the
'horrors of war', the enigmatic prints of the later period seem

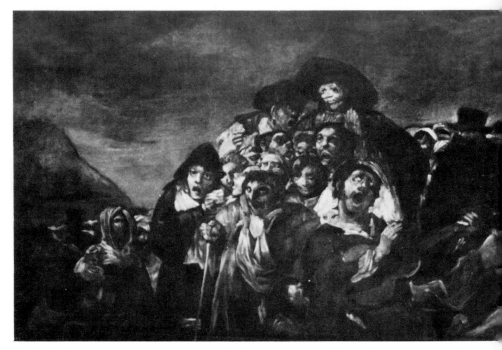

73. The romeria of San Isidro, *c.*1820–23 (black paintings)

an appendix, a matter for scholarly exegesis. This was certainly not what Goya intended. For what he intended to do was to carry the capricho begun in 1810 to its conclusion, to complete it. In a very real sense, the *Disparates* and even the Black Paintings are a fulfilment of the *Caprichos* of 1799. The last plates of the *Disasters* certainly are. The perspective in which Goya conceived his series *was the perspective not of the war but of the Restoration,* in which the dialectic of reason and unreason of the original *Caprichos* had become unbearable. It is this which gives their full, intolerable power to the *Disasters of War.*

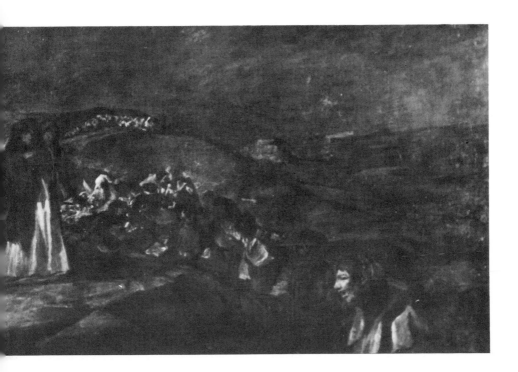

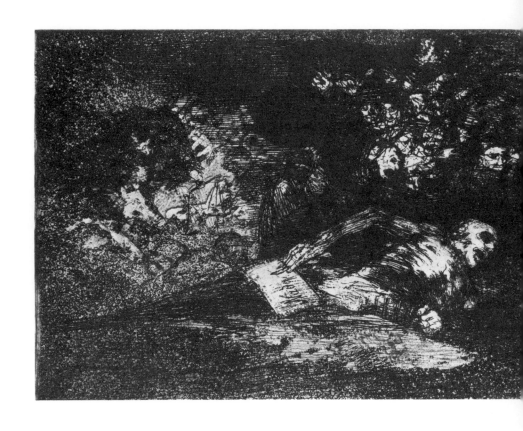

74. Nothing. That's what it says. *Desastres*, 69, *c*.1820
(The Academy altered the caption to: Nothing. Time will tell.)

7 The Disasters of War

The *Disasters* were first published in 1863 by the Academy of San Fernando, which invented the title. The eighty published prints, after the frontispiece – 'Sad forebodings of what is about to happen' [69] – fall broadly into three groups:

plates 2–47	'horrors of war'
plates 48–64	famine
plates 65–80	a radically different group, employing beasts and monsters in *Capricho* style to pillory the reactionary restoration of Ferdinand VII.

This was not the form Goya intended the series to take. His own vision he made explicit in the lavishly bound set he gave to his friend Ceán Bermúdez, labelled 'Capricho' in gold. This carried two further plates, 81 and 82, in the spirit of the third group of prints, and bound in with them three small but powerful engravings of chained prisoners, similar in character to many private drawings he made during the royalist repression. The album carried the inscription – 'Fatal consequences of the bloody war in Spain against Bonaparte and other striking caprichos (*caprichos enfaticos*) in 85 prints'.

The three prisoner prints are much smaller than the others, do not seem organically one with them, carry no numbers and were excluded from the edition published in 1863. That Goya specifically included them in a set of '85 prints', however, is surely significant.[1] Their inclusion perceptibly sharpens the perspective opened up by the third group which is precisely that of the Restoration, rather than that of the War itself.

A close examination of the engravings strengthens this impression. For while they cannot be assigned exact dates it is clear that they fall into three distinct sequences.[2]

The late *caprichos enfaticos* form a distinctive group, not only in subject and style, but in size and quality. They were

made on good plates of larger and uniform size, generally
17·5 × 21·5 cm. They are unique in that they do not carry
an earlier number which Goya carelessly scratched on the
others. Their size, uniformity, mature style and obvious
kinship with many drawings Goya made during the Restoration
indicate that they were made after, possibly quite some time
after, the War.

A second group is also uniform in plate size, generally
15·5 × 20·5 cm. Seventeen of these deal with famine, clearly
the terrible famine which ravaged Madrid between September
1811 and August 1812. The quality of the plates varied but
was generally superior to that of other war engravings.
The French were driven out of Madrid in August 1812,
returned in November and finally quit in March 1813.
In June 1812 Goya's wife died and in October the family
property was divided. It was probably around this time that
Goya tried to flee the country, possibly in association with
Leocadia Weiss.

Plates of this size carried eighteen engravings of 'horrors of
war' in addition to those of famine. Their style is distinctive,
bolder than that of other war drawings. Unlike many of the
others, they do not group small figures centre. Moreover,
while horrors are horrors, there seems to be a shift in
emphasis. In war prints *outside* the 15·5 × 20·5 cm group
there is only one which shows Spaniards in action against the
French. There are scenes of execution and rape, but there is
less overt stress on conscious human agency. The impression
is of mountains of corpses, flight, wrecked groups of wounded;
people are portrayed almost as victims of natural disaster.
Within the group of 15·5 × 20·5 cm plates there is a subtle
but visible change [75, 76, 77, 78]. Four of them depict
Spaniards attacking the French. They concentrate in particular
on women in battle. The portrait of Agustina of Aragon, the
Joan of Arc of the Saragossa siege, is the only genuinely
'heroic' print in the collection [77]. There are no fewer than
nine prints of executions, seven by the French which are
ghastly atrocities. Others show French soldiers attacking monks.

These are clearly contemporaneous with the famine prints.
In his first numbering Goya intermingled the two sequences.
They must be located at the earliest during or more probably
after the famine of 1812. The perceptible stress in the war
prints on Spanish courage and French atrocity may suggest
that they were made after the liberation of Madrid. Certainly
this group of famine and war prints form a group 'late' in
relation to the others.

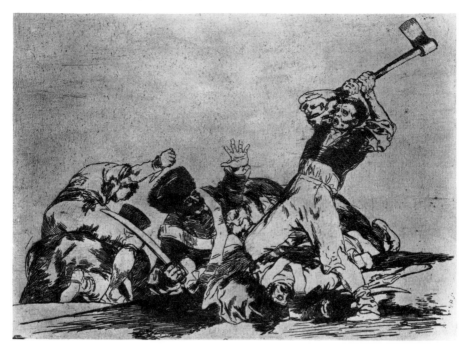

75. The same. *Desastres*, 3 (companion to no. 2: with reason or without, plate 5),
c.1820

76. And they are like wild beasts. *Desastres*, 5, *c*.1820

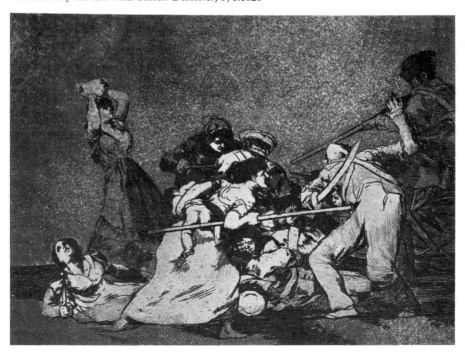

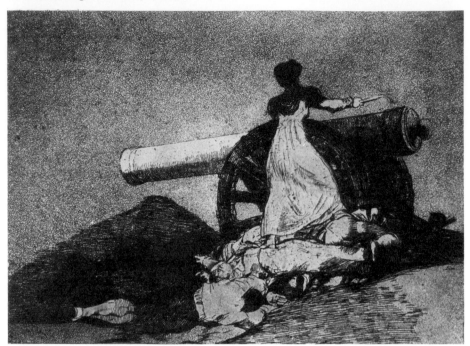

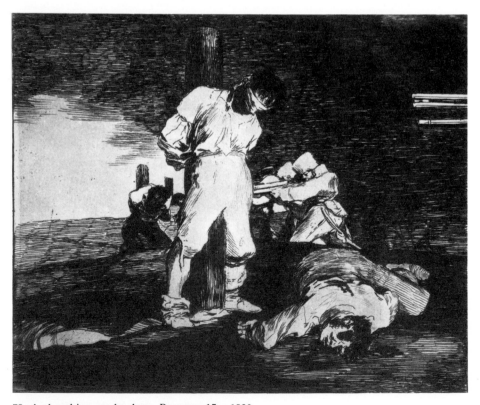

78. And nothing can be done. *Desastres*, 15, *c*.1820

The third group is heterogeneous. The plates vary considerably in size. Their quality and that of the materials used seems inferior. Goya was visibly struggling against wartime shortages and disruption. Indeed, he made four of the prints by taking two plates already engraved with landscapes and splitting them roughly in half. Moreover in this group are the only engravings which are dated; three of them carry the date 1810. These are generally assumed to be the earliest.

In 1810, the year he painted the French and the *afrancesados,* Goya began to engrave the 'fatal consequences', working as best he could with whatever materials he could lay his hands on. Some time after the famine of 1812 he engraved on a more uniform set of plates scenes of war and famine of a different kind in a different style. Some time after the war ended he engraved the *enfaticos* and the prisoners. From these he built the series he gave to Ceán Bermúdez.

It is not possible to say when he completed the job. The frontispiece, a late *enfatico,* has the kneeling man with outstretched arms who figures in many of his drawings and paintings between 1814 and 1823, not least the remarkable Christ on the Mount of Olives of 1819. A drawing in this style greeted the Revolution of 1820 [67, 68, 69]. It is known that the *Disasters* plates were re-worked even after the first numbers had been scratched on. He must have been working on the *Disparates* engravings and possibly even the Black Paintings as he finished the 'Fatal Consequences'. When he left for France in 1824, the *Disparates* were interrupted and the *Disasters* plates stored away by his son. The completion of the latter could be located at any post-war date up to 1823.

On the other hand, internal evidence strongly suggests a date before 1820. The final plates of the series actually published in 1863 have Truth being buried by clerical reaction and carry the query – Will she rise again? [93, 94]. True, the last of these plates in Goya's *own* scheme, No. 82, is a re-affirmation of human, humane and bucolic values and could be counted to a degree 'optimistic', but plate and caption – This is the Truth – are essentially a counter-assertion to the dreadful message of the series as a whole. It can be interpreted as an eve-of-Riego intimation of hope, but Goya followed it with his three shackled prisoners. What is absent is the joyful celebration which infuses his *drawings* after the revolution which temporarily broke absolutism. Whenever they were physically completed, in spirit, concept and tone, the *Disasters* close before the Revolution of 1820.

Goya repeated the Sueños-*Caprichos* process of 1797–9.
He made a false start. On fifty-six of the plates he cut a
number in the bottom left-hand corner. The number series
is incomplete but it embraces both 'early' and 'late' war
engravings. The plate finally numbered 59, for example, one
of the famine scenes, was first given the number 3. On four
occasions the number was duplicated; final plates 10 and 19,
rape scenes, were both given the early number 19. Twice, the
duplicates set in context suggest alternative sequences – either
a famine or a rape sub-series – but it is difficult to see the
numbering as anything other than a first tentative sketch.
Entirely excluded were the *enfaticos*. Some time after he had
made both the early and late war engravings, Goya began to
group them into a series, presumably for publication, before
the idea of the *enfaticos* had struck him. When he decided to
engrave the *enfaticos* on the Restoration, he abandoned his
earlier numbering scheme, indeed returned to further work
on and alterations to the already-numbered engravings.
He then re-shaped the whole series. Final numbers and those
captions which, as in all his caprichos, are essential to the
work, appear only in the set he gave Ceán Bermúdez.
The final *Disasters,* therefore, differ in some important
respects from their first version.

Goya's first numbering of the Fatal Consequences

Number	Final plate number and caption		Type	Subject
1	34	for a knife	late	garrotting
2	35	no-one can know why	late	multiple garrotting [82]
3	59	what use is one cup	late	famine
4	16	they make use	early	soldiers strip dead
5	57	the sound and the sick	late	famine, social contrast
7	22	all this and more	early	heap of corpses
8	20	treat them and on again	early	wounded
10	41	they escape through flames	early	flight
11	27	charity	early	summary burial [80]
12	24	they'll still be useful	early	wounded
13	25	these too	early	wounded
14	23	the same elsewhere	early	heap of corpses
15	44	I saw this	early	flight
16	18	bury them and be quiet	early	heap of corpses [79]
17	17	they do not agree	early	officers in battle

146

Number	Final plate number and caption		Type	Subject
18	11	nor these	early	rape
19	10	nor do these	late	rape
	19	there's no longer time	early	rape
20	13	bitter presence	early	rape
21	30	ravages of war	early	raped women, dead
22	15	and nothing can be done	early	French execution [78]
23	14	hard is the way	early	a hanging
24	12	for this you were born	early	man dying on heap of corpses
25	21	it will be the same	early	carrying off corpses
26	6	it serves you right	early	dying French soldier
27	26	one can't look	early	execution [2]
28	5	and they are like wild beasts	late	women attack French soldiers [76]
29	9	they don't want to	late	rape
30	56	to the cemetery	late	famine, carrying corpses
31	60	there is no one to help them	late	famine
32	31	that's tough	late	French execution
	37	this is worse	late	French atrocity mutilated man impaled on tree
33	47	this is how it happened	late	sack of a church or monastery
34	4	the women give courage	late	women attack French
	58	it's no use crying out	late	famine
35	61	as if they are of another breed	late	famine, social contrast [83]
36	49	a woman's charity	late	famine
	2	with reason or without	late	men attack French [5]
37	55	the worst is to beg	late	famine [86]
38	64	cartloads to the cemetery	late	famine [84]
39	36	nor in this	late	French execution
40	43	so is this	late	monks fleeing
41	7	what courage	late	woman mans gun (Agustina of Aragon) [77]
42	33	what more can one do?	late	French atrocity, castration
43	53	he died without help	late	famine
44	63	dead bodies in a heap	late	famine
45	54	they cry in vain	late	famine

Number	Final plate number and caption		Type	Subject
46	51	thanks to the millet	late	famine
47	48	a cruel shame	late	famine
48	3	the same	early	men attack French [75]
49	32	why?	late	French execution [81]
50	52	they do not arrive in time	late	famine
51	39	great deeds! against the dead!	late	atrocity, mutilated bodies
53	46	this is bad	late	French kill monk
55	50	unhappy mother	late	famine
57	38	barbarians!	late	French kill monk
69	69	Nothing, that's what it says	late	message from the grave [74]

The basic message of the series is clear and remains unchanged from the earlier sequence to the final series: the brutal lunacy of war, the murderous inversion of values, the meaninglessness. The savage irony is all the more effective because of the particular historical irony of this bloody war 'in Spain', but in fact the absence of the *enfaticos* in this first series makes this correlation less visible. That it was present in Goya's mind, however, is clear from his choice of prints to start the series. His first choice fell on two engravings of executions by *Spaniards*. There they are, Spaniards with the sign of the Cross on their foreheads and the symbols of their 'crimes' hanging around their necks, strangled in traditional style by their compatriots and 'no one can know why' as Goya ultimately commented on the plate which is number 2 in this first series [82]. The character of civil war which the national struggle often assumed is here employed to rivet the mind on the ambivalence of war in a series which in this first version, without the *enfaticos,* becomes a brutally specific but conceptually generalized statement on war and 'human nature'.

In effect, Goya had three sets of drawings to work from. The earlier prints, by and large, are genuinely concerned with 'consequences'; they portray *victims*. Their spirit is summed up by the execution – One can't look – which is No. 27 of this series and No. 26 of the ultimate *Disasters*. This was clearly one model for the great painting of the Third of May [2]. The great majority of these earlier prints, with their little figures in agony against a sketchy landscape and ominous buildings, are prints of victims, heaps of dead,

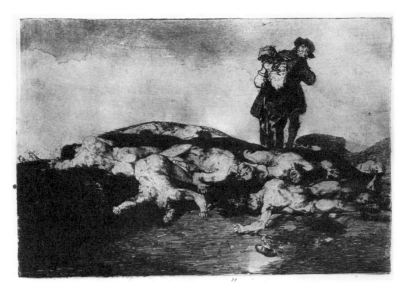

79. Bury them and keep quiet. *Desastres,* 18, *c.*1820

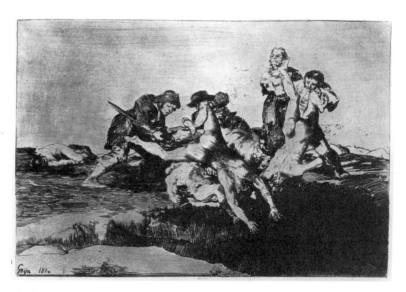

80. Charity. *Desastres,* 27, *c.*1820

stripped dead, patched-up wounded, 'consequences' of action
which has taken place elsewhere [79, 80].

In the later series there is a change. The selectivity and
close focus which characterize all the prints here become
almost unbearably intense; some of them are very difficult to
look at, such is their close and concentrated power. The famine
prints, often beautiful, are poignant, laced with social comment
and almost elegaic in tone [83, 84, 85, 86]. The horrors however
become merciless. Spanish women are shown in action as well

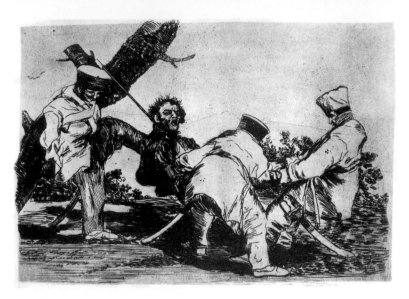

81. Why? *Desastres*, 32, *c*.1820

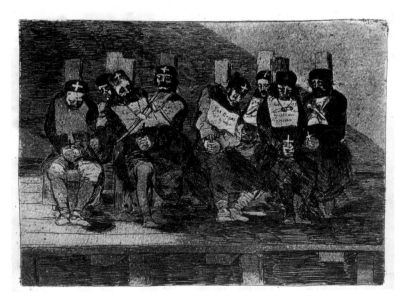

82. No one can know why. *Desastres*, 35, *c*.1820

as suffering rape [76]. The ambiguity is there – the women
'give courage' but also 'fight like wild beasts' – but the Maid
of Saragossa stands a heroine by her gun, the most sickening
atrocities are those of the French [77, 78, 81]; monks as victims
are treated more sympathetically by Goya here than they ever
were anywhere else (the contrast when the *enfaticos* were
added was all the sharper). It is possible that these drawings
were made at the time of final victory and liberation, when
Goya was shaping his Second and Third of May, before

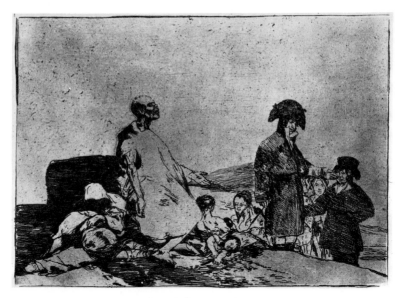

83. As if they are of another breed. *Desastres*, 61, *c*.1820

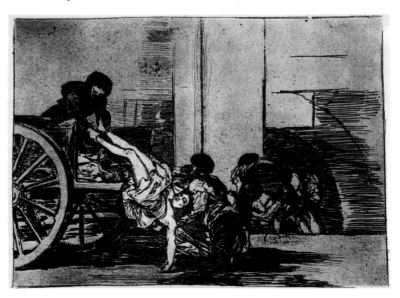

84. Cartloads to the cemetery. *Desastres*, 64, *c*.1820

Ferdinand abolished the Constitution and unleashed the
clerical reaction. For whatever reason, in some of these later
engravings an element of popular and patriotic heroism and
pity is injected.

Goya, in sketching his first series, used that element in fact
to toughen the ambiguity. He begins with a number of later
drawings, the Spanish executions, famine scenes and a
stripping of the dead, and then leads us through an appalling
sequence of earlier drawings of victims, a pilgrimage through

151

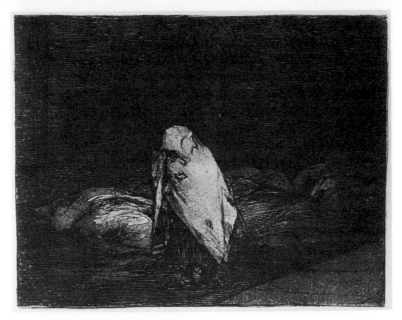

85. The beds of death. *Desastres,* 62, *c.*1820

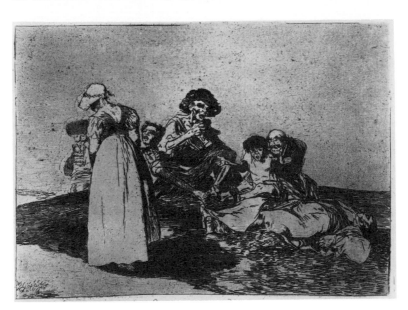

86. The worst is to beg. *Desastres,* 55, *c.*1820

corpses to the first 'break' in his No. 17 – They do not agree –
a satire on officers arguing in the midst of battle which is
almost 'political'. This is followed by a procession of rapes,
executions and corpses. At No. 26 a dying French soldier is
displayed and at No. 28 the first action by Spaniards, as
women attack the enemy, a scene preceded by an execution
and followed by a rape [76].

152

Thereafter it is difficult to detect any very coherent pattern; no doubt scenes were juxtaposed for artistic effect. One may perhaps detect something of a rhythm in that actions are followed by retribution and endless corpses; the famine drawings intervene more and more frequently and grow into a small series, and in this section, mainly drawn from the later drawings, there is a manic intensification of atrocity. The numbers give out at 57, but one shattering plate, No. 69, was probably intended as the conclusion. It is the harrowing *Nada*: a half-buried corpse surrounded by gibbering horrors and the scales of justice, scrawls a message from the grave – Nothing, that's what it says. This was too much for the 1863 editors, who softened it to a Time will tell [74]. Its naked atheist pessimism concludes a sequence which, for all the subtle ambiguity of its particulars, is simple and utterly devastating in meaning.

This pattern was abandoned when Goya drew the *enfaticos*.

The final form of Goya's Fatal Consequences

Plate number	Caption	Type	Subject
1	Sad forebodings of what is to come	*enfatico*	frontispiece [69]
2	with reason or without (rightly or wrongly)	late	men attack French [5]
3	the same	early	the same [75]
4	the women give courage	late	women attack French
5	and are like wild beasts	late	the same [76]
6	it serves you right	early	dying French soldier
7	what courage!	late	Maid of Saragossa [77]
8	it always happens	*enfatico*	fallen horseman
9	they don't want to	late	rape
10	nor these either	late	rape
11	nor these	early	rape
12	for this you were born	early	man dying on heap of corpses
13	bitter presence	early	rape
14	hard is the way	early	hanging
15	and nothing can be done	early	French execution [78]
16	they make use	early	stripping the dead
17	they do not agree	early	officers argue in battle
18	bury them and keep quiet	early	heap of dead [79]
19	there's no longer time	early	rape

Plate number	Caption	Type	Subject
20	treat them and then on again	early	wounded
21	it will be the same	early	carrying off corpses
22	all this and more	early	heap of dead
23	the same elsewhere	early	heap of dead
24	they'll still be useful	early	wounded
25	these too	early	wounded
26	one can't look	early	execution (model for 3 May) [2]
27	charity	early	summary burial [80]
28	rabble	*enfatico*	Spanish atrocity against Spaniard [6]
29	he deserved it	*enfatico*	the same [7]
30	ravages of war	early	raped women, corpses
31	that's tough	late	French execution
32	why?	late	the same [81]
33	what more can one do?	late	French execution, castration
34	for a knife	late	Spanish execution
35	no one can know why	late	the same [82]
36	nor in this	late	French execution
37	this is worse	late	French execution, mutilated man impaled on tree
38	barbarians!	late	French execution of monk
39	great deeds! against the dead!	late	atrocity, mutilated bodies
40	makes some use of it	*enfatico*	figure with beast
41	they escape through the flames	early	flight
42	everything is topsy turvy	*enfatico*	monks in flight
43	so is this	late	the same
44	I saw this	early	flight
45	and this, too	*enfatico* (*probably*)	flight
46	this is bad	late	French kill monk
47	this is how it happened	late	sack of church or monastery
48	a cruel shame	late	famine
49	a woman's charity	late	famine
50	unhappy mother	late	famine
51	thanks to the millet	late	famine

Plate number	Caption	Type	Subject
52	they do not arrive in time	late	famine
53	he died without help	late	famine
54	they cry in vain	late	famine
55	the worst is to beg	late	famine [86]
56	to the cemetery	late	famine
57	the sound and the sick	late	famine
58	it's no use crying out	late	famine
59	what use is one cup	late	famine
60	there's no one to help them	late	famine
61	as if they are of another breed	late	famine [83]
62	the beds of death	*enfatico*	grouped with famine scenes [85]
63	dead bodies in a heap	late	famine
64	cartloads to the cemetery	late	famine [84]
65	what's this hubbub?	*enfatico*	distraught people before official
66	strange devotion!	*enfatico*	devotion of saint's relics
67	this is no less so	*enfatico*	the same
68	what madness!	*enfatico*	squatting figure, eating among relics, masks with shadowy figures
69	Nothing, that's what it says	late	message from the grave [74]
70	they don't know the way	*enfatico*	unseeing figures roped together and wandering over a landscape [95]
71	against the general good	*enfatico*	clerical figure with claws and vampire-like ears filling a ledger [87]
72	the consequences	*enfatico*	vampire-like creatures suck at a human body [88]
73	feline pantomime	*enfatico*	cleric bows before a cat and an owl
74	this is the worst!	*enfatico*	a wolf writes 'wretched humanity, the guilt is yours' as people grovel before it and a money-grubbing cleric [91]
75	farandole of charlatans	*enfatico*	grotesque creatures in clerical garb [92]
76	the carnivorous vulture	*enfatico*	people drive off huge vulture [90]

Plate number	Caption	Type	Subject
77	may the rope break	*enfatico*	the Pope on a tightrope [89]
78	he defends himself well	*enfatico*	a horse attacked by dogs
79	Truth has died	*enfatico*	Female figure of truth buried by clerics [93]
80	Will she rise again?	*enfatico*	glowing Truth confronts hostile clerics [94]
81	(separated) cruel monster	*enfatico*	the beast of No. 40 gorging or disgorging bodies
82	(separated) this is the truth	*enfatico*	peasant and female figure glowing in peaceful plenty
(83)	Chained prisoner: the imprisonment is as barbarous as the crime		
(84)	Chained prisoner: the imprisonment of a criminal does not demand torture		
(85)	Chained prisoner: if he is guilty let him die quickly		

The entirely novel element of course is the final cluster of *enfatico* prints. These are often enigmatic; efforts to 'explain' them in terms of current events – the horse attacked by dogs, for example, has been related to Napoleon's Hundred Days – seem unrewarding. It is possible to pin some down.
A preliminary drawing identifies the cleric on a tightrope as the Pope himself, who may also peer between the legs of the flesh-eating Vulture [89,90].[3] Such a search seems unnecessary; the message of the engravings is clear. They pillory clerical reaction after 1814 as the rule of vampires, wolves, charlatans, sustained by the equally horrible servile superstition of a black *pueblo*, who 'do not know the way' [87, 88, 91, 92, 95]. Their inclusion with the war and famine scenes adds a whole dimension to the sorry panorama of delusion, gives elemental power to the dialectic of reason and unreason already established in the *Caprichos* twenty years earlier.

The parallel with the *Caprichos* in style and content is very close. The incorporation of the *enfaticos* decisively shifts the whole series in a *Capricho* direction; the label of the Ceán Bermúdez volume speaks for itself. In any case, the element of 'reportage' even in the war and famine scenes has been exaggerated beyond measure. Apart from his brief trip to Saragossa which may find reflection in some of the early

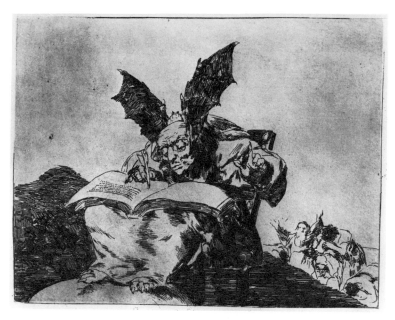

87. Against the general good. *Desastres, 71, c.*1820

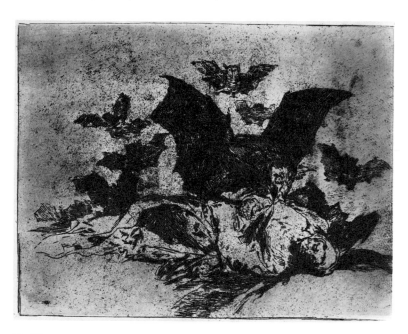

88. The consequences. *Desastres, 72, c.*1820

engravings, and his escape bid to Piedrahita in 1812, Goya
remained in Madrid throughout the war, as schizophrenically
'loyal' to its successive rulers as many of his friends. The
caption 'This I saw' is reserved for two prints. Several
of his scenes were also celebrated by lesser artists who

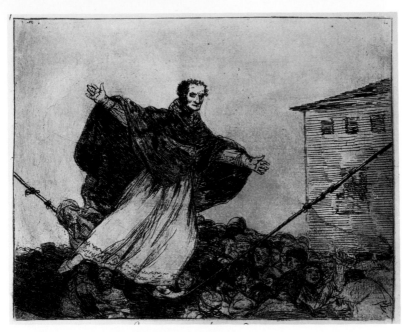

89. May the rope break. *Desastres*, 77, *c.*1820

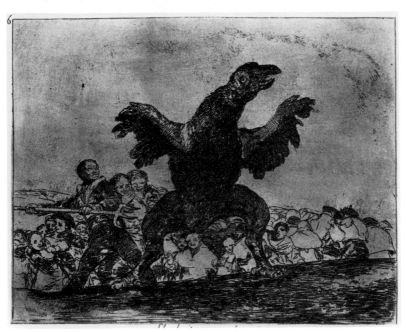

90. The carnivorous vulture. *Desastres*, 76, *c.*1820

found far greater immediate favour, precisely because his
purpose was not to 'report' or edify. The uniform of his
soldiers is often sketchy; the soldiers in his drawings seem
to bear the same relation to French troops as do John Arden's
soldier-avengers in his play *Serjeant Musgrave's Dance* to

158

91. This is the worst! *Desastres*, 74, *c.*1820

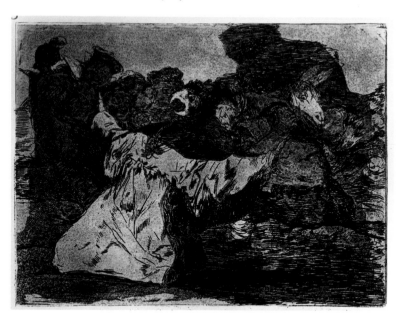

92. Farandole of charlatans. *Desastres*, 75, *c.*1820

soldiers of the Queen. Goya was drawing and painting
'disasters' before war broke out. The war certainly gave him
an abundance of new material, but the essential perspective,
however elemental it had become, remained that of Moratín's
Logroño *Relación*.

159

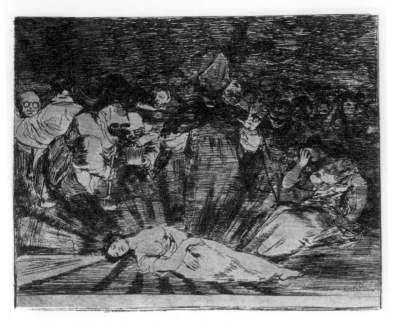

93. Truth has died. *Desastres,* 79, *c.*1820

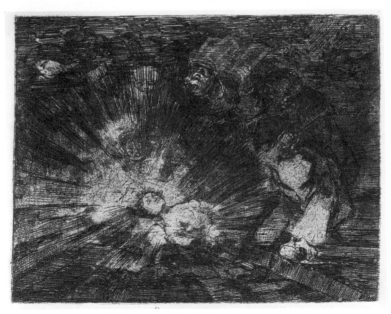

94. Will she rise again? *Desastres,* 80, *c.*1820

The relationship between the *Caprichos* and the *Disparates* is even closer. These, the most impenetrable of his engravings and still incomplete when he went into exile in 1824, teem with direct echoes of the *Caprichos.* They re-work many of the same themes; the plates (those he used for the *Tauromaquia*

of 1815–16) are larger, and in the concentration he essayed, the prints become monumental. But even the phantasmagorical aspect, the theatrical, guignolesque, recalls the theatre of the absurd of the *Caprichos*. There is a direct relationship between the later plates of the *Disasters* and the *Disparates* and between both and the Black Paintings. The desperate illness of late 1819 cuts across the process, but the plates of both series, the Black Paintings and many of the drawings from some time after 1814 through to exile in 1824, with their constant and characteristic re-working or 'paraphrasing' of earlier themes, strongly suggest one massive 'capricho' developing and elaborating into new dimensions the perspective that Goya had achieved in the crisis of 1792–9.

Goya's engraving of the *enfaticos* and his incorporation of them into the *Fatal Consequences* sharpened that particular perspective. It was not simply a matter of adding a new series to cover the post-1814 period or of printing a suitable 'presentiments' frontispiece in the style of his 1819 painting. Several *enfaticos* were carefully inserted into the sequences of earlier engravings. A fallen horseman (No. 8), for example, is used to break a sequence of increasingly 'heroic' Spanish actions in the early stages to drop the reader into the pit. The second of his 'This I saw' prints seems in fact to be an *enfatico* deliberately drawn to twin an early plate (No. 45). Two *enfaticos*, one of monks in disorder and the classic Beds of Death (Nos. 42 and 62), may originally have had nothing to do with the war sequences on flight and on famine into which they fit [85].

The most striking of the 'inserted' *enfaticos* are Nos. 28 and 29, which introduce Spanish atrocities upon Spaniards. They are the yoked *Populacho* couple [6, 7]. They depict a similar scene – a Spanish crowd dragging a man through the streets to inflict a horrible death upon him. The victim is presumably an *afrancesado*, one of the 'enlightened' killed by a 'black' populace with the bourgeoisie in ambiguous attendance. But whereas one caption is a curt, dismissive 'Rabble', the other baldly states 'He deserved it'. It is an almost perfect illustration of the duality of the series and it is strongly reminiscent of the *burro-pueblo* pair of engravings in the *Caprichos* [8, 9]. It is moreover set in a short sequence which seems a fulcrum to the series. No. 26 is the One can't look execution which prefigures the Third of May painting [2]; it is followed by Charity, the most searing of the burial prints [80]; then come the *enfatico* couple of the Two-Spains dichotomy [6, 7], and we are led straight into a sequence of

devastating atrocities. The *burro-pueblo* is become the People as Beast-Hero.

The final series shows signs of very careful planning, much more rigorous than the first numbering. There is, first, a measure of concentration; the famine prints are grouped [83, 84, 85, 86], so are most of the *enfaticos,* so are the later war prints of atrocities, so are the earlier ones which meander through heaps of corpses. Other, linking sections are very carefully composed of early, late, and *enfatico* plates. After the frontispiece, for example, plates 2–7 form a unit. Unlike the first numbering, which began with executions, this series begins with the insurrection of the Spanish people. In the first two prints Spanish men fight the French, in the next two, Spanish women; they are unidealized, they kill, but they are the *pueblo* in arms [75, 76]. A dying French soldier is greeted 'serves you right!', and then we see Agustina of Aragon the heroine [77]. It is at that point that we are brought crashing down with the *enfatico* fallen horseman, to confront four rapes, a man vomiting into death, two executions [78] and a stripping of the dead. They do not agree (No. 17) affords a momentary break before we are off again on a Long March through the early prints and their pathetic piles of dead and the broken [79]. At No. 26 we confront the thematic execution, the Charity, the twin Beast-Hero of the people, and are plunged into ten scenes of frenzied atrocity [80, 81, 82]. An enigmatic *enfatico* which yokes a woman to a vile beast leads us into a short sequence built up from plates of all periods chronicling flight, refugees, murdered monks and a sacked church which yields abruptly to the long Golgotha of the famine [83, 84, 85, 86]. The last print in that sub-series, in which a young and beautiful girl, legs erotically exposed, is carted off to the cemetery [84], gives place to popular dismay before restored Spanish reaction, and we are into the nightmare of the last *enfaticos* [87, 88, 89, 90, 91, 92]. Truth is buried; will she ever rise again? [93, 94]. The man-eating monster is confronted with the vision of Truth and peace, and the series ends with the three small shackled wretches who leave us imprisoned.

It is a series of unparalleled power, perhaps the most remarkable and most memorable treatment of war in art. But the power derives essentially from that dialectic first sketched in the *Caprichos.* The use of the *enfaticos* focuses precisely that dialectic, peculiarly Spanish in its intensity. Through Goya's mind and spirit we are admitted to the travail of the Spanish people in this, their war of independence

and the first of their modern civil wars. Through Goya's mind and spirit that travail of the Spaniards is made, for us, the travail of 'mankind'. The crucible is the peculiar strength, the peculiar quality of that mind and spirit, which lie too deep for the historian. But how could Goya ever have achieved transcendence if his mind and spirit had not been those of a particular Spaniard in a particular Spain?

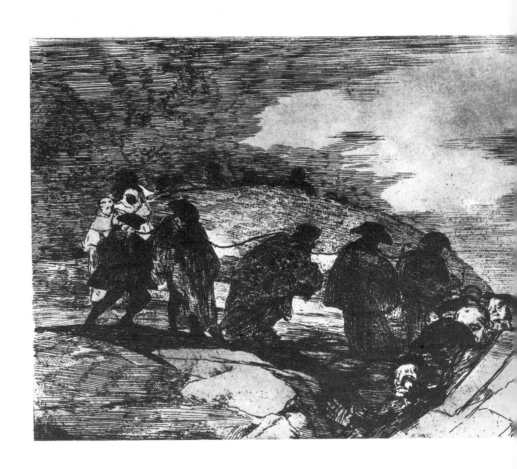

95. They do not know the way. *Desastres*, 70, *c.*1820

8 Trágala

Tu que no quieres
lo que queremos
la ley preciosa
puesta en bien nuestro

Trágala!
Trágala!
Trágala!
perro!

Y mientras dure este canalla
no cesaremos de decir trágala!

Trágala!
Trágala!
Trágala!
perro!

Dicen que el trágala
es insultante
pero no insulta
más que al tunante

Trágala!
Trágala!
Trágala!
perro!

You who don't want what we seek – the precious law made for our good,
Swallow it, swallow it, swallow it, dog!

They say the Trágala is insulting, but it insults only the idle crook,
And while this canaille lasts, we won't stop singing Trágala! . . .
Swallow it, swallow it, swallow it, dog!

What the dogs had to swallow was the Constitution of 1812.
So ran the *Trágala,* song of the *exaltados* of the 1820
Revolution. It echoes the caption to Goya's ferociously
anti-clerical *Capricho* of 1799. The song itself echoed.
During the revolution of 1936 the no less ferociously anti-
clerical workers' militias sang it again. They did not need to
change a word.

'Spain is a country tied on an historical rack – the symbolic
equivalent of its own Inquisition's instrument of torture.
It is stretched between the tenth and the twentieth centuries.'
So John Berger, in his essay on Picasso.[1] This is metaphor.

165

What it expresses is a concrete reality – the terrible continuity of the Spain of the necessary but impossible revolution.

Some continuities are patent. In his *Dream and Lie of Franco* (1937) Picasso drew directly on the Goya of the drawings and the *Disasters,* as he did in his preparatory work for *Guernica.* Goya looms equally visible behind Picasso's painfully personal late drawings.[2] Who can fail to recognize the acrid and alien flavour of Goya in so many of the films of Luis Buñuel? On another plane, the tiny Communist Party of Spain, in the early 1930s, based itself on Lenin's 1905 analysis of 'backward' Russia in order to get to grips with the problematic opened by Jovellanos's *Informe* of 1795. In the embattled Madrid of 1937, 'front line of the war against fascism', as gifts for the Republican President Azaña, Mrs Eleanor Roosevelt and Joseph Stalin, the Calcografía produced superb editions of all Goya's great engravings.

It is this permanence of the peculiarly Spanish dilemmas which accounts for the alien and archaic character which so much Spanish self-examination presents to observers from societies which have at least reached a *modus vivendi* with their own history. Much Spanish historical writing seems peculiarly *hallucinatory* in character. So much of it is the work of exiles. The *afrancesado* emigration of 1814 was the first of a sad sequence which attained tragedy in the heart-rending diaspora of 1939. There was something remote, disturbing and yet all too real – in the style of the Black Paintings – in the spectacle of Spanish historians grouping themselves into factions as the rivals Américo Castro and Claudio Sánchez Albornoz ranged the whole sweep of Hispanic history in a brilliantly desperate search for Spain's *autentico ser* – from exile. A recognizably modern historian, a European master of his dark and sullen craft, Jaime Vicens Vives (a Catalan) seemed, in his one-man revolution in Campomanes style, a lone and uneasy *ilustrado* in a culture whose public architecture celebrated Philip II and whose public memory cherished Ferdinand VII.

The shuffle towards modernization begun in the eighteenth century did not reach its destination. Spain seemed imprisoned in yet another paradox, a 'permanent' state of transition. It is probable that the explosive modernization of Spain in the middle years of the twentieth century will write *finis* to this story and eradicate the permanent challenge which Spanish experience has presented to Europe. But the cycle which opened in the late eighteenth century proved to be, in terms of objective historical process, a cycle of frustration.

Whatever the subjective realities and socio-political immediacies of Bourbon modernization, its objective function in Spanish history was the function performed by the 'bourgeois revolution' in France and Britain. For reasons rooted in the history of Spain, that species of revolution proved to be as impossible as it was necessary. Spain, like its American derivatives, turned itself into a living folk-museum of contradictory polities, with its half-formed and unarticulated 'classes' inhabiting different historic time-scales.

The young Karl Marx, wrestling out of Hegelianism, faced a Germany in 1843 whose condition in one particular was not dissimilar.

> If we wanted to start with the German status quo itself, the result would still be an anachronism even if one did it in the only adequate way, i.e. negatively. Even the denial of our political present is already a dusty fact in the historical lumber room of modern peoples. Even if I negate powdered wigs, I still have unpowdered wigs. If I negate the situation in Germany of 1843, I am, according to French reckoning, scarcely in the year 1789, still less at the focal point of the present.

He called his Germany of the necessary but impossible bourgeois revolution 'the comedian of a world order whose real heroes are dead'.[3] Bourbon Spain fits – perhaps one explanation for Marx's rather unexpected perspicacity on the war of 1808–14!

John Berger, in seeking to *locate* Picasso, writes: 'What I want to establish is that the Spanish middle class, among whom Picasso was brought up, had – even if they wore the same clothes and read some of the same books – very little in common with their French or English or German contemporaries. Such middle-class virtues as there were in Spain were not created *of necessity*; if they existed, they were cultivated theoretically. There had been no successful bourgeois revolution.'[4] How much more true was this of 1800 than 1900, at the initiation of that impossible revolution whose non-fulfilment confronted the young *Spanish* Picasso with a complex of contradictions not essentially dissimilar from those which confronted Goya on his emergence into an *historic* identity in the 1790s.

Marx transcended his problem in 1843 by the creation of what was then a largely abstract concept – the proletariat –

> a class in civil society that is not a class of civil society, a social class that is the dissolution of all social classes, a sphere that has a universal character because of its universal sufferings, and lays claim to no particular right, because it is the object of no particular wrong but of

wrong in general. This class can no longer lay claim to an historical status but only to a human one . . . it is the complete loss of humanity.

From this perceived totalism he transferred himself physically, out of German unreality into Anglo-French actuality, and conceptually, by means of a decisive intellectual rupture, into a new problematic which located a real proletariat in the historical process and the social formation.

96. The family connexion. *Caprichos*, 57, 1799

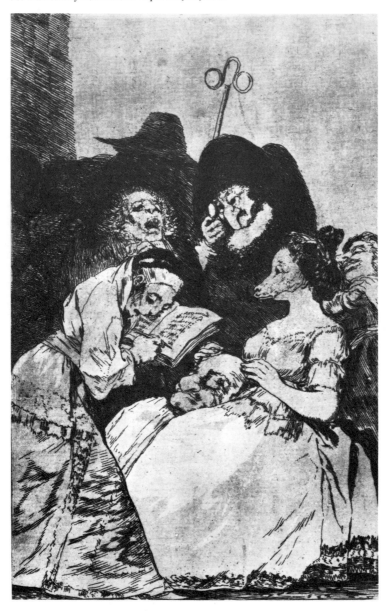

There was, of course, nothing remotely parallel in Goya's achievement of historic identity. Nevertheless, if one takes the *totality* of Goya's work from about 1800 onwards (as opposed to that relatively minor fragment of it which was actually published), the first, immediately obvious and effectively determinant feature of it is the *centrality of the pueblo*. This mirrors, of course, the historical experience of the

97. Student-frog, drawing, 1797–8

ilustrados, which in practice reduced itself to a dialogue of the deaf with the *pueblo* and in 1808–14 to a brute and contradictory confrontation. Already, in the Goya of the 1790s crisis, in his masks and mirror drawings, there is an instinctive awareness of the 'role-carrying' function of individuals within a particular structure of social living, an opaque sensitivity to the historical nature of individuality [96, 97]. From about 1800 onwards his work is a continuous exploration of Spanish people. It is not simply a matter of proletarian paintings or of peopling an atrocity scene. There is precious little representation in it, precious little reportage. It is the exploration of a predicament, conscious and directed,

169

though with the nerve-ends of the imagination exposed.
In consequence he, too, effected a rupture. An *ilustrado,*
indeed, in some respects an *exaltado* by conviction, a man of
the *pueblo* by 'temperament' (also historical in formation), he
was, whether consciously or not, trapped like his fellows in
the impossible revolution. He found no escape. But he found
an essential focus. Outside the relatively minor fringe of
contingent and commissioned work after 1800, it is the
'people' who engage his mind and who shape his work around
the central *Caprichos–Disasters* axis. Later and more secure
individualities in more anchored and integrated societies
identify these 'people' as 'humanity' in timeless relevance.
The perception of his 'people' as 'timeless' and 'universal' is
itself historically conditioned. His 'humanity' is in fact
historically specific: it is the Spanish *pueblo.* And it is here,
I think, that we can grope after some explication of both the
power of his work and its apparently transcendental quality.

It is first of all necessary to distinguish between the
subjective and the objective. In the *Caprichos* of 1799,
growing out of his first major experimentation with drawing,
for example, there is little doubt that Goya's central subjective
preoccupation was with his *craft,* with the imperative drive
to find a form for a personal vision in the materials,
techniques, skills of his 'mystery', with the translation of that
elusive quality in him we call 'genius' into an artefact.
The 'subject-matter' was the material created in the
communication between himself, his experience, direct and
vicarious, his memory, his perception of experience and
memory and transmutation of them, including his discourse
with Jovellanos, Moratín and other *ilustrados.* Objectively,
however, the *Caprichos* were unmistakably an iconography of
Censor enlightenment. Intended for publication, they were
also a commodity produced for sale, though admittedly, the
Inquisition made the market something less than perfect!

Similarly, it is necessary to distinguish between Goya, a
particular Spaniard working in a particular Spain, and the
possible role his production could play within a problematic,
the possible function it could serve within a social formation.
Goya's four major series of engravings were, or were
intended to be, commodities produced for sale. The fact that,
as commodities, they all failed or were still-born, is itself
some indication that their problematic and function were not
those of 'their time', the chronological time in which they
were produced, of that 'time' as it was perceived by a particular
society. In this sense they inhabited a different historic

'time-scale'. The 'time' they inhabited has in fact proven to be that which twentieth-century observers in Europe perceive as their own. It was in the last quarter of the nineteenth century and, more especially, in the twentieth century, that they came to play a recognizable role in a problematic, to serve a comprehensible function within a social formation.

In subjective terms, the comprehension of Goya the human being is no longer possible; the evidence is insufficient. A few basic and apparently permanent traits may be detected. There was his preoccupation with money. It was central in his early days, punctuated and *measured* his sense of his own achievement. How far this in turn was itself a measure of achieved status and recognition it is difficult to say. The 15,000 *reales* of the royal painter were certainly also a moral compensation for the snub from Saragossa! The King's Painter felt it was 'undignified' to listen to popular music. By the late 1780s this vulgar sense of self-importance was running into and becoming indistinguishable from the driving need to assert his own creativity. He was protesting at the 'burden' of commissioned work as early as 1788; in 1790 came the psychological 'disorder' which led to his revolt of 1791 and prefigured the collapse of 1792. The artisan had become an 'artist'. Certainly, there is in later years little or nothing of the bouncing, self-indulgent, self-revelling new-rich *baturro* of the 1780s.

The shrewd concern for money, however, persisted. Even in his crisis of 1792–3 he went to rather comic lengths of amateur deception to disguise his flight from Madrid and to preserve his salary. One notes the jewellery of the 1812 inventory. At the end of his life he was making hazardous journeys from exile to Madrid to secure his pension. There is nothing very rewarding in these observations, except perhaps some indication of a populist ('artisan', 'peasant', 'bourgeois' seem equally apt – and equally revealing in this context!) insecurity. His father the gilder had died intestate.

It does run parallel, however, with other character traits – a sense of 'coldness' or 'detachment' which many commentators have noticed. Perhaps Aragonese *are baturros?* This is most noticeable in his public roles, where he was quintessentially a *politique*. Even the *Caprichos* did not, in the particular conjuncture of 1798–9, demand an unusual courage. Throughout his life Goya seems to have been publicly non-political. It was, after all, his imperative self-regard which had carried him into the *ilustrado* fraternity in the 1780s,

171

when they represented respectability and establishment.
The shocks of the 1790s, which displaced and ultimately
destroyed this particular species of respectability, do seem to
have been a significant factor in his intense personal crisis.

On the other hand there are outright contradictions to be
noted. He *did* publish the *Caprichos,* after the clericals had
broken Jovellanos. He *did* try to escape to 'a free country' in
1812. As soon as he attained some financial independence in
1800 he *did* devote himself almost wholly to the elaboration
of his own art, an obligation to which he remained true
despite occasional spurts of self-preservation. Above all, there
is the evidence of his personal drawings from 1814 onwards,
which stamp him as a committed, near-fanatical, anti-clerical
liberal or radical, which constitute a *J'accuse!* the equal of any
in history and which afford glimpses into an inner life that
was tumultuous, breathtakingly imaginative, passionate, fierce
and large.

It was precisely this self-concern which ran into, married
and eventually powered his obsession with his craft, in which
he achieved a qualitative breakthrough. He was always an
original. His youth yields ample evidence of a bubbling
creativity before he subjected it to the royal tapestry works.
His attitude before his forties, however, was episodically
unexacting. Throughout his life, commitment was necessary
to him for full achievement. Ebbs in that commitment no
doubt account for the inadequacies in his work, which are
unusually numerous for a painter of his stature. Through the
late 1780s, however, there is evidence of a deeper commitment
developing out of and transcending an artisan concern for a
job well done. From the 1790s his work became a passion.
It is difficult to think of anyone who could rival him in his
readiness to learn, to teach himself, to experiment. The range
of his techniques and experiments is staggering. 'Still learning'
he scrawled on a drawing of an ancient at the end of his
life; he taught himself the new lithography on the lip of the
grave.

That growth into passion was punctuated by major
illnesses. All three of them *register* a change of direction.
In 1777–8 a serious disorder followed several years of
derivative, decorative painting and took him direct to his
first original engraving, which dramatically anticipates his
later work. His desperate illness in 1819 was perhaps less
'creative'; desperate illnesses are an occupational hazard of a
man's seventies. Nevertheless, it was followed by the Black
Paintings. Central, of course, and central to the decisive

'mystery' of Goya's emergence as an *historic identity,* was the illness of 1792–3, whose inner meaning will now always remain a mystery. Its objective meaning in the trajectory of his work, however, is clear. Organically connected to his newer commitment to work itself and to the unhinging shock of the *displacement* of *ilustrado* culture, its demotion to a dissident sub-culture, its effects interpenetrated with those of the Alba affair and the developing crisis of Spanish polity. In the years that immediately followed, the historic Goya took shape, committed intellectually and in increasing passion to the values of the *ilustrados,* committed by temper and experience to the exploration of the human and social realities of unregenerate people, committed of necessity to a developing and ever more affluent style, in drawing, engraving, genre painting, the study of violence, which was of necessity dual, a dichotomy, a *dialectic* of reason and unreason in a specific human context. His drawings begin at Sanlúcar in 1796 and are henceforth the very motor of his work. As soon as he was rich enough and as soon as clerical pressure grew too intense around 1800, he withdrew. Outside work in future he undertook when he had to, or thought politic – which amounts to the same thing. His real identity, his historic identity, crystallized around the *Caprichos–Disasters* core. Following the inner if unperceived but necessary logic of the *ilustrado* predicament (a logic not unlike that which propelled the young Marx in 1843) his work, of necessity, came to focus on the *pueblo.*

From this point, it is possible to approach his work as an objective reality. Its trajectory can be established in quantitative terms. Gassier and Wilson's superb catalogue pinpoints the early 1790s as the point of rupture, the early 1800s as the emergence of the new problematic. Of his total production, graphic work accounts for no less than two thirds, drawings alone for nearly a half. This is the core of the historic Goya, and, virtually in its entirety, it dates from 1792, in fact from 1796. The most productive period of his life was that between 1808 and 1819. Half his known portraits date from the period 1792–1808. In fact, *commissioned* portraits and paintings dwindle very rapidly and quite massively after 1800–3; they are surpassed by paintings and portraits done for friends and kinsfolk and for his own service. There is, in truth, a wholesale shift into the private and the graphic; the great engravings and the major paintings grow out of this ground.

In objective terms, it is possible tentatively to suggest

function. Portraiture, of course, underwrote and idealized the chosen social role of the sitter; it celebrated a social role and warranted the structure which determined that role. To quote John Berger, 'The portrait must fit like a hand-made pair of shoes, but the type of shoe was never in question.'[6] This, self-evidently, was the character of the great majority of Goya's commissioned and *bien-pensant* portraits. That several of the major artists on occasion startle and delight in portraits by their insights, their psychological penetration – as Goya so often did – implies personal, sometimes obsessional interests on the part of the artist which transcend his professional function. These paintings, which approach self-portraits in their tension, are in effect autobiographical.[7] That most of Goya's portraits fall within these categories and that their specific weight in his total work diminishes sharply after 1800 or so are facts that speak for themselves.

In a different category were the paintings of his friends, the leading *ilustrados*, which he made in the 1790s virtually as a political statement, and the paintings of the bourgeois Madrileños he produced in the 1800s, together with the many 'gift and recognition' portraits he executed in later years. These in fact approximate to what became a common mode in the nineteenth century when The Artist had emerged as an 'autonomous' and generally 'alienated' creature in bourgeois society. The values implied are those of friendship – with a 'creative genius' – or those of the subjection of the sitter to such a genius; in each case, what matters is the *artist's* 'vision' and personality.[8] Again the shifting relative weight of these two types of portraiture within Goya's work after 1800 or so speaks for itself: it runs parallel to the themes of his drawings where the *Censor* ideology, with its intense and painful ambivalence before the *pueblo*, escalates into the *exaltado* passion of 1820. In terms of function, this work 'celebrates' (to use the word as Goya used it about his priapic priest in the *sueños* preliminary to the *Caprichos* [46]) that 'bourgeois' transformation of values which in Spain was 'impossible'.

But a deal of Goya's painting and much of his portraiture and work which approximates to portraiture cannot fit into either category. Here some comments by John Berger on the work of the French artist Géricault seem almost intolerably apposite. He talks of

two or three extraordinary portraits of lunatics by Géricault, painted in the first period of romantic disillusion and defiance which followed the defeat of Napoleon and the shoddy triumph of the French

bourgeoisie. The paintings were neither morally anecdotal nor symbolic: they were straight portraits, traditionally painted. Yet their sitters had no social role and were presumed to be incapable of fulfilling any. In other pictures Géricault painted severed human heads and limbs as found in the dissecting theatre. His outlook was bitterly critical: to choose to paint dispossessed lunatics was a comment on men of property and power; but it was also an assertion that the essential spirit of man was independent of the role into which society forced him. Géricault found society so negative that, although sane himself, he found the isolation of the mad more meaningful than the social honour accorded to the successful. He was the first and, in a sense, the last profoundly anti-social portraitist. The term contains an impossible contradiction.[9]

The relevance of this comment to Goya's essential work is striking. Much of it falls precisely into this paradoxical 'anti-social portraiture'. If the notion of portraiture be extended into his drawings and engravings, as I think it can be, since many are in fact miniature 'portraits' – the figures are collectivities and subjects for comment on the 'human', but they are *not* anonymous – Berger's characterization of Géricault could apply to much of Goya.

The centrality of Goya lies in that area of work defined by the *Caprichos* at one pole and that cluster of drawings and engravings which form one multiple capricho around 1820 at the other; drawings occupy the heartland and paintings and engravings emerge from it. The *dramatis personae* are 'people', 'ordinary people'. Through them, what Goya evidently thought of as the 'human predicament' is explored, in a tense and creative dialectic of the rational and the non-rational. Even the most fantastic and grotesque of his productions have this purpose. Their guignolesque theatre is ultimately a human theatre.

This is the first, perhaps controversial, point which has to be made on the objective character of his work. It has to be called humanist, provided the word is not used in an optimistic sense. The religious sense appears to be weak in Goya. Some of the earlier religious works have power and panache, but it is difficult to locate this in a specifically religious sensibility. It is surely not religious feeling which gives the frescoes in San Antonio Florida their character. Most of his religious work is unconvincing. The exceptions, significantly, come late in life, and their Christs and saints are squarely in the tradition of *human* crucifixion which runs through the *Disasters* and the drawings [67]. As for the grotesque, the maniacal, the occult, the witchery, they are

98. Good counsel, drawing H4, *c.*1824–8 (drawn in Bordeaux)

precisely the product of the sleep of *human* reason; they are *human* nightmares. *That these monsters are human is, indeed, the point.* No, the universe of Goya's drawings is delimited by the scribbling, blind and skeletal corpse of his *Disasters – Nada.* Nothing, that's what it says [74].

Within this human world, it is the *pueblo* which is central; this not merely in the sense of 'ordinary people', but very often in a more specific sense, that of the *menu peuple* in France, the *popular* classes of pre-industrial society, so many of whom lived outside and often against the law of that society. In a considerable number of Goya's drawings and engravings, the bourgeoisie, in a fairly specific sense, distinguished by tall hats and respectable dress, are present as onlookers, outsiders, *spectators.* This is very striking, of course, in his famine scenes and in his drawings of plebeian massacres of *afrancesados,* but it is a frequent presence.

This *pueblo* is not consciously picaresque; nor is it treated in any paternalist manner. It is delineated 'straight'. The frequent appearance of physical deformity served a purpose in comment, of course, but it was hardly any deformation of actual reality, any more than the gipsy-like and semi-bandit styles were. This was what the pre-industrial plebs generally looked like. More striking, they are not anonymous. These crowds have *faces.* Exactly how Goya achieved this effect it is difficult to say, but even among the collectivities one is conscious of the individuality of these little figures. A few touches bring a man or woman to individual life in a manner which is quite surprising, given the role in comment that he has assigned them. It is in his personalized treatment of these faces in a crowd that Goya, paradoxically, breaks out of his own prison of the first person singular.

His *pueblo* is, of course, marshalled to serve the comment he wishes to make [98]. He is commenting on what he conceives of as 'mankind'; verbal comment itself, deepening the ambivalence, is essential to the engravings. The many couplings reinforce the point. They all, even the victims in the *Disasters,* even the monsters, serve his capricho. That Goya, by the logic of his enterprise, should be driven to confront the *pueblo,* is symptomatic of the 'impossible contradiction' in the objective historical situation of those friends in whose shared exile he died. The Spanish *pueblo* was not only an expression of their dilemma, it was one of the terms of the equation. In a sense it was determinant. About Goya's superb proletarian paintings there is something

more than Breughel's confidently bourgeois celebration of work [50, 51, 52]. They are monumental; there is a certain affirmation in them. What structure do these 'portraits' serve? What problematic do they open?

Unlike Marx, however, Goya made no breakthrough, achieved no transcendence. He is irredeemably pessimistic. The positive assertion, the optimistic in his work, rare at the best of times, tends to be tactical rather than strategic. Liberty is hailed, prisoners are freed, disrobing monks celebrated, but these sparse and spare instances lack the power and intensity of the more characteristic pieces. The 'affirmation' at the close of the *Disasters*, for example, with its peasant looking like a Tolstoyan muzhik, and its plump and banal Truth, is singularly unconvincing – as unconvincing as most of his religious paintings. It is promptly followed by an Unholy Trinity of chained prisoners of the Inquisition. *Nada*. That's what it says.

In terms of its objective function, of its role in a problematic, the meaning of the essential art of the historic Goya seems fairly clear. It is the iconography of a necessary but impossible revolution. Hence, no doubt, its resonance in the twentieth century.

Notes

Chapter 1

1. See Nigel Glendinning, 'Portraits of War', *New Society*, 19 March, 1970.

Chapter 2

1. See R. Herr, *The Eighteenth Century Revolution in Spain* (Princeton, 1958) pp. 20ff; Laura Rodriguez, 'The Spanish Riots of 1766', *Past and Present*, 59 (1973). In the developing social history of this period, the riots have become the subject of controversy between Laura Rodriguez and Pierre Vilar in *Reviste de Occidente*, 107, 121, 122 (1972–3); and see Josep Fontana, *Cambio económico y actitudes políticas en la España del siglo xix* (Barcelona, Ariel, 1972). Rodriguez believes that the riots in Madrid, unlike those in the provinces, were politically manipulated; certainly the Crown made scapegoats of the Jesuits.
2. R. Herr, op. cit., pp. 220–28. For the background, see the comprehensive J. Sarrailh, *L'Espagne éclairée de la seconde moitié du xviiiè siècle* (Paris, 1954).
3. A. Machado, 'A orillas del Duero' in *Campos de Castilla*. I have used the *Colección Austral* edition (Espasa-Calpe, Buenos Aires, 1946).
4. Of the more accessible texts, basic are Raymond Carr, *Spain 1808–1939* (O.U.P., 1965); Jaime Vicens Vives, *An Economic History of Spain*, trans. F. M. Lopez-Morillas (Princeton, 1969); Karl Marx, *Revolution in Spain* (International Publishers, New York, 1939); E. J. Hamilton, *War and Prices in Spain 1651–1800* (Cambridge, Mass., 1947); A. Domínguez Ortiz, *La sociedad española en el siglo xviii* (Madrid, 1955); M. Menéndez Pelayo, *Historia de los heterodoxos españoles* (Santander, 1947–8); R. Herr, op. cit.; J. Sarrailh, op. cit.
5. On economic history, see in particular, the magisterial and seminal work of J. Vicens Vives. There is relevant material in the critical analysis of the nineteenth century by Jordi Nadal in *Fontana Economic History of Europe*, ed. Carlo M. Cipolla, vol. ii (1973) and in D. R. Ringrose, *Transportation and Economic Stagnation in Spain 1750–1850* (Durham, N.C., 1970); recent work by Spanish historians is opening up the field; see, for example, Gonzalo Anes, *Economía e ilustración en la España del siglo xviii* (Barcelona, Ariel, 2nd edn, 1972) and *Las crisis agrarias en la España moderna* (Madrid, Taurus, 2nd imp., 1974), Josep Fontana, op. cit., and *La quiebra de la monarquía absoluta 1814–20* (Barcelona, Ariel, 1974).
6. On Catalonia, see the monumental work, Pierre Vilar, *La Catalogne dans l'Espagne moderne* (Paris, 1962).
7. On Olavide, see M. Defourneaux, *Pablo de Olavide ou 'l'Afrancesado'* (Paris, 1959).
8. On the enlightenment, see the works of J. Sarrailh and R. Herr already cited. There is an admirable essay on eighteenth-century writing in Nigel

179

Glendinning, *The eighteenth century, A literary history of Spain,* ed.
R. O. Jones (Benn, London, 1972).

9. There is an interesting picture of the *majo* in F. D. Klingender, *Goya in
 the Democratic Tradition* (Sidgwick & Jackson reprint, London, 1968),
 pp. 15ff.
10. The appearance of the first full *catalogue raisonné* of his work has
 superseded most biographies of Goya. See the massive and magnificent
 study of Pierre Gassier and Juliet Wilson, *Goya, His Life and Work,*
 ed. F. Lachenal (Thames & Hudson, London, 1971).
11. Apart from the works of R. Carr and R. Herr cited above, see Carlos
 E. Corona Baratech, *Revolución y reacción en el reinado de Carlos IV*
 (Madrid, 1957). Karl Marx, op. cit., offers a brilliant and caustic
 commentary.
12. Karl Marx, op. cit., pp. 56ff and especially pp. 63ff.

Chapter 3

1. See Edith Helman, *Trasmundo de Goya* (Revista de Occidente, Madrid,
 1963) pp. 118ff.
2. See, in particular, her study *Trasmundo de Goya* (Madrid, 1963) and her
 collection of essays, *Jovellanos y Goya* (Taurus, Madrid, 1970). I thank
 my friend Joaquin Romero Maura for having introduced me to the
 scholarly and sinewy work of Edith Helman, which is decisive.
3. Edith Helman, *Trasmundo de Goya,* pp. 199–200, and 'Los Chinchillas de
 Goya', in *Jovellanos y Goya,* pp. 183–97.
4. Edith Helman, 'Don Nicolas Fernández de Moratín y Goya: sobre *Ars
 amatoria*', *Jovellanos y Goya,* pp. 219–35.
5. On Goya's relationship with Jovellanos, see both books by Edith Helman
 and Gassier and Wilson, op. cit.
6. See N. Glendinning, 'The Monk and the Soldier in Plate 58 of Goya's
 Caprichos', *Journal of the Warburg and Courtauld Institutes,* xxiv (1961),
 and Edith Helman, *Trasmundo de Goya,* pp. 87–8.
7. Edith Helman, *Trasmundo de Goya,* pp. 72ff for a convincing discussion
 of this theme.
8. Edith Helman, 'Cadalso y Goya: sobre caprichos y monstruos', *Jovellanos
 y Goya,* pp. 125–55.
9. On Moratín and Goya, see Edith Helman, 'The Younger Moratín and
 Goya: on *Duendes* and *Brujas*', *Hispanic Review,* xxvii (1959), also in
 Spanish in *Jovellanos y Goya*; 'Goya y Moratín hijo: actitudes ante el
 pueblo en la Ilustración española', *Jovellanos y Goya,* pp. 237–56; 'Goya,
 Moratín y el teatro', ibid., pp. 257–71; *Trasmundo de Goya,* pp. 178ff.

Chapter 4

1. Edith Helman, *Trasmundo de Goya,* pp. 30–3. José Ortega y Gasset,
 'Goya y lo popular', *Obras completas* (Madrid, 2nd edn, 1964) vii, 521–36,
 and comments in *Papeles sobre Velázquez y Goya* (Madrid, 1950).
2. On this question, see Gassier and Wilson, op. cit., p. 79; José Gudiol,
 Goya (New York, 1964), pp. 23, 45, 83.
3. See Edith Helman, *Trasmundo de Goya,* pp. 17–26, and 'Identity and
 Style in Goya', *Burlington Magazine,* cvi (1964), also in *Jovellanos y Goya,*
 pp. 111–23.
4. Gassier and Wilson, op. cit., pp. 22, 48–53; Edith Helman, *Trasmundo de
 Goya, passim.*
5. See Gassier and Wilson, op. cit., pp. 51–68, and the brilliant essay by
 Edith Helman in *Trasmundo de Goya,* pp. 20ff, 163ff.
6. Edith Helman, *Trasmundo de Goya,* pp. 33–4; Gassier and Wilson, op. cit.,
 pp. 22–3, 71, 106.

7. The evidence is set out clearly in Gassier and Wilson, op. cit., pp. 105–6. The key source is Valentín de Sambrició, *Tapices de Goya* (Madrid, 1946).
8. Gassier and Wilson, op. cit., pp. 62ff.
9. Edith Helman, *Trasmundo de Goya*, pp. 98ff.
10. Gassier and Wilson, op. cit., p. 68.
11. These works have been the subject of controversy: the *Yard with Lunatics* disappeared from view after a sale in 1922 and was published as a rediscovery in 1967. The argument is set out in full in Gassier and Wilson, op. cit., catalogue and notes, pp. 161 and 169, text, pp. 105–13. A basic source is Xavier de Salas, 'Precisiones sobre pinturas de Goya, *El entierro de la sardina*, la serie de obras de gabinete de 1793–4, y otras notas', *Archivo Español de Arte*, xli (1968).
12. The placing of these eight paintings of the Romana collection remains difficult. F. J. Sánchez Cantón, 'Como vivía Goya', *Archivo Español de Arte*, xix (1946), first identified them with the 'horrors of war' inventoried in Goya's house in 1812. The argument, following José Gudiol, for placing them in the 1790s is discussed in Gassier and Wilson, op. cit., notes to catalogue III, 914–21, p. 254, where the 'savages' are also considered.
13. The Alba affair is most sensibly treated in Gassier and Wilson, op. cit., pp. 114–17.
14. The albums are magnificently handled in Gassier and Wilson, op. cit., pp. 117ff and reproduced in miniature on pp. 171–6.
15. Miniatures of the *sueños*, the *Caprichos* and the preparatory drawings may be found in Gassier and Wilson, op. cit., pp. 176–88.

Chapter 5

1. Tomás Harris, *Goya: Engravings and Lithographs* (Oxford, 1964) i, 140.
2. Inventories analysed by F. J. Sánchez Cantón, 'Como vivía Goya', *Archivo Español de Arte*, xix (1946), and the issue fully treated in Gassier and Wilson, op. cit., pp. 246–50.
3. The catalogue created by Gassier and Wilson, op. cit., fully documents this statement.
4. Gassier and Wilson, op. cit., pp. 154–8 and catalogue, pp. 200–1.
5. An entertaining story summarized in Gassier and Wilson, op. cit., p. 261.
6. Basic on the crisis are the works of Miguel Artola, *Los orígenes de la España contemporanea* (Madrid, 1959) and *La España de Fernando VII* (Madrid, 1968). A social history of the crisis is in the making in Spain, deriving in part from the work of J. Vicens Vives and marxist or marxisant in tone (with Maurice Dobb and Edward Thompson major influences); see, for example, the works of Gonzalo Anes and Josep Fontana, op. cit.; but much Spanish writing on the crisis tends to be notable for quantity rather than quality. Useful are Carlos E. Corona Baratech, op. cit., M. Izquierdo Hernández, *Antecedentes y comienzos del reinado de Fernando VII* (Madrid, 1963). Most illuminating are the early chapters of Raymond Carr, op. cit. (where Azanza is quoted), a few all too brief remarks in J. Vicens Vives, *Approaches to the History of Spain*, trans. Joan Connelly Ullman (Berkeley, 1970) and the short but memorable pieces which Karl Marx wrote for the *New York Tribune*, collected in *Revolution in Spain* (New York, 1939).
7. The narrative of the rising and the guerrilla war (which still lacks an adequate historical analysis) has to be pieced together from a wide range of sources which vary greatly in quality. Central is the detailed narrative of the Count de Toreno. I have used the French version – *Histoire du soulèvement, de la guerre et de la révolution d'Espagne* (Paris, 1836).
8. The best approach to the period in English is by Raymond Carr, *Spain 1808–1939*. W. N. Hargreaves-Mawdsley, *Spain under the Bourbons*

181

1700–1833 (London, 1973), prints, from p. 198 onwards, a number of illustrative documents in English translation, including a classic *cri de coeur* of Spanish liberalism in Quintana's letter to Lord Holland of November 1823.

9. The narrative of Goya's life in this period in Gassier and Wilson, op. cit., pp. 205–344, supersedes all others.

10. The subject is fully treated in Gassier and Wilson, op. cit., pp. 246–9. Key sources are Valentín Sambricio, *Tapices de Goya*, F. J. Sánchez Cantón, 'Como vivía Goya', *Archivo Español de Arte*, xix (1946) and *Vida y obras de Goya* (Madrid, 1951), revised in *The Life and Works of Goya* (Madrid, 1964) and Xavier de Salas, 'Sur les tableaux de Goya qui appartinrent à son fils', *Gazette des Beaux-Arts*, lxiii (1964).

11. E. Lafuente Ferrari, *Goya: El Dos de Mayo y los Fusilamientos* (Barcelona, 1946), p. 23, n32; Pedro Beroqui, *El museo del Prado* (Madrid, 1933), p. 101; Gassier and Wilson, op cit., p. 257.

12. M. Nuñez de Arenas, 'Manojo de noticias – La suerte de Goya en Francia', *Bulletin Hispanique* (Bordeaux) 3 (1950); Gassier and Wilson, op. cit., p. 335.

Chapter 6

1. Goya's drawings are for the first time fully published and annotated in Gassier and Wilson, op. cit., catalogue and notes, pp. 171–88, 194–6, 267–96, 325–7, 329–30, 363–71; text commentaries are on pp. 117–31, 217–22, 227–39, 301–4, 308–12, 333–49.

2. Reproduced in Anthony Blunt, *Picasso's Guernica* (O.U.P., 1969), p. 10.

3. This paragraph is based on a close analysis of the argument and specimens fully deployed in Gassier and Wilson, op. cit., catalogue and notes, pp. 254, 263–5.

4. Gassier and Wilson, op. cit., catalogue, notes and specimen miniatures pp. 254, 264, and 195 (for the drawing after Flaxman).

5. Gassier and Wilson, op. cit., catalogue, notes and specimens, pp. 254, 262–3; José López-Rey, 'Goya's Still-Lifes', *Art Quarterly*, xi (1948).

6. Gassier and Wilson, op. cit., pp. 227–9, 276–81 (catalogue).

7. Gassier and Wilson, op. cit., pp. 308–12, 325–7 (catalogue). Among the best reproductions of Goya's four major series of engravings are E. Lafuente Ferrari, *Goya: the Complete Etchings, Aquatints and Lithographs* (New York, 1962) and Tomás Harris, *Goya: Engravings and Lithographs*, 2 vols., (Oxford, 1964).

8. Tomás Harris, op. cit., ii, 365–407.

9. Gassier and Wilson, op. cit., pp. 310, 325; F. D. Klingender, *Goya in the Democratic Tradition*, pp. 208–9 (London, reprint 1968).

10. The cogent and convincing argument is set out in Gassier and Wilson, op. cit., pp. 313–18; see also Appendix vi; the catalogue, notes and specimens are on pp. 323, 327–8; see also F. J. Sánchez Cantón, *Goya and the Black Paintings* (London, 1964).

11. For his work in France, see Gassier and Wilson, op. cit., pp. 333–54, and catalogue on pp. 356–72.

12. On this period in his life, see chapters 4 and 5 of F. D. Klingender, *Goya in the Democratic Tradition*; while these range with extraordinary abandon over time and space, they are also extraordinarily powerful and evocative and seem to me to have the heart of the matter in them.

Chapter 7

1. Art historians generally seem to me (as a mere common-or-garden historian) *bland* in their nonchalant acceptance of the excision of these three small prints, in the teeth of Goya's explicit statement. Their

criteria are presumably 'artistic' rather than 'historical'.

2. The entire argument of this chapter is based on a very close and particular examination of the eighty-five prints of the original *Fatal Consequences* capricho, set out in detail in Gassier and Wilson, op. cit., catalogue, notes and specimens on pp. 257, 268–76; text treatment, pp. 217–21; this study was correlated with work on contemporary drawings, engravings and paintings and related to other detailed studies of the series. Of major significance are E. Lafuente Ferrari, op. cit., and *Los desastres de la guerra de Goya y sus dibujos preparatorios* (Barcelona, 1952); Tomás Harris, op. cit.; and the very full collection (though still without the chained prisoners) in *The Disasters of War,* introduction by Philip Hofer (New York, 1967).

3. Gassier and Wilson, op. cit., p. 221.

Chapter 8

1. John Berger, *Success and Failure of Picasso* (Penguin, London, 1965), p. 22.
2. See Anthony Blunt, op. cit., and J. Berger, op. cit., pp. 114, 187–202.
3. Karl Marx, *Introduction to a Critique of Hegel's Philosophy of Right* (*1843–44*), most conveniently located in D. McLellan (ed.), *Karl Marx: Early Texts,* Blackwell's Political Texts (Oxford, 1971), p. 117.
4. J. Berger, op. cit., p. 20.
5. Karl Marx, op. cit., p. 127 (I have used some elements of the older translation).
6. John Berger, 'The Changing View of Man in the Portrait', in *The Look of Things: Selected Essays and Articles* (Pelican, London, 1972), p. 38.
7. See the argument in John Berger, op. cit., p. 36.
8. John Berger, op. cit., p. 39.
9. John Berger, op. cit., p. 38.

Bibliography

Pierre Gassier and Juliet Wilson, *Goya, His Life and Work, With a Catalogue Raisonné of the Paintings, Drawings and Engravings,* ed. Francois Lachenal, trans. from the *Office du Livre* (Fribourg) French edition of 1970 (Thames & Hudson, London, 1971). A magnificent and monumental work of impeccable scholarship which, for the first time, establishes and documents Goya's entire production. The editors' text is a cogent and perceptive monograph in its own right. This splendid volume supersedes most biographies of Goya, though F. J. Sánchez Cantón, *Vida y obras de Goya* (Madrid, 1951), revised in *The Life and Works of Goya* (Madrid, 1964), is still useful and José Gudiol, *Goya,* biography and *catalogue raisonné* in 4 volumes (Barcelona, 1970) makes a literally massive contribution.

Enrique Lafuente Ferrari, *Goya: His Complete Etchings, Aquatints and Lithographs* (New York, 1962) has good reproductions of the same size as the originals, and an interpretive essay.

Tomás Harris, *Goya: Engravings and Lithographs,* 2 vols. (Oxford, 1964) is a massive and scholarly collector's catalogue. The illustrations, including details, are magnificent and the editor's comments are penetrating, though not always those of a historian.

José Gudiol, *Goya* (New York, 1964) is a very fine and large-scale book, which should be read with his other work.

Gassier and Wilson provide a comprehensive bibliography. Important among specialized studies are F. J. Sánchez Cantón, *Goya and the Black Paintings* (London), 1964) and 'Como vivia Goya', *Archivo Español de Arte,* xix (1946); Valentín de Sambricio, *Tapices de Goya* (Madrid, 1946); E. Lafuente Ferrari, *El Dos de Mayo y los Fusilamientos* (Barcelona, 1946) and *Los desastres de la guerra de Goya y sus dibujos preparatorios* (Barcelona, 1952); Xavier de Salas, 'Precisiones sobre pinturas de Goya, *El entierro de la sardina,* la serie de obras de gabinete de 1793–4, y otras notas', *Archivo Español de Arte,* xli (1968).

Of the many popular presentations of Goya, Enriqueta Harris, *Goya* (Phaidon, London, 1969) offers remarkable value for money.

Interpretations of Goya are legion. Pride of place goes to the studies of Edith Helman, *Trasmundo de Goya* (Revista de Occidente, Madrid, 1963) and her collected essays *Jovellanos y Goya* (Taurus, Madrid, 1970), a scholarly and often brilliant, always cogent exploration of Goya and the *ilustrados.*

F. D. Klingender, *Goya in the Democratic Tradition* (London, reprint 1968) was in 1948 a vigorous, pioneering essay in the Marxist mode. Its handling of the problem is too simplist, but it remains a powerful, rich and generous book by a remarkable and attractive man.

D. B. Wyndham Lewis, *The World of Goya* (London, 1968) is notable chiefly

for its lush wealth of fine illustration. The text is baroque, but full of interest and some entertainment.

Hugh Thomas, *Goya: The Third of May 1808,* Art in Context series (Allen Lane, The Penguin Press, London, 1972), places the painting in the historical situation.

André Malraux, *Saturn: An Essay on Goya* (London, 1957) is a breathtaking work which tends to induce a truly Gaullist stupefaction, but is quite revealing, at least on Malraux.

The history of Spain in this period is not very well served yet. The best entry is Raymond Carr, *Spain 1808–1939* (O.U.P., 1965) a magnificent achievement. Jaime Vicens Vives should be read, in his monumental *An Economic History of Spain* (Princeton, 1969) and in his challenging short survey *Approaches to the History of Spain,* trans. J. C. Ullman (Berkeley, 1970). Richard Herr, *The Eighteenth Century Revolution in Spain* (Princeton, 1958) is a good craftsmanlike job, which may be supplemented by Nigel Glendinning's admirable *The Eighteenth Century,* a literary history of Spain (London, Benn, 1972). Wider in scope is J. Sarrailh, *L'Espagne éclairée de la seconde moitié du xviiie siècle* (Paris, 1954). M. Menéndez Pelayo, *Historia de los heterodoxes españoles* (Santander, 1947–8) has become a classic to many; a recent treatment is Gonzalo Anes, *Economía e ilustración en la España del siglo xviii* (Barcelona, 2nd edn, 1972). M. Defourneaux, *Pablo de Olavide ou l'Afrancesado* (Paris, 1959) is informative. Carlos E. Corona Baratech, *Revolución y reacción en el reinado de Carlos IV* (Madrid, 1957) leads into the complexities of a baffling reign, while Miguel Artola, *Los origenes de la España contemporanea* (Madrid, 1959) and *La España de Fernando VII* (Madrid, 1968) explore its even more baffling successor. The field opened up by such seminal studies as those of Pierre Vilar in his monumental *La Catalogne dans l'Espagne moderne* (Paris, 1962) and in his specialized studies since, of E. J. Hamilton in his *War and Prices in Spain 1651–1800* (Cambridge, Mass., 1947), is now being explored by Spanish historians. See, for example, Gonzalo Anes, op. cit., and *Las crisis agrarias en la España moderna* (Barcelona, 1972), Josep Fontana, *Cambio económico y actitudes politicas en la España del siglo xix* (Barcelona, 1973) and *La quiebra de la monarquia absoluta* (Barcelona, 1974), Jordi Nadal, *La población española* (Barcelona, 3rd edn, 1973) and his essay on Spain in *Fontana Economic History of Europe,* ed. C. M. Cipolla, vol. ii (1973).

A comprehensive and effective critical history of Spain in crisis across the turn of the eighteenth and nineteenth centuries has still to be written. An unexpected pleasure are the articles Karl Marx wrote for the *New York Tribune* in 1854, collected in *Revolution in Spain* (New York, International Publishers, 1939). They are some of the most stimulating pieces he ever wrote.

Too late to serve as reference for this text, but now the essential point of departure for any study of Goya, is Pierre Gassier's magnificent edition of the drawings which, together with his and Juliet Wilson's great catalogue, puts us finally in *possession* of the most challenging European artist:

Pierre Gassier, *The Drawings of Goya, The Complete Albums,* trans. from the Office du Livre (Fribourg) French edition of 1973 (Thames & Hudson, 1973).

List of Illustrations

187

45. Goya, *Parten la vieja* (drawing B60). Paris, Louvre. (Photo: Office du Livre, Fribourg).

46. Goya, *Buen sacerdote, ? donde se ha celebrado?* (drawing B86). Boston (USA) Museum of Fine Arts. (Photo: Office du Livre, Fribourg).

48. Goya, *Brujas,* 1797–98 (Osuna, 86). Madrid: Fundación. Lázaro Galdiano. (Photo: Mas).

49. Goya, *Alegoria de la Villa de Madrid,* 1809–10. Madrid: Ayuntamiento. (Photo: Mas).

50. Goya, *La aguadora,* 1808–12. Budapest (Hungary) Museum. (Photo: Mas).

51. Goya, *El afilador,* 1808–12. Budapest (Hungary) Museum. (Photo: Mas).

52. Goya, *obra* (the forge), 1812–16. New York, collection: Frick. (Photo: Mas).

53. Goya, *Lucha entre Fray Pedro de Zaldivia y el bandido Maragato,* 1806–7. Chicago, Art Institute. (Photo: Mas).

54. Goya, *Fabricación de balas en la Sierra de Tardienta, c.*1810–14 Madrid: Palacio Real. (Photo: Mas).

55. Goya, *El coloso,* 1808–12. Madrid, Prado. (Photo: Mas).

56. Goya, *Despreciar los insultos* (drawing E16). France, collection: Héritiers C. de Hauke. (Photo: Office du Livre, Fribourg).

57. Goya, *No sabe lo que hace* (drawing E19). Berlin-Dahlem (Germany) Kupferstichkabinett. (Photo: Mas).

58. Goya, *Por linage de Ebreos* (drawing C88). London, British Museum. (Photo: Mas).

59, 60, 61, 62, 63, 64, 65, 66, 68. Goya, *dibujos,* C85, C98, C97, C104, C123, C120, C118, C122, C115, Madrid, Prado. (Photo: Mas).

67. Goya, *Oración en el Huerto* (Christ on the Mount of Olives), 1819. Madrid: Escuelas Pías de San Antón. (Photo: Mas).

70, 71, 72. Goya, *Los Disparates (Proverbios), c.*1815–24. Barcelona, collection: Torello. (Photo: Mas).

73. Goya, *La romería de San Isidro,* 1820–23. Madrid, Prado. (Photo: Mas).

97. Goya, *dibujo* (student-frog mirror drawing), 1797–98. Madrid, Prado. (Photo: Mas).

98. Goya, *Buenos consejos* (drawing H4), *c.*1824–28. Madrid, Prado. (Photo: Mas).

All identifications taken from Pierre Gassier and Juliet Wilson, *Goya: His Life and Work,* with a catalogue raisonné of the paintings, drawings and engravings, ed. François Lachenal, preface by Enrique Lafuente Ferrari (Thames & Hudson, 1971), an English version of the text first published by Office du Livre, Fribourg, in 1970. I am most grateful to Mrs Juliet Wilson and Pierre Gassier and the Office du Livre, Fribourg, for their generous assistance.

Index

About the Author

Gwyn A. Williams is Professor of History at University College, Cardiff. He has written *Medieval London* (1963), *Rowland Detroisier: A Working-class Infidel* (1965), *Artisans and Sans-culottes: Popular Movements in Britain and France During the French Revolution* (1968), several articles on Welsh history, and *Proletarian Order* (1975), which, together with his translation of Paolo Spriano's *Occupation of the Factories* (1975), forms part of his work on the Italian marxist Antonio Gramsci.